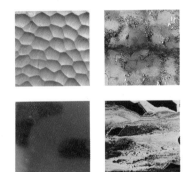

The Sculptor's Bible

The Sculptor's Bible

The all-media reference to surface effects
and how to achieve them

John Plowman

kp books
An imprint of F+W Publications, Inc.

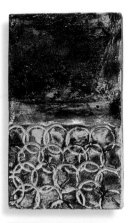

A Quarto Book

First published in North America in 2005 by
KP Books
700 East State Street
Iola, WI 54990-0001

Library of Congress Catalog Card Number applied for
ISBN 0-89689-194-1

QUAR.SBB

Conceived, designed, and produced by
Quarto Publishing plc
The Old Brewery
6 Blundell Street
London N7 9BH

Project Editor Liz Pasfield
Art Editor Sheila Volpe
Copy Editor Claire Waite Brown
Designer Anthony Cohen
Assistant Art Director Penny Cobb
Picture Research Claudia Tate
Photographers Martin Norris, Paul Forrester, Colin Bowling
Proofreader Anna Amari-Parker
Indexer Pamela Ellis

Art Director Moira Clinch
Publisher Piers Spence

Manufactured by Modern Age Repro House Ltd, Hong Kong

Printed in China by Midas Printing International Ltd

9 8 7 6 5 4 3 2 1

Contents

Note to the reader

Many sculpting materials are toxic and hazardous if not handled carefully. Please study carefully the health and safety information on pages 8-9 and adhere to good practice at all times. The author, publisher, and copyright holder cannot be held liable if this advice is disregarded.

When working with measurements of materials for these recipes it is vital that you keep to one method of measuring (imperial or metric) and do not mix the two. While every care has been taken with the color reproduction in this book, the limitations of the printing process mean we cannot guarantee total color accuracy in every instance.

Introduction

SCULPTURE IS THE ART of making three-dimensional shapes and forms. It is the act of taking hold of a material and changing it into a new and unique shape. Whether that shape is representational and realistic or abstract, the principles are the same and the sculptor takes advantage of the expressive possibilities that this three-dimensional art form has to offer.

Sculptors need solid materials to work with, and can choose from the vast variety of stones, woods, clays, metals, and plastics that are available. Each material has special techniques and tools needed to work it and, as you learn more, you can choose from the myriad of possibilities to create the effect that you want by way of the color, density, grain, and unique characteristics of every material.

The importance of surface treatments

The way in which the surface of a sculpture is finished strongly influences the way the piece is experienced. Creating the right feel in the finish can make or break a sculpture, supporting or undermining what the artist is trying to express. Regardless of shape or style, whether modern or traditional, the surface treatment will affect the mood, atmosphere, energy, and associations of the sculpture. Therefore, if sculptors master a wide range of finishing techniques, they can choose the one that best serves their aims and lends the sculpture the qualities they wish it to convey.

Beginners in sculpture often make the mistake of thinking that, to look finished, a piece must be smooth and highly polished, and so exclude some of the most expressive finishes that they could have chosen from. Instead, it is important to understand that qualities of texture, tone, color, and exactness or sketchiness in the surface of a sculpture allow the viewer to experience the finished work as if they are touching it or running a hand over its surface. The surface could be hard and reflective, or create an impression of softness because of the way light falls on it. Colorings can be matte and natural, or bright, glossy, and modern-looking. The tone of a piece, whether light and transparent or dark and heavy, can create a mood of mystery or of clarity and openness.

The Sculptor's Bible aims to arm the sculptor with a comprehensive range of possible surface treatments that can be accessed in an instant. You can glance through the following swatches of effects on various materials to find the ideal one for your work, or adapt the finishes to suit your needs.

The modern way

At the turn of the last century, c.1900, the French sculptor Rodin saw Michelangelo's unfinished *Slaves* and was inspired by the powerful effect of its unfinished state. He began to use the full range of tool marks and textural possibilities, through every grade of mark to the finest polished surface. Considered by many to be the father of modern sculpture, he opened the way for sculptors to make full use of all the textural effects available to them.

Today's sculptors have a wide range of possible surface finishes available to them, due both to the range of materials available and the open attitude of modern art, which allows the use of substances and processes outside the boundaries of traditional sculptural techniques.

Some sculptors want to show the viewer that their work was made by hand, and leave traces of their efforts with a gouge, chisel, or saw. In the modern age, when many of the everyday items that surround us are made in factories and have an anonymous quality, it can be important to show that a piece was carefully and thoughtfully carved by an individual. The visible tool marks show energy lines and directions used in creating the piece, and have an expressive textural quality of their own. When working in a soft material the imprints of the fingers and hands leave a unique signature of the artist's creative efforts, illustrating how they moved and manipulated the material.

Other sculptors want to create the impression of something very modern and simulate the industrial feel in their work. By using modern materials and finishes they can make an individual piece by hand that has the associations of huge mechanical processes.

Other options include polishing a surface, which allows the quality of the material to be seen and creates one of the simplest and most pleasing effects in sculpture, where the forms made by the artist and the beauty of the material work together.

Sculpture has a long history of creating images to look as if they are the real thing. The vast range of materials available today makes this even easier. By creating the right textures and colors, the sculptor can create pieces that take on the semblance of reality.

This book can guide the artist to whatever finish they require, or serve as a springboard for the sculptor's own experimentation.

Health and safety

Sculpting should be enjoyed, but it should also be safe so it is important that the sculptor is aware of practices and materials that are potentially harmful.

Some dangers in sculpting are obvious and immediate, such as sharp tools that can cut your hand in a moment of inattention. Other dangers are less obvious and the effects may take a long time to show up. Breathing clay or stone dust, for example, can, over many years, result in silicosis, an illness that clogs the lungs and impairs breathing. Most materials, will have safety information listed on their labels so make sure that you always read and follow the recommendations.

However, you should not be put off by all these safety warnings. Approach each project with an informed, sensible attitude and you can enjoy the creativity without compromising your health.

PROTECT YOUR EYES

There are a number of reasons why safety goggles are necessary:

• When carving, wood and stone chips can fly at great speeds into your eyes. Generally speaking, the harder the material, the harder you have to hit it and the faster the chips will fly. A piece of the hammer or chisel may also splinter off and can enter your eyes.

• Dust and splinters from power saws, sanders, and drills are produced at high speed and should not be allowed anywhere near the eyes.

• When doing metalwork, sharp pieces of metal can fly off when hammering, while grinding produces a stream of hot sparks that can burn the eyes.

• When mixing chemicals, such as paints, resins, patinas, and dyes, it is very easy for a splash to get into the eyes and cause damage.

PROTECT YOUR EARS

If your ears are ringing after a job, or at the end of the day, it is because you should have been wearing ear defenders. Power tools are notorious for causing hearing damage because of the high-pitched, continuous noise they make. Hammering metal and carving stone can also be damaging. Hearing damage takes place over a long period of time and you may not notice the gradual deterioration until it is too late. So don't be tempted to leave the ear defenders off.

PROTECT YOUR LUNGS

There are two types of masks. The first protects from dust particles and should be worn whenever dust is produced:

• When carving, sanding, grinding, and even sweeping up, a dust mask prevents the particles from getting through your nose and into your lungs.

• Working in a well-ventilated area or outside, where the dust can disperse, and using a water spray will help to keep the levels of airborne dust to a minimum.

The other type of mask filters chemicals out of the air that are poisonous if inhaled. This mask is needed when working with polyester resins, epoxy resins, patinating chemicals, when melting certain metals, and even when using strong paints.

Good working practices in the studio

Create a clean, organized, and well-lit studio. Accidents happen much more often in a messy, cluttered environment.

• To keep the studio organized, always plan your projects and clean up when they are finished. Dust left behind from carving and sanding, and fumes from open paint cans, drying paint, or polyester resin can become a background hazard that you may not even notice.
• Make sure your studio is well ventilated. Have a separate area for works that are give off fumes, and only work in that area with a mask on.
• Store sharp tools and poisonous substances out of harm's reach. If there is the possibility that children will come into the studio, make sure that anything potentially dangerous is safely locked away.
• When disposing of poisonous substances, do so in a safe, environmentally friendly way.
• Power tools have the potential to do more harm more quickly than hand tools. Chainsaws are well known to be the most dangerous of

handheld power tools, so it is a good idea to enroll in a course and to get professional training before attempting to use one for sculpting. Bench saws, band saws, skill saws, and jigsaws must all be treated with great respect. Grinders and drills also operate at high speed and can quickly cause injury. Power tools also make a high-pitched noise and will damage your hearing after only a short period of use, so always use ear protectors.
• Have a first-aid kit in your studio and keep it stocked and up to date.
• Wear protective clothing appropriate to the work you are doing. When you remove these clothing articles leave them in the studio so that you do not take harmful dust or chemicals into the home.
• Take a common-sense approach to looking after your body. Use protective equipment wherever necessary, so that if an accident does occur, you will not get injured.
Use materials and processes that you are comfortable with. Choose the safer option, and if you are unsure, seek advice.

Again, having a well-ventilated workspace is important to keep chemical levels down. If you plan to do a lot of work with these types of materials, it is recommended that you have a dedicated area set up specifically for that purpose.

PROTECT YOUR SKIN
Many of the materials you handle in sculpting can have a damaging effect on your skin:
• Clay has a drying effect that can be counteracted by using moisturizing hand cream.
• Plaster has a stronger drying effect and should be handled with gloves if you use it frequently or if you have sensitive skin.
• Cement is a strong alkali and will rapidly dry out the skin, causing cracking and bleeding. Always wear gloves when working with cement.

• Strong acids used for cleaning and patinating metals will burn the skin so always wear gloves and protective clothing when using them.
• Other materials are dangerous because of their poisonous chemical nature, which can soak through the skin. Resins, paints, and dyes come into this category so always wear gloves and protective clothing.

PROTECT YOURSELF FROM BURNS
When working with metal whether you are welding, grinding, cutting, or casting high heats are generated, so take care to wear thick leather gloves and an an apron since your clothes can be burnt through or may even catch fire. Have a bucket of

water on hand for cooling down hot pieces and keep appropriate fire extinguishers in the studio. You also need to make sure that the studio environment is appropriate for this type of work. There should be an inflammable work surface and enough space to work in to ensure that any stray sparks will not set the place on fire.

PROTECT YOUR BACK
Sculpture can involve moving heavy materials:
• Practice using your body sensibly to lift and move heavy pieces without damaging your back or injuring yourself.
• Invest in lifting and moving equipment if you are intending to work on a large scale.

Materials

Sculptors can choose from a wide range of materials to create effects of color, texture, and density that capture a mood or quality they want to express in their work. Many of these are traditional materials that have been in use for hundreds of years and are accepted as artistic mediums. They are stable and predictable and have stood the test of time. Other modern materials have only recently become available for use by sculptors, and it is exciting to see how artists continue to find new creative uses for them.

Making impressions Every household is full of materials that can be used to create special effects in sculptures. Subtleties in surface effects can be achieved by impressing with coarse sandpaper (**1**), hessian (**2**), plastic mesh (**3**), muslin (**4**) or use scrunched-up plastic bags (**5**), bubble wrap, cling film (**6**), or a pan scourer (**7**). To create surprising rhythmic patterns, a woven basket (**8**) comes in handy, a cheese grater (**9**), or different grades of wire mesh (**10**).

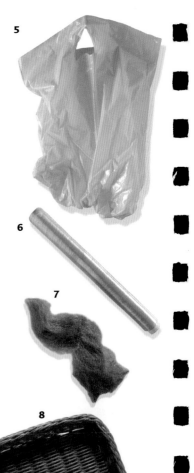

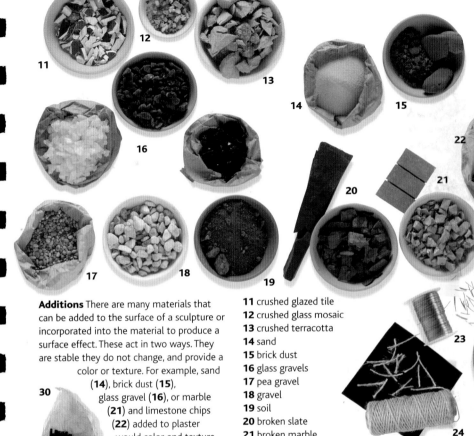

Additions There are many materials that can be added to the surface of a sculpture or incorporated into the material to produce a surface effect. These act in two ways. They are stable they do not change, and provide a color or texture. For example, sand (**14**), brick dust (**15**), glass gravel (**16**), or marble (**21**) and limestone chips (**22**) added to plaster would color and texture the piece permanently. Alternatively, there are materials that react and change, such as wood shavings (**23**), which dissolve away over time to leave marks, textures, and colors, or copper wire (**10**) that will rust and color the piece.

11 crushed glazed tile
12 crushed glass mosaic
13 crushed terracotta
14 sand
15 brick dust
16 glass gravels
17 pea gravel
18 gravel
19 soil
20 broken slate
21 broken marble
22 broken limestone
23 copper and galvanized wire, cut into pieces
24 string, cut into lengths
25 brush-head bristles
26 shredded paper
27 swarf
28 polystyrene chips
29 wood shavings
30 charcoal

1 **2** **3** **4** **5** **6**

9 **7** **11**

10

8

bronze, or brass fillers (**13**) are added. Similarly, a wide range of materials can be covered with a metallic coating to make them appear to be made of metal. Traditionally, gold and silver leaf is applied to the surface of bronze, wood, or stone sculptures. Today, other products are available: metal powders (**14**) and iron paste (**15**), gilt waxes (**16**), liquid leaf (**17**), and gilt varnishes and cream (**18**), which can be rubbed in or applied like paint, and give a realistic look on many surfaces. Antique fluid in various finishes (**19**) and

Subtle finishes Sealers (**1**), varnishes (**2**), and finishing oils (**3**) are transparent or near-transparent coatings with gloss, semi-gloss, or matte finishes. They are most often used on wood but can be used to protect steel from rusting. White polish (**4**) and French polish (**5**) are available in solid or liquid forms. Both are applied to the surface, allowed to dry, and then rubbed with a cloth or brush to achieve a smooth, shiny surface. Wooden sculptures that are to be placed outdoors will need to be protected from the weather and rot by chemical preservers. These are available as house or fence stains and can come as a clear product or in a range of colors, including

natural wood shade (**6**). Beeswax (**7**) can be used in its natural state, although it is usually purchased ready for use, having been dissolved with turpentine. It adds a luster and a distinctive smell.

Speciality waxes These are available in various shades, black patinating (**8**), liming (**9**), verdigris (**10**), and all-purpose wax products for use on every type of material—wood, metal, leaf, and plastic. Boot polish (**11**) can be applied and polished to enliven a surface.

Metallic additions and coatings Ferric nitrate and hydrochloric acid (**12**) are used to treat steel before coloring it. To give the impression that a sculpture is worked in metal, copper,

12

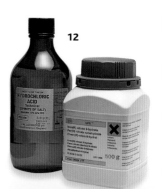

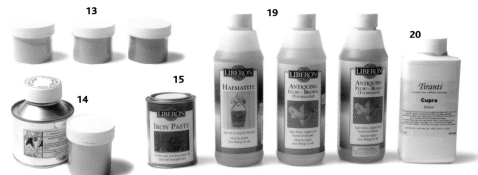

13 **19** **20**

15 **14**

16 **17** **18**

(**22**) are tough. They are suitable for outdoor use and some include rust protection. Paints can have other materials added to them, such as metal powders or sand, to produce special effects. Spray paint (**23**) is available in a wide range of materials, such as enamel, lacquer, and acrylic, and is especially good for creating a smooth, even surface without brush marks. Acrylic paints (**24**) and dried pigments (**25**) can transform the appearance of plaster.

verdigris patination (**20**) are used to distress metals.

Paints, dyes, inks, pigments
Paints cover and seal a surface, while inks and dyes soak into the material, coloring the sculpture but leaving the original surface quality visible. Inks and dyes (**21**) are only useful for porous materials such as

wood and plaster. Dyes normally used for fabric or for wood can be used on a wide range of materials, although their permanence and light fastness may be affected. Generally, paints and dyes fall into either spirit- or water-based categories. Water-based materials give off fewer odours and dry quicker. Solvent-based paints, such as Hammerite,

24

22

23

25

21

Tools

Specialized tools are used for creating surface effects. A surface may be given a smooth and highly polished treatment—created using tools such as rifflers—or a highly textured, tactile finish, sometimes created using dedicated tools, often using specially adapted implements that the sculptor may have developed after years of perfecting a particular technique. Some tools can be made—adapted from kitchen utensils—while others can be bought from art materials suppliers.

Rifflers These are very small rasps (**1**) used to smooth and shape areas of a sculpture. They can be used on wood, stone, plaster, or car body filler and come with a range of profiles.

Surform and rasps
A surform (**2**) and rasps (**3**) give rough shape and form to plaster, wood, or aerated concrete blocks. The marks left by the blade can be used as a decorative surface texture.

Wooden mallet or carver's mallet
To avoid damaging tools, always use a wooden mallet (**4**) with wooden-handled chisels or gouges. Traditionally made of beech or *Lignum vitae*, the latter are the best because of the density of the wood.

Lump hammer A heavy lump hammer (**5**) is used with steep stone carving tools.

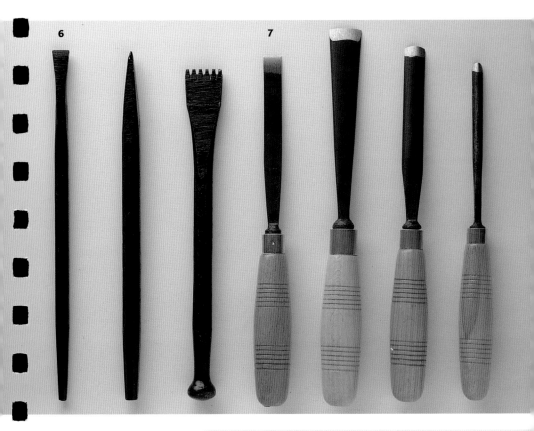

Stone carving chisels Stone carving chisels (**6**) come with a variety of cutting edges. Use a nylon mallet for tools with a rounded handle and a lump hammer for the others.

Carving gouges
Wooden-handled carving gouges (**7**) with curved and shaped cutting edges are used for carving wood. The tools and handles can be bought separately, but ask the supplier to fit your chosen handle, which must be put on straight.

POWER TOOLS

Power tools can make a job quicker and easier, such as roughing out the surface of a sculpture or removing large areas of waste wood. Power tools are expensive and there are a huge range of different makes available, so seek an expert opinion before you buy and be sure that you will actually use the tool. Power tools can also be dangerous, so it is important to learn how to use them safely and then to take appropriate precautions every time.

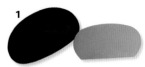

Metal kidneys A metal kidney (**1**) is very useful for clay and plaster. It is used to refine the surface. Kidneys come in various sizes, grades (thicknesses), and shapes— from oval to square. They can also have serrated edges for paring down rough surfaces.

Awl An awl (**2**) is a useful tool for marking and making holes in wood and plaster.

Drill bits and zip bits Drill bits (**3**) are appropriate for use on wood and thin gauge steel; zip bits (**4**) can be used for large-diameter holes.

USEFUL BRUSHES FOR SCULPTORS

Brushes are an important part of the sculptor's armory and most art materials suppliers offer a variety of designs for specialist applications. They are made of different bristles and hairs, both synthetic and natural. Generally, the higher the price, the better the quality.

Flat brush or paintbrush
These can be used to apply paint, glazes, stains, and varnish. They are made from hog or horse hair.

Wire brush Useful in woodwork for opening up the grain and for stripping carvings. A wire brush can be used to shape expanded styrofoam and for fine details.

Synthetic bristle brush
These are made from vegetable fibers, and are ideal for applying pigments.

Toothbrush
Old toothbrushes are useful for roughening clay surfaces. They can also be used for spattering on finishes (where you run a knife or a thumbnail along the surface of the paint-charged brush).

Craft knife A craft knife (**5**) serves as a general cutting implement, as well as a useful tool for serrating edges in plaster and wood.

5

Kitchen knife Another multi-purpose tool, the kitchen knife (**6**) is especially useful when working with plaster.

6

7

Tenon saw The tenon saw (**7**) is useful for diagonal cuts or small dimension work.

Junior hacksaw A junior hacksaw (**8**) is suitable for round objects.

8

G-clamp A G-clamp (**9**) holds work securely to the surface.

9

Directory of effects

This section of the book is organized into seven sections: stone, wood, metal, fired clay, plaster, resin, cement, and cement fondue.

Each section is introduced with techniques for working in that material. Swatches then follow which allow you to choose the recipe for the surface effect you wish to create. Finished pieces by accomplished sculptors are also included to inspire you.

On the next few pages, you will find all the surface effects included in the book. Use this selector to choose the effect you want, and then turn to the correct page for instructions on how to create it.

Surface selector

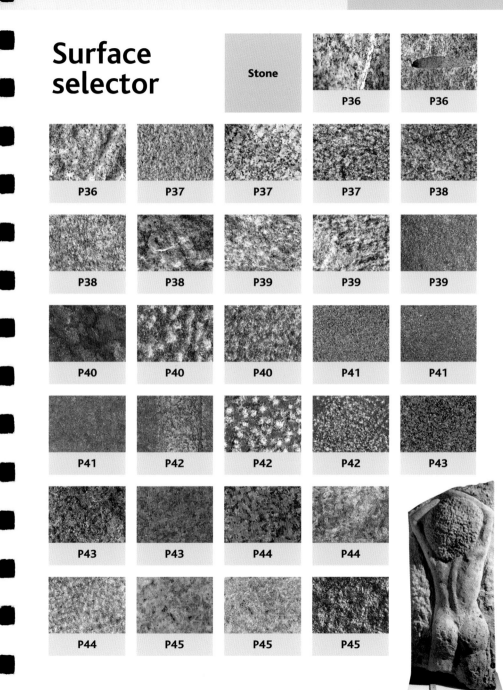

Stone

P36

P36

P36

P37

P37

P37

P38

P38

P38

P39

P39

P39

P40

P40

P40

P41

P41

P41

P42

P42

P42

P43

P43

P43

P44

P44

P44

P45

P45

P45

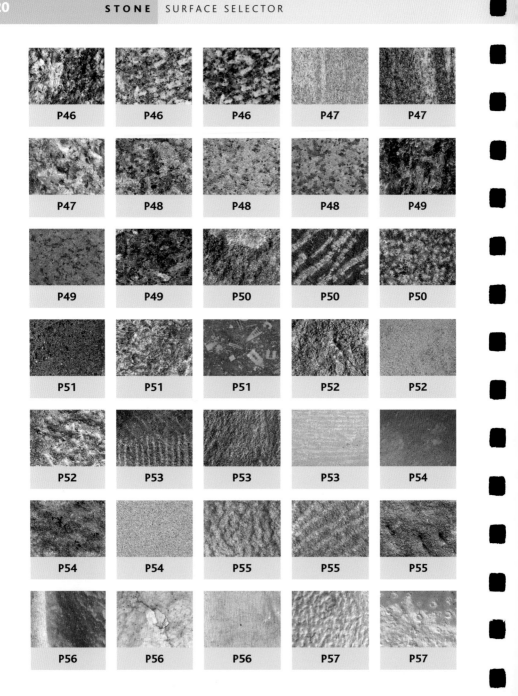

P46

P46

P46

P47

P47

P47

P48

P48

P48

P49

P49

P49

P50

P50

P50

P51

P51

P51

P52

P52

P52

P53

P53

P53

P54

P54

P54

P55

P55

P55

P56

P56

P56

P57

P57

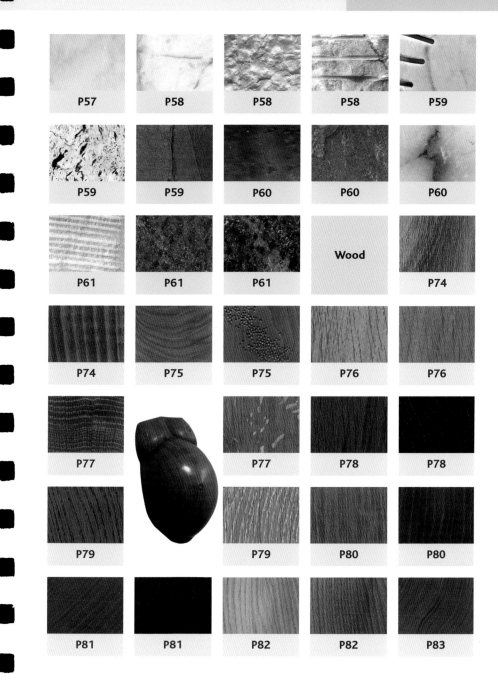

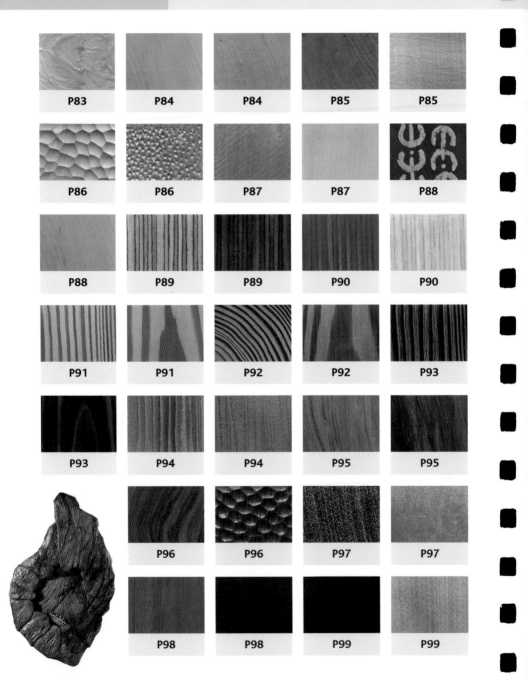

Metal

P108

P108

P109

P109

P110

P110

P111

P111

P112

P112

P113

P113

P114

P114

P115

P115

P116

P116

P117

P117

P118

P118

P119

P119

Fired clay

P132

P132

P132

P133

P133

P133

P134

P134

P134

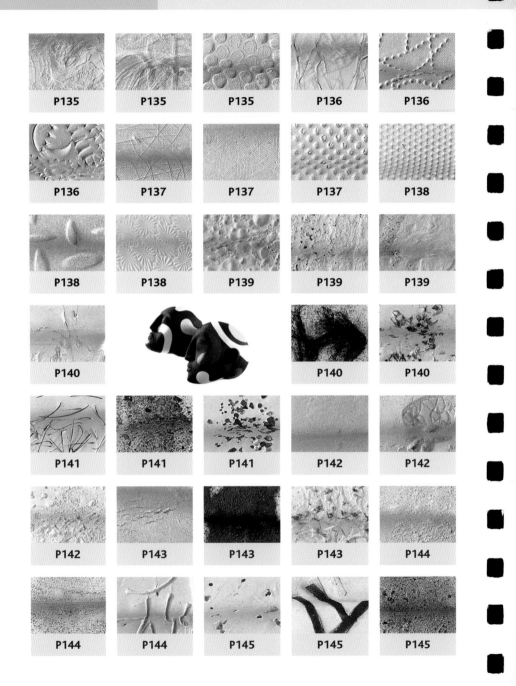

P135
P135
P135
P136
P136

P136
P137
P137
P137
P138

P138
P138
P139
P139
P139

P140
P140
P140

P141
P141
P141
P142
P142

P142
P143
P143
P143
P144

P144
P144
P145
P145
P145

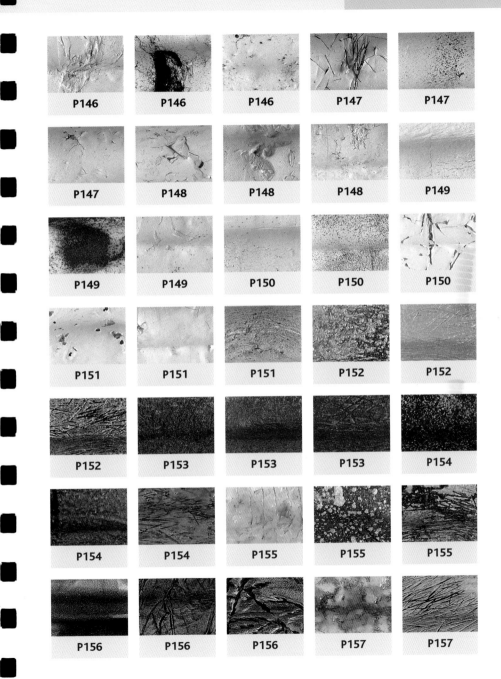

P146 P146 P146 P147 P147

P147 P148 P148 P148 P149

P149 P149 P150 P150 P150

P151 P151 P151 P152 P152

P152 P153 P153 P153 P154

P154 P154 P155 P155 P155

P156 P156 P156 P157 P157

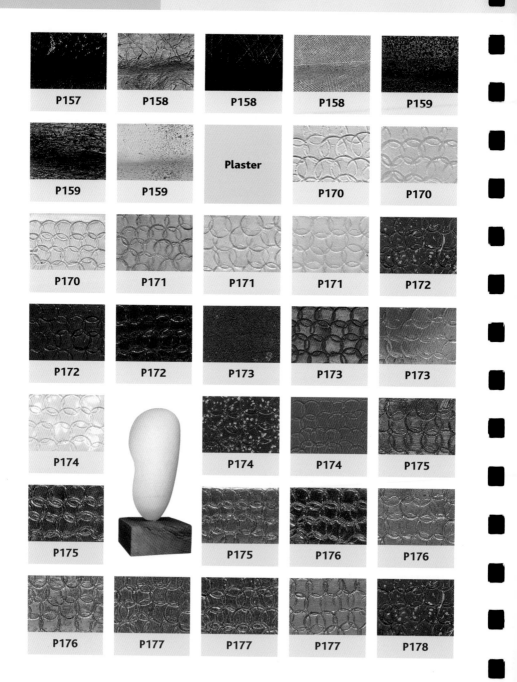

P157

P158

P158

P158

P159

P159

P159

Plaster

P170

P170

P170

P171

P171

P171

P172

P172

P172

P173

P173

P173

P174

P174

P174

P175

P175

P175

P176

P176

P176

P177

P177

P177

P178

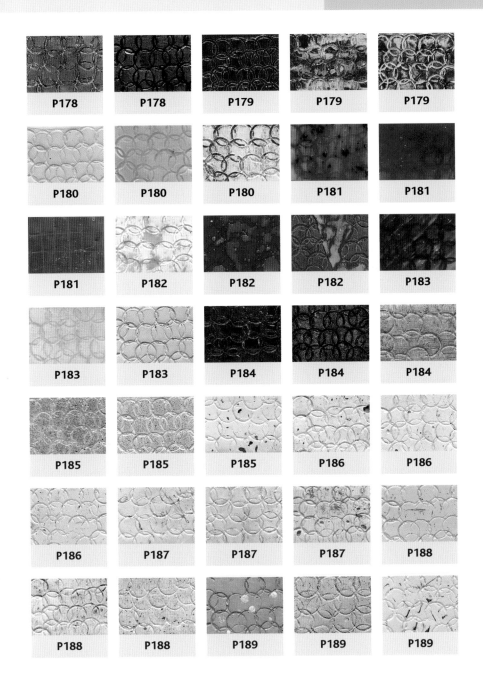

P178 P178 P179 P179 P179

P180 P180 P180 P181 P181

P181 P182 P182 P182 P183

P183 P183 P184 P184 P184

P185 P185 P185 P186 P186

P186 P187 P187 P187 P188

P188 P188 P189 P189 P189

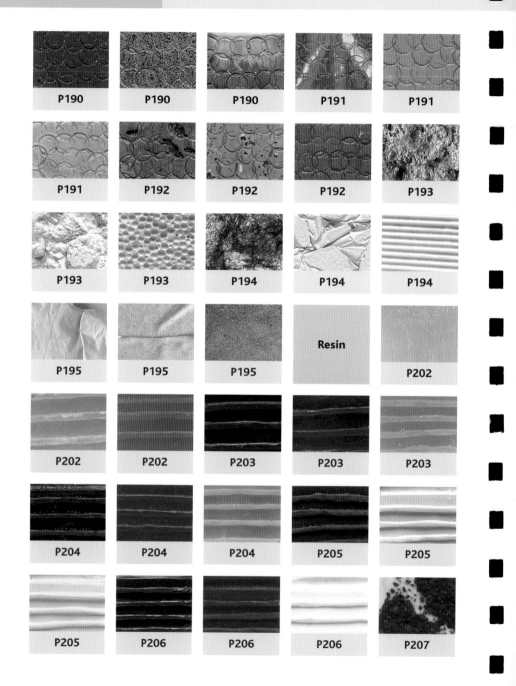

P190 P190 P190 P191 P191

P191 P192 P192 P192 P193

P193 P193 P194 P194 P194

P195 P195 P195 Resin P202

P202 P202 P203 P203 P203

P204 P204 P204 P205 P205

P205 P206 P206 P206 P207

P207 P207

P208 P208

P208 P209 P209 P209 P210

P210 P210 P211 P211 P211

P212 P212 P212 P213 P213

P213 P214 P214 P214 P215

P215 P215 P216 P216 P216

P217

P217

P217

P218

P218

P218

P219

P219

P219

Cement

P228

P228

P228

P229

P229

P229

P230

P230

P230

P231

P231

P231

P232

P232

P232

P233

P233

P233

P234

P234

P234

P235

P235 P235 P236 P236 P236

P237 P237 P237 P238 P238

P238 P239 P239 P239 P240

P240 P240 P241 P241 P241

P242 P242

P242 P243

P243 P243

Stone

There are three basic categories of stone used today, which have evolved over the millions of years of earth's existence. However, there are a huge number of differing types of stone, each with its own characteristics. These features in turn determine the use to which they are best put. The examples in this section are divided into the three categories of stone: *igneous* (hard), *sedimentary* (medium), and *metamorphic* (soft). These stones will all polish to a high and very seductive finish.

The surface textures shown are indicative of the various stages necessary to reach that finish. However, you do not have to go for the highly polished finish, instead consider the possibilities offered by the use of one or more of the effects.

Carving stone

This stone-carving technique is an example of a relief sculpture, where the sculpted shape elevates from a flat base. When working in relief it is necessary to make a drawing first, in order to plan the highest and lowest points of the relief.

YOU WILL NEED:

- Paper and pencil
- Tape measure and carpenter's square
- Sandstone
- Dust mask and safety goggles
- Water spray
- Selection of stone-carving chisels
- Dummy mallet
- Selection of rifflers

- Rasp
- Sandpaper

SAFETY

- Work in a well-ventilated area.
- Always wear safety goggles and a dust mask when carving stone, and use a water spray to help keep the dust levels down.

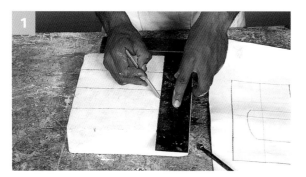

1 Make a full-size drawing of the relief design. Use a tape measure and carpenter's square to measure and mark a grid on the drawing, and then draw a matching grid on the sandstone. Use the grid to transfer the relief design onto the face of the stone.

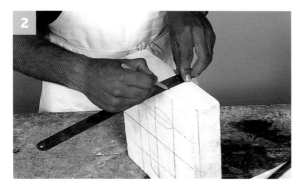

2 Work out the highest and lowest points of the design. In this case, the highest point is the mid-point of the scroll, while the lowest will be the background out of which the scroll emerges. Use a tape measure to mark the background depth on the four sides of the slab of stone.

3 Using a selection of stone carving chisels, start the carving by disposing of areas of waste material, the largest of which will be in the background area. Using the marks made on each side of the stone, start cutting away the stone. Position the chisel horizontally and parallel to the bench and hit it with a dummy mallet with firm, consistent taps. It is good stone-carving practice to keep up a rhythmic tapping of the mallet on the chisel. With this line, cut away around the block the depth of the background to establish.

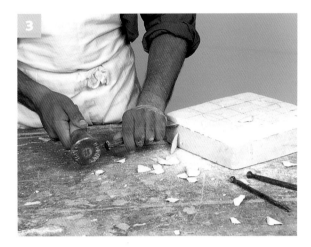

4 Start carving on the waste side of the drawn line that describes the relief form, and follow this line all the way around. This releases the relief from the waste material. Make the surface of the background level with a flat chisel. Redraw the grid on this surface as a point of reference.

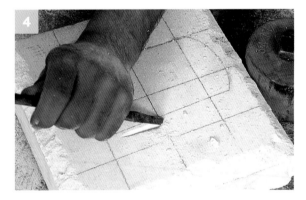

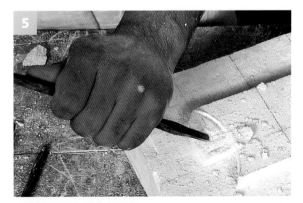

5 Begin carving the relief, starting with the receding area. In this case, the straight edge of this area is just higher than the level of the background. The surface then rises gradually to a point just below the lower level of the exterior of the scroll.

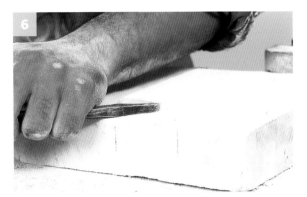

6 Tilt the chisel at an angle and tap it gently with the mallet, where necessary, to shape some areas, such as the undercut of the scroll.

7 Use rifflers of various sizes for the final shaping. Smooth off the background surface with a rasp, then use rifflers to level off any undulations in the background, if necessary.

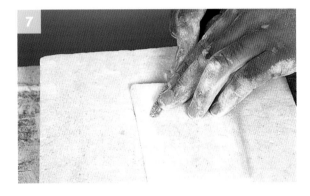

8 Finally, use sandpaper to smooth off and establish any sharp edges that run along the relief, such as the bottom and sides of the scroll.

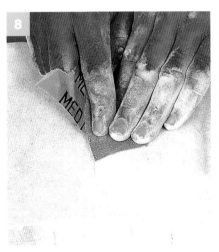

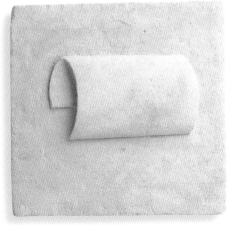

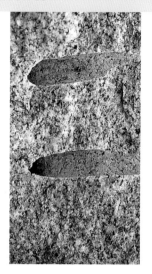

HARD STONE

Igneous stone was formed deep below the earth's surface as the intense heat from volcanic action cooled over the years. As a general rule, this type of stone is very hard to work and best left to experienced sculptors. Special tungsten-tipped chisels are needed, although using a compressor and a pneumatic hammer will help. Always wear protective goggles, a respirator, gloves, and earplugs when using pneumatic tools and especially if you are working with granite.

Silver gray granite:
split

When granite is split in the quarry, in order to obtain the correct size block for carving, this feathering effect occurs.

METHOD The stone is drilled down into in several places. The drilling drives feathers into the stone, which in turn cause the stone to split apart.

Silver gray granite:
punched

TOOLS
• **Pitching chisel**
• **2 lb hammer**

PREPARATION Rough out the stone with a pitching chisel, although this technique can be used on stone in its raw state.

METHOD Hold the pitching chisel at about 40 degrees to the surface of the stone. Then use a 2 lb hammer to strike the chisel with firm, even strokes to create parallel lines on the surface of the stone.

Silver gray granite:
bush-hammered

TOOL
• Bush hammer

PREPARATION Rough out the stone and begin carving the shape with stone-carving chisels, although this technique can be used on stone in its raw state.

METHOD Hold the face of a bush hammer about 6 in (15cm) from and parallel to the surface of the stone. Hit the stone repeatedly with a firm and consistent rhythm to create an evenly indented surface.

Silver gray granite:
polished

TOOLS
• Pneumatic grinder, compressor, and diamond grit discs

PREPARATION Rough out and carve the stone, then smooth and shape the form with a pneumatic hammer and bushing tool.

METHOD Work over the surface using a pneumatic grinder with a central water feed to wash away the debris. Use diamond grit discs in descending order, down to the smallest grit, to obtain the desired finish.

Brown Baltic granite:
bush-hammered

TOOL
• Bush hammer

PREPARATION Rough out the stone and begin carving the shape with stone-carving chisels, although this technique can be used on stone in its raw state.

METHOD Hold the face of a bush hammer about 6 in (15cm) from and parallel to the surface of the stone. Hit the stone repeatedly with a firm and consistent rhythm to create an evenly indented surface.

Brown Baltic granite:
polished

TOOLS
• Pneumatic grinder,
compressor, and diamond
grit discs

PREPARATION Rough out and
carve the stone, then smooth
and shape the form with a
pneumatic hammer and
bushing tool.

METHOD Work over the surface
using a pneumatic grinder with a
central water feed to wash away
the debris. Use diamond grit
discs in descending order, down
to the smallest grit, to obtain the
desired finish.

Chinese tiger skin granite

A medium-grained speckled
granite found and quarried in
China, this is high-quality
granite, although there may be
some color variation. It is a hard
stone to carve but very durable,
and takes a high polish.

Chinese tiger skin granite: punched

TOOLS
• Pitching chisel
• 2 lb hammer

PREPARATION Rough out the
stone with a pitching chisel,
although this technique can be
used on stone in its raw state.

METHOD Hold the pitching
chisel at about 40 degrees to
the surface of the stone. Then
use a 2 lb hammer to strike the
chisel with firm, even strokes to
create parallel lines on the
surface of the stone.

Chinese tiger skin granite: bush-hammered

TOOL
• Bush hammer

PREPARATION Rough out the stone and begin carving the shape with stone-carving chisels, although this technique can be used on stone in its raw state.

METHOD Hold the face of the bush hammer about 6 in (15cm) from and parallel to the surface of the stone. Hit the stone repeatedly with a firm and consistent rhythm to create an evenly indented surface.

Chinese tiger skin granite: polished

TOOLS
• Pneumatic grinder, compressor, and diamond grit discs

PREPARATION Rough out and carve the stone, then smooth and shape the form with a pneumatic hammer and bushing tool.

METHOD Work over the surface using a pneumatic grinder with a central water feed to wash away the debris. Use diamond grit discs in descending order, down to the smallest grit, to obtain the desired finish.

Black basalt

Basalt is a hard and tough igneous stone. There are many varieties from almost glassy to fine-grained compact types. It is slightly easier to carve than granite. It is a good stone for sculpture and takes a fine surface polish.

Black basalt: oxidized

This stone is mostly black or dark gray. Where red parts occur, it is likely to be due to oxidation, possibly because of the presence of iron oxide.

Black basalt: punched

TOOLS
• **Pitching chisel**
• **2 lb hammer**

PREPARATION Rough out the stone with a pitching chisel, although this technique can be used on stone in its raw state.

METHOD Hold the pitching chisel at about 40 degrees to the surface of the stone. Then use a 2 lb hammer to strike the chisel with firm, even strokes to create parallel lines on the surface of the stone.

Black basalt: bush-hammered

TOOL
• **Bush hammer**

PREPARATION Rough out the stone and begin carving the shape with stone-carving chisels, although this technique can be used on stone in its raw state.

METHOD Hold the face of the bush hammer about 6 in (15cm) from and parallel to the surface of the stone. Hit the stone repeatedly with a firm and consistent rhythm to create an evenly indented surface.

Black basalt: machine bush-hammered

TOOLS
• Pneumatic hammer, compressor, and bushing tool

PREPARATION Rough out the stone and begin carving the shape with stone-carving chisels, although this technique can be used on stone in its raw state.

METHOD Hold the face of the pneumatic hammer with bushing tool about 6 in (15cm) from and parallel to the surface of the stone. Hit the stone repeatedly with a firm and consistent rhythm to create an evenly indented surface.

Black basalt: polished

TOOLS
• Pneumatic grinder, compressor, and diamond grit discs

PREPARATION Rough out and carve the stone, then smooth and shape the form with a pneumatic hammer and bushing tool.

METHOD Work over the surface using a pneumatic grinder with a central water feed to wash away the debris. Use diamond grit discs in descending order, down to the smallest grit, to obtain the desired finish.

Black granite: split

When granite is split in the quarry, in order to obtain the correct size block for carving, this feathering effect occurs.

METHOD The stone is drilled down into in several places. The drilling drives feathers into the stone, which in turn cause the stone to split apart.

Black granite: split and sawn

The stone is split to size by drilling down into it in several places. The drilling drives feathers into the stone, which cause the stone to split apart.

METHOD The stone is sawn in the quarry using a water-cooled, diamond-tipped cutting wheel.

Black granite: punched

TOOLS
• **Pitching chisel**
• **2 lb hammer**

PREPARATION Rough out the stone with a pitching chisel, although this technique can be used on stone in its raw state.

METHOD Hold the pitching chisel at about 40 degrees to the surface of the stone. Then use a 2 lb hammer to strike the chisel with firm, even strokes to create parallel lines on the surface of the stone.

Black granite: machine bush-hammered

TOOLS
• **Pneumatic hammer, compressor, and bushing tool**

PREPARATION Rough out the stone and begin carving the shape with stone-carving chisels, although this technique can be used on stone in its raw state.

METHOD Hold the face of the pneumatic hammer with bushing tool about 6 in (15cm) from and parallel to the surface of the stone. Hit the stone repeatedly with a firm and consistent rhythm to create an evenly indented surface.

Black granite: polished

TOOLS
• Pneumatic grinder,
compressor, and diamond
grit discs

PREPARATION Rough out and
carve the stone, then smooth
and shape the form with a
pneumatic hammer and
bushing tool.

METHOD Work over the surface
using a pneumatic grinder with a
central water feed to wash away
the debris. Use diamond grit
discs in descending order, down
to the smallest grit, to obtain the
desired finish.

Red granite

All types of granite are hard and
compact, making them difficult
to carve. There are many
varieties from fine- to coarse-
grained. Granites take a very
high polish.

Red granite: sawn

When large areas of stone
need to be removed quickly,
diamond-tipped cutting tools are
used. The process leaves cutting
marks in the stone that can be
left or polished out later.

PREPARATION The stone is split
to size by drilling down into it in
several places. The drilling drives
feathers into the stone, which
cause the stone to split apart.

METHOD The stone is sawn in
the quarry using a water-cooled,
diamond-tipped cutting wheel.

Red granite: polished

TOOLS
• Pneumatic grinder, compressor, and diamond grit discs

PREPARATION Rough out and carve the stone, then smooth and shape the form with a pneumatic hammer and bushing tool.

METHOD Work over the surface using a pneumatic grinder with a central water feed to wash away the debris. Use diamond grit discs in descending order, down to the smallest grit, to obtain the desired finish.

Chinese brown granite

Granite is an extremely hard and compact stone, making carving intricate elements and details difficult, except for the very experienced. Substantial undercuts and fine projections will also be problematic in granite.

Chinese brown granite: machine bush-hammered

TOOLS
• Pneumatic hammer, compressor, and bushing tool

PREPARATION Rough out the stone and begin carving the shape with stone-carving chisels, although this technique can be used on stone in its raw state.

METHOD Hold the face of the pneumatic hammer with bushing tool about 6 in (15cm) from and parallel to the surface of the stone. Hit the stone repeatedly with a firm and consistent rhythm to create an evenly indented surface.

Chinese brown granite: sawn

The stone is split to size by drilling down into it in several places. The drilling drives feathers into the stone, which cause the stone to split apart.

METHOD The stone is sawn in the quarry using a water-cooled, diamond-tipped cutting wheel.

Chinese brown granite: polished

TOOLS
• Pneumatic grinder, compressor, and diamond grit discs

PREPARATION Rough out and carve the stone, then smooth and shape the form with a pneumatic hammer and bushing tool.

METHOD Work over the surface using a pneumatic grinder with a central water feed to wash away the debris. Use diamond grit discs in descending order, down to the smallest grit, to obtain the desired finish.

Mount Sorrell granite

A pink to gray-colored granite. It is a very hard, rough stone and coarse-grained, making it difficult to carve.

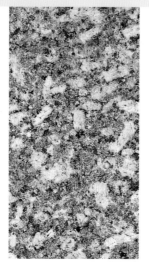

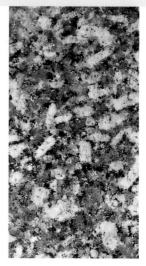

Cornish granite

Granite is extremely suitable for outdoor use. It is very durable, has low porosity, and is highly resistant to the natural elements.

Cornish granite: sawn

When large areas of stone need to be removed quickly, diamond-tipped cutting tools are used. The process leaves cutting marks in the stone that can be left or polished out later.

PREPARATION The stone is split to size by drilling down into it in several places. The drilling drives feathers into the stone, which cause the stone to split apart.

METHOD The stone is sawn in the quarry using a water-cooled, diamond-tipped cutting wheel.

Cornish granite:
polished

TOOLS
• **Pneumatic grinder, compressor, and diamond grit discs**

PREPARATION Rough out and carve the stone, then smooth and shape the form with a pneumatic hammer and bushing tool.

METHOD Work over the surface using a pneumatic grinder with a central water feed to wash away the debris. Use diamond grit discs in descending order, down to the smallest grit, to obtain the desired finish.

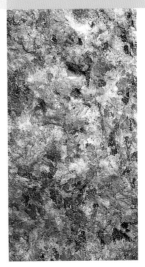

Gneiss granite: sawn

When large areas of stone need to be removed quickly, diamond-tipped cutting tools are used. The process leaves cutting marks in the stone that can be left or polished out later.

PREPARATION The stone is split to size by drilling down into it in several places. The drilling drives feathers into the stone, which cause the stone to split apart.

METHOD The stone is sawn in the quarry using a water-cooled, diamond-tipped cutting wheel.

Gneiss granite: polished

TOOLS
• **Pneumatic grinder, compressor, and diamond grit discs**

PREPARATION Rough out and carve the stone, then smooth and shape the form with a pneumatic hammer and bushing tool.

METHOD Work over the surface using a pneumatic grinder with a central water feed to wash away the debris. Use diamond grit discs in descending order, down to the smallest grit, to obtain the desired finish.

Portuguese pink granite

Granite is composed of quartz, micas, and other minerals that will affect its color and texture. The higher the quartz content, the harder the stone is to carve.

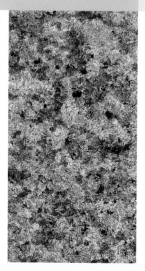

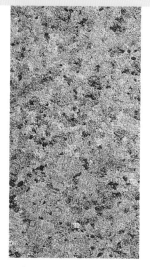

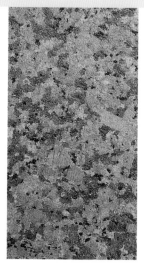

Portuguese pink granite: flamed effect

This effect is achieved by applying blowtorch-strength heat to the surface of the granite. It bursts some of the crystals creating a dramatic, deeply textured surface.

Portuguese pink granite: sawn

When large areas of stone need to be removed quickly, diamond-tipped cutting tools are used. The process leaves cutting marks in the stone that can be left or polished out later.

PREPARATION The stone is split to size by drilling down into it in several places. The drilling drives feathers into the stone, which cause the stone to split apart.

METHOD The stone is sawn in the quarry using a water-cooled, diamond-tipped cutting wheel.

Portuguese pink granite: polished

TOOLS
• Pneumatic grinder, compressor, and diamond grit discs

PREPARATION Rough out and carve the stone, then smooth and shape the form with a pneumatic hammer and bushing tool.

METHOD Work over the surface using a pneumatic grinder with a central water feed to wash away the debris. Use diamond grit discs in descending order, down to the smallest grit, to obtain the desired finish.

Larvik

This hard stone, also called Regular Blue Pearl, is from a village in Larvik, Norway.

Larvik: sawn

The stone is split to size by drilling down into it in several places. The drilling drives feathers into the stone, which cause the stone to split apart.

METHOD The stone is sawn in the quarry using a water-cooled, diamond-tipped cutting wheel.

Larvik: polished

TOOLS
• **Pneumatic grinder, compressor, and diamond grit discs**

PREPARATION Rough out and carve the stone, then smooth and shape the form with a pneumatic hammer and bushing tool.

METHOD Work over the surface using a pneumatic grinder with a central water feed to wash away the debris. Use diamond grit discs in descending order, down to the smallest grit, to obtain the desired finish.

MEDIUM STONE

Sedimentary stone has been formed by a buildup of organic matter—plants, insects, and sea creatures—in low-lying areas. Over time, the pressure caused by the buildup of layers of sediment has caused the layers to harden. Out of these layers come limestone and sandstone. These stones are a popular choice for sculptors, limestone being the softer of the two.

Kilkenny limestone:
punched

TOOLS
• Pitching chisel
• 2 lb hammer

PREPARATION Rough out the stone with a pitching chisel, although this technique can be used on stone in its raw state.

METHOD Hold the pitching chisel at about 40 degrees to the surface of the stone. Then use a 2 lb hammer to strike the chisel with firm, even strokes to create parallel lines on the surface of the stone.

Kilkenny limestone:
machine bush-hammered

TOOLS
• Pneumatic hammer, compressor, and bushing tool

PREPARATION Rough out the stone and begin carving the shape with stone-carving chisels, although this technique can be used on stone in its raw state.

METHOD Hold the face of the pneumatic hammer with bushing tool about 6 in (15cm) from and parallel to the surface of the stone. Hit the stone repeatedly with a firm and consistent rhythm to create an evenly indented surface.

Kilkenny limestone:
polished

TOOL
• **Wet and dry paper**

PREPARATION Rough out and carve the stone, then define and smooth the sculpture with rasps and rifflers.

METHOD Finish smoothing the form with wet and dry paper, working through the grades, from rough right down to fine, to achieve the desired finish.

Derbyshire fossil limestone

This is a mid-gray limestone abundant with fossils.

Derbyshire fossil limestone: sawn

The stone is split to size by drilling down into it in several places. The drilling drives feathers into the stone, which cause the stone to split apart.

METHOD The stone is sawn in the quarry using a water-cooled, diamond-tipped cutting wheel.

Ancaster limestone

Also called Weather Bed, this is a stone with a good shell content, which enables it to be polished to a high shine. It is a dense stone with good resistance to weathering.

Ancaster limestone

The stone is split to size by drilling down into it in several places. The drilling drives feathers into the stone, which cause the stone to split apart.

METHOD The stone is sawn in the quarry using a water-cooled, diamond-tipped cutting wheel.

Ancaster limestone: punched

TOOLS
- **Pitching chisel**
- **2 lb hammer**

PREPARATION Rough out the stone with a pitching chisel, although this technique can be used on stone in its raw state.

METHOD Hold the pitching chisel at about 45 degrees to the surface of the stone. Then use a 2 lb hammer to strike the chisel with firm, even strokes to create parallel lines on the surface of the stone.

Ancaster limestone:
clawed

TOOLS
- **Claw chisel**
- **2 lb hammer**

PREPARATION This effect can be brought about on the stone in its raw state, or on a sawn surface. Rough out the stone and define the form of the sculpture with stone-carving chisels.

METHOD Hold a claw chisel at about 45 degrees to the surface of the stone. Use a 2 lb hammer to strike the chisel with firm, even strokes to create a crisscross of parallel lines on the surface of the stone.

Jurassic limestone

Limestone from the Jurassic period has three main layers: the roach, which contains the shells and fossils and is rough textured; the whit; and the base bed, which contains little shell, making it a higher quality stone used for finer texture.

Portland limestone:
sawn

Portland limestone from the Jurassic period is creamy white in color and has good weathering properties.

PREPARATION The stone is split to size by drilling down into it in several places. The drilling drives feathers into the stone, which cause the stone to split apart.

METHOD The stone is sawn in the quarry using a water-cooled, diamond-tipped cutting wheel.

French green limestone

Limestone is a widely used material; it is mostly composed of calcium carbonate. It can be fine- or coarse-grained and has a granular appearance. It can also vary in density from the fragile types with high shell content, to a more compact variety that can be highly polished. The heavier, less porous varieties are best for sculpture. It is usually easier to carve than granite and sandstone, with a variety of textures possible. It can support undercutting and fine detail can be achieved. Colors tend to be gray to buff color.

Sandstone

Sandstone is a fairly porous sedimentary stone that varies in compactness and durability. Fine grains of sand are bound together. The size and graining of the silica particles can vary even within a single block. Control of the chisel is vital since hard spots may occur in soft areas. Pure siliceous sandstones are the most durable but harder to carve. Sandstone has high porosity making it less desirable for outdoor use. Some types will not polish as the grains crumble away in the process.

Sandstone: sawn

The stone is split to size by drilling down into it in several places. The drilling drives feathers into the stone, which cause the stone to split apart.

METHOD The stone is sawn in the quarry using a water-cooled, diamond-tipped cutting wheel.

Sandstone: punched

TOOLS
• **Pitching chisel**
• **2 lb hammer**

PREPARATION Rough out the stone with a pitching chisel, although this technique can be used on stone in its raw state.

METHOD Hold the pitching chisel at about 45 degrees to the surface of the stone. Then use a 2 lb hammer to strike the chisel with firm, even strokes to create parallel lines on the surface of the stone.

Sandstone: directional punching

TOOLS
• **Pitching chisel**
• **2 lb hammer**

PREPARATION Rough out the stone with a pitching chisel, although this technique can be used on stone in its raw state.

METHOD Hold the chisel at about 45 degrees to the surface of the stone. Use a 2 lb hammer to strike the chisel with firm, even strokes to create a series of parallel lines on the surface of the stone.

Red sandstone: punched

TOOLS
• **Pitching chisel**
• **2 lb hammer**

PREPARATION Rough out the stone with a pitching chisel, although this technique can be used on stone in its raw state.

METHOD Hold the pitching chisel at about 45 degrees to the surface of the stone. Then use a 2 lb hammer to strike the chisel with firm, even strokes to create parallel lines on the surface of the stone.

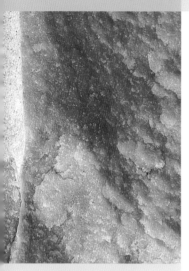

SOFT STONE

Metamorphic stone is a further development of the sedimentary process. Where the sediments have been exposed to enormous pressure and heat, a chemical reaction crystalizes the sediment, producing a stone such as marble. Although it can be hard to carve, the sculptor can work in very fine detail. Alabaster and soapstone are also both very soft stones and recommended for those new to carving.

White marble: riven

This effect occurs when stone splits and breaks off from a larger block.

White marble: sawn

The stone is split to size by drilling down into it in several places. The drilling drives feathers into the stone, which cause the stone to split apart.

METHOD The stone is sawn in the quarry using a water-cooled, diamond-tipped cutting wheel.

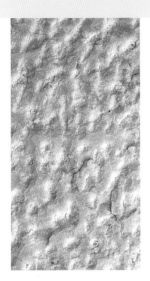

White marble: punched

TOOLS
• Pitching chisel
• 2 lb hammer

PREPARATION Rough out the stone with a pitching chisel, although this technique can be used on stone in its raw state.

METHOD Hold the pitching chisel at about 45 degrees to the surface of the stone. Then use a 2 lb hammer to strike the chisel with firm, even strokes to create parallel lines on the surface of the stone.

White marble: machine bush-hammered

TOOLS
• Pneumatic hammer, compressor, and bushing tool

PREPARATION Rough out the stone and begin carving the shape with stone-carving chisels, although this technique can be used on stone in its raw state.

METHOD Hold the face of the pneumatic hammer with bushing tool about 6 in (15cm) from and parallel to the surface of the stone. Hit the stone repeatedly with a firm and consistent rhythm to create an evenly indented surface.

White marble: polished

TOOL
• Wet and dry paper

PREPARATION Rough out and carve the stone, then define and smooth the sculpture with rasps and rifflers.

METHOD Finish smoothing the form with wet and dry paper, working through the grades from rough right down to fine, to achieve the desired finish.

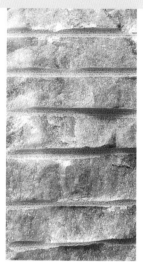

Gray vein marble:
polished

TOOL
• **Wet and dry paper**

PREPARATION Rough out and carve the stone, then define and smooth the sculpture with rasps and rifflers.

METHOD Finish smoothing the form with wet and dry paper, working through the grades from rough right down to fine, to achieve the desired finish.

Gray vein marble:
punched

TOOLS
• **Pitching chisel**
• **2 lb hammer**

PREPARATION Rough out the stone with a pitching chisel, although this technique can be used on stone in its raw state.

METHOD Hold the pitching chisel at about 45 degrees to the surface of the stone. Then use a 2 lb hammer to strike the chisel with firm, even strokes to create parallel lines on the surface of the stone.

Gray vein marble:
cut and pinched

This technique should be carried out on a sawn marble block that has flat surfaces at right angles to one another.

TOOLS
• **Pitching chisel**
• **3 lb hammer**

PREPARATION Have the marble sawn in the quarry, using a water-cooled, diamond-tipped cutting wheel.

METHOD Place a pitching chisel about 2 in (5cm) from the edge of the block and perpendicular to the surface. Forcefully hit the chisel once with a 3 lb hammer to break a chip off the edge of the block.

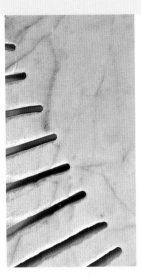 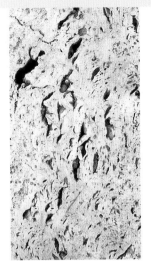 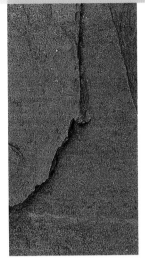

Gray vein marble:
angle grinder cut

This method is used as an aid to rough out the block of stone, although it is equally effective as an interesting surface effect.

TOOLS
• **Electric angle grinder or pneumatic angle grinder with compressor and diamond cutting blade**

METHOD Use either an electric angle grinder or one powered by the compressor and a diamond cutting blade to create cuts across the surface of the stone.

Travertine marble:
sawn

The stone is split to size by drilling down into it in several places. The drilling drives feathers into the stone, which cause the stone to split apart.

METHOD The stone is sawn in the quarry using a water-cooled, diamond-tipped cutting wheel.

Green Cumbrian slate:
riven

This effect occurs when stone splits and breaks off from a larger block.

Green Cumbrian slate: polished

TOOL
• Wet and dry paper

PREPARATION Rough out and carve the stone, then define and smooth the sculpture with rasps and rifflers.

METHOD Finish smoothing the form with wet and dry paper, working through the grades from rough right down to fine, to achieve the desired finish.

Welsh gray slate: riven

This effect occurs when stone splits and breaks off from a larger block.

Alabaster: polished

TOOL
• Wet and dry paper

PREPARATION Rough out and carve the stone, then define and smooth the sculpture with rasps and rifflers.

METHOD Finish smoothing the form with wet and dry paper, working through the grades from rough right down to fine, to achieve the desired finish.

Alabaster: clawed

TOOLS
- Claw chisel
- 2 lb hammer

PREPARATION This effect can be brought about on the stone in its raw state, or on a sawn surface. Rough out the stone and define the form of the sculpture with stone-carving chisels.

METHOD Hold a claw chisel at about 45 degrees to the surface of the stone. Use a 2 lb hammer to strike the chisel with firm, even strokes to create a crisscross of parallel lines on the surface of the stone.

Soapstone: sawn

The stone is split to size by drilling down into it in several places. The drilling drives feathers into the stone, which cause the stone to split apart.

METHOD The stone is sawn in the quarry using a water-cooled, diamond-tipped cutting wheel.

Soapstone: polished

TOOL
- Wet and dry paper

PREPARATION Rough out and carve the stone, then define and smooth the sculpture with rasps and rifflers.

METHOD Finish smoothing the form with wet and dry paper, working through the grades from rough right down to fine, to achieve the desired finish.

Inspirational pieces

ASSUMPTION
GEORGE TKABLADZE

Using traditional materials (marble and bronze) and addressing the religious concept of the Assumption, this sculpture achieves a totally modern effect and asks us to look at this theme in a new way. The white marble is formed and sanded to give a soft, floating cloud-like effect, which only gently touches the four bronze plates upon which it rests. The green marble base, on the other hand, is rectangular, with sharply defined edges creating stability and clarity. The bronze plates bridge these two different qualities and create a strong vertical statement. The art is in the way these three qualities are brought together into a harmonious whole.

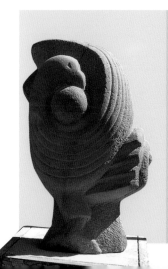

DOVE
KEN SMITH

Based on medieval carvings of doves, this piece uses the repetition of line and movement to emphasize the gesture that encloses and protects an inner form. The surface of the stone is smoothed in some areas to give a clearer, sharper effect and, in other areas, the carving marks are left visible to give a less formed feel.

Smooth Ripple
Jay Battle

This sculpture beautifully illustrates how different surface treatments can be used to stunning effect on the same piece of stone. The outer part of the form has been shaped and textured using a bouchard hammer (which has many small points on its surface). Even though the surface is "rough," it is even and consistent; a surface does not need to be smooth to be perfect. The inner "ripple" has been carved, sanded, and polished to create a smooth, shining surface. The combination of a simple, textured outer shape spiraling inward and the shining ripple flowing gently outward makes this stone appear to move and breathe.

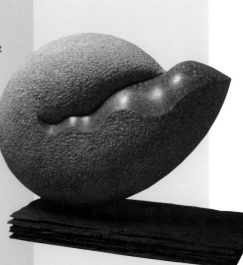

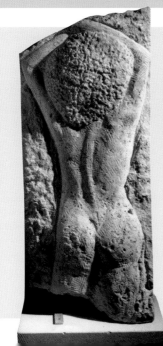

Relief
Jamie Vans

By using a stone that has an unpredictable structure, such as this limestone with large shells and voids in it, the sculptor is encouraged to work more freely and not aim for a finely polished and even finish. The combination of natural texture, tool marks, and the random, broken edges give this carving of a female figure a rustic, elemental energy.

MEMORIAL
JAMIE VANS

The extremes of roughly worked
and highly polished surfaces are
placed next to each other in this
sculpture to dramatic effect.
The polished rounded forms of
the upper figure give it a soft,
sensuous, and exposed character
that is held and supported by
the lower figure, whose boldly
worked surface creates
an impression of inner
reserves of strength.

THERE MUST BE
THE SUN SOMEWHERE
GEORGE TKABLADZE

The dark piece of granite, placed
on top of the lighter marble, has a circular
sun-like hole that is echoed in the concave
disc below, capturing the mood of the title when
the sun is hidden from our view. The stone is worked
to a smooth, polished surface which brings out their
contrasting light and dark qualities.

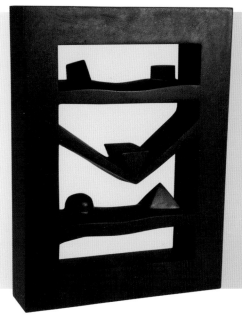

WINDOW
GIORGIE CPAJAK

Part of the effect of this piece is the surprise at seeing the hard granite treated to resemble something soft that can flow wave-like, as in the upper and lower parts, or something elastic that is being stretched and pushed down in the center. Carving out such fine and precise shapes in granite and polishing to this level of smoothness is not an activity for the impatient.

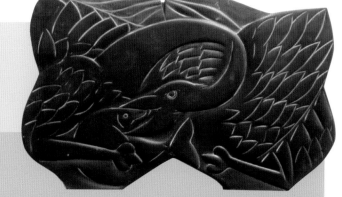

BIRD EATING FISH—OBUERSE
PETER NICHOLAS

Shallow-relief sculpture, such as this one in slate, depends upon the clear linear definition of the shapes. Light falling on the sculpture brings out the figures by contrast, highlighting some parts and casting others into shadow. After carving, the slate has been polished to a shine with wet and dry paper.

THE CHANGELING
HAMISH HORSLEY

The Ancaster stone in this sculpture reveals its beautiful striped coloring when polished and this is contrasted by the energetically textured middle form. Choosing a base is an art in itself and this dark piece of granite, which is polished on its top surface and left rough on its edges, picks up and supports the smooth and rough combination of surfaces in the sculpture.

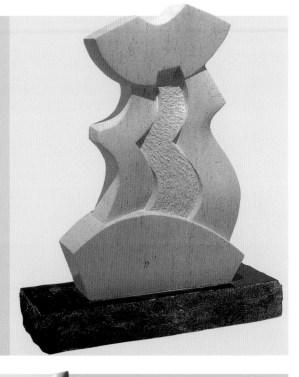

WING
GIORGIE CPAJAK

Although carved from a single piece of marble, this sculpture gives the impression of being made up of separate elements added to the surface of the wing shape. The soft, gentle surface transitions in the forms of the wing strongly contrast with the hard-edged, precariously balanced, geometrical forms. The sculpture seems to evoke two aspects of flight, the smooth organic speed of the wing and the broken, disturbed air tumbling after it.

SHUTTING OUT THE WORLD
BERNARD McGUIGAN

The soft, rounded shapes and the inward gesture combine to create a very intimate expression of tenderness and vulnerability. The surface of the slate is finely worked and softly catches and reflects the light. The energetic waves of the hair, the strong line of the nose, and the carved fingernails catch more light than the rest of the piece and bring an element of clarity and definition.

OLD LOVE STORY
GEORGE TKABLADZE

Combining drilled holes, sharply incised lines, and soft, rounded transitions between shapes, this sculptural composition uses the expressive possibilities of hardness and softness to great effect in exploring the theme of past relationships.

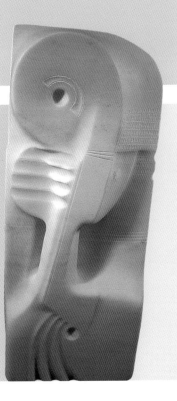

Wood

As a direct product of living growth, wood is a material unlike other major sculptural media. Its complex structure is reflected in its appearance and working properties, which depend upon the angle from which it is approached. Cut across a log and you expose end grain. Cut the log along its length and you create a long-grain surface. Growth rings at right angles to the surface are referred to as "quarter grain," whereas any other angle of cut reveals "tangential grain."

When working with wood, consider the eventual location of your piece. A stable environment indoors permits any finish. Wood suffers with changes in humidity and oiling or waxing can help even out such changes. Outdoors wood has a much more limited life, but choice of wood, pre-treatment with preservatives, and frequent applications of oil or a suitable paint finish all help extend its life.

Wood varies enormously, not only between species but also between individual trees. Two pieces are seldom alike, so save "scraps" to test before treating your sculpture. Finishing is about experimentation; keep testing until you get the surface quality that you want.

Carving wood

A relief design can be carved from a single block of wood, using either a single degree of relief or varying the degrees of relief to form a pictorial piece, such as this mask. The techniques of setting in and roughing out are often repeated a number of times as you gradually progress toward the finished piece.

YOU WILL NEED:

- Paper and pencil
- Tracing or carbon paper
- Block of wood, here 9 x 5-½ x 4 inches (230 x 140 x 100mm)
- Workbench, vise, and offcut of wood
- Coping saw

SAFETY

- **Work in a well-ventilated area.**

- Selection of wood-carving gouges and chisels
- Mallet
- Cabinet scrapers

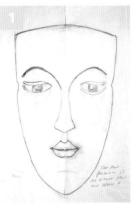

1 Make a full-size drawing of your design. Japanese masks influenced this one.

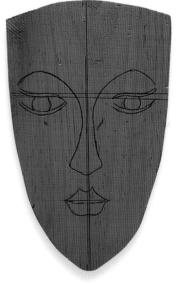

2 Use tracing paper or carbon paper to transfer the design onto the block of wood. Draw a central line down the length of the design and any other lines that help you to visualize the degree of relief depth required for certain areas. Saw around the outline with a coping saw.

3 Clamp the wood to the workbench, padded with an offcut of wood. Start setting in the features with a No. 9 or No. 10 gouge, cutting close to the lines. Most carving is done with two hands on the gouge or chisel, one hand pushing while the other guides the tool. Sometimes, however, it is more effective to tap the gouge or chisel with a mallet.

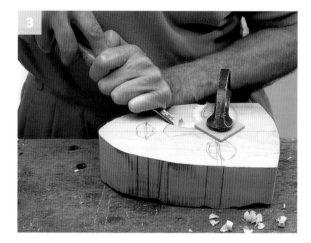

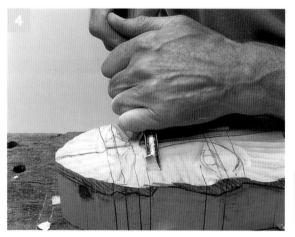

4 Mark more guidelines across the design and down the sides. Draw the profile on each side, and carve down to it across the face to achieve the front and side views.

5 Carve to the correct depths on the front while keeping to one plane to make it easier to start shaping and modeling the curved surfaces later on. Redraw guidelines, especially the centerline, as you carve them away.

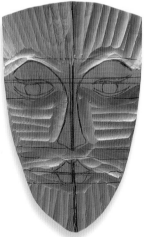

6 When you have reached the approximate depths, start to round off the mask. Try to keep all areas progressing at the same rate.

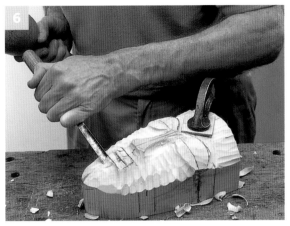

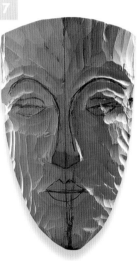

7 It is important to stand back from time to time and look critically at what you are doing. Though only boldly roughed out, the rounded shape across this mask has been clearly established.

8 Now gradually refine all areas, using flatter gouges on the larger rounded forms. It is a common error to make faces too flat. This photograph shows the sort of section you should aim for.

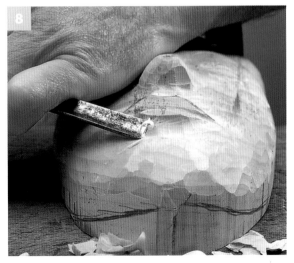

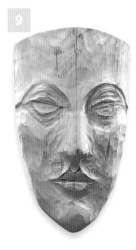

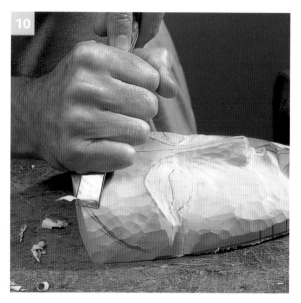

9 The centerline is particularly important for achieving symmetrical balance, so keep renewing it and check measurements against your drawing. The mask is now sufficiently advanced to start the subtler modeling, especially around the eyes, mouth, and nose, using different gouges and chisels.

10 The top of the mask is, in effect, a semi-dome. Begin to carve that before finishing around the eyes.

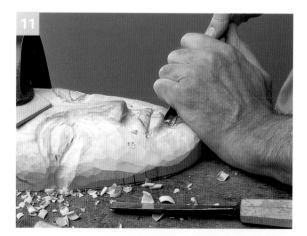

11 Move from place to place on the head, finishing the forms as you go.

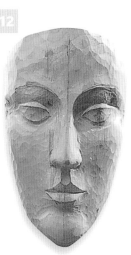

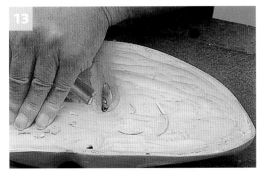

13 If required, you can now hollow out the back of the sculpture using the largest gouge and a mallet. Secure the carving in a loose-fitting box lined with strips of material to wedge and protect it while you work. Then make sloping cuts, beginning the cut steeply then bringing the handle down through the curve until the blade coincides with cuts from other directions. To pierce out the eyes, use a drill to make a hole, then use a coping saw to cut out the shape. Clean up the holes with gouges.

12 All the forms have now reached the stage where you can smooth them with scrapers. Push or pull the cabinet scraper at a constant angle of 60 to 80 degrees to the surface to remove fine shavings and to define the carved shapes.

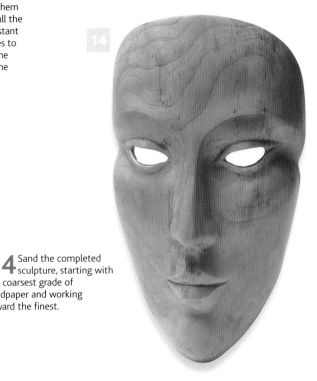

14 Sand the completed sculpture, starting with the coarsest grade of sandpaper and working toward the finest.

Cherry (*Prunus avium/domestica spp.*): sanded tangential grain

This sample is descriptive of a range of woods from the genus *Prunus* (cherry, plum, gean) that share common characteristics. The woods are all fairly hard and close-grained, taking fine detail very well. Prominent figuring usually consists of dark or greenish stripes and wild patterns on a pinkish-yellow background. Many species of *Prunus* are available, notably American cherry (*Prunus serotina spp.*), which is often rather pink and coarser than most others. Plum wood often shows beautiful, deep red figuring.

MATERIALS
• **Abrasive papers, ranging from 80 to 300 grit**

PREPARATION Shape the sculpture with rasps or gouges.

METHOD Smooth the surface with successively finer grades of abrasive, working with the grain. Work from coarse to fine, starting at 80 grit (if the initial surface is rough) or 180 grit (if the surface is already quite smooth). The final grade used will be governed by the degree of smoothness or shine required. A convenient alternative to abrasive paper is fine Webrax, an abrasive plastic matrix rather like a pan-scrubber, which tends to get into textured areas better than paper.

Cherry (*Prunus avium/domestica spp.*): sealed and waxed tangential grain

Polishing cherry reveals its striking grain pattern.

MATERIALS
• **Sanding sealer (bleached shellac in alcohol)**
• **Very fine abrasive paper, such as 240–300 grit**
• **Pale paste wax, a beeswax, and carnauba mix**

PREPARATION Shape the sculpture with rasps or gouges, and smooth to the desired degree with abrasive papers.

METHOD Use a brush or cloth to thinly apply sanding sealer and leave to dry. Rub down well with very fine abrasive paper, such as worn 240 grit. Use a cloth to rub on pale paste wax, or a stiff brush on rough wood or details. After one or two hours, buff up with a soft cloth.

Cherry (*Prunus avium/domestica spp.*): sealed and waxed end grain

Cherry end grain is quite close and not as absorbent as many other woods, making the color difference between end- and long-grain surfaces less pronounced.

MATERIALS
- Sanding sealer (bleached shellac in alcohol)
- Very fine abrasive paper, such as 240–300 grit
- Pale paste wax, a beeswax, and carnauba mix

PREPARATION Carve the sculpture with rasps or gouges, and smooth to the preferred degree with abrasive papers.

METHOD Use a brush or cloth to thinly apply sanding sealer and leave to dry. Rub down well with very fine abrasive paper; worn 240 grit is often ideal. Use a cloth or stiff brush to rub on pale paste wax. After one or two hours, buff up with a soft cloth.

Cherry (*Prunus avium/domestica spp.*): punched, sealed, and dark waxed tangential grain

Cherry and other fruitwoods present a firm, compact surface that produces a tidy dot when punched. Since there is little tearing of fibers, wax or oil may be used to finish. In this sample, darker wax is used to emphasize both grain and punched areas. If less contrast is required, pale wax or oil can be used to finish. Increased contrast can be achieved by filling fine punchings with colored grain filler before finishing.

MATERIALS
- 4 in (10cm) round nail with its point ground to a dome
- Sanding sealer (bleached shellac in alcohol)
- Fine Webrax
- Medium-dark paste wax, a beeswax, and carnauba mix

PREPARATION Form the sculpture with rasps or gouges.

METHOD Punch the wood surface by tapping the nail with a small hammer, spacing out the marks as desired. Apply sanding sealer thinly with a stiff brush or cloth and allow to dry. Rub down with finest Webrax. Use a cloth or stiff brush to rub on medium-dark paste wax. After one or two hours, buff up with a soft cloth.

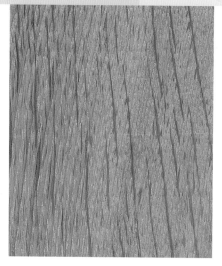

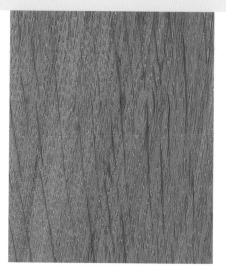

Oak (*Quercus robur or petraea spp.*): sanded tangential grain

Oak is a moderately hard timber with a fairly coarse grain and exceptionally large, open pores that can be charged with contrasting filler or wax. It turns permanently blue/black in the presence of iron and darkens with ammonia—properties shared with few other woods, except for sweet chestnut (*Castanea sativa spp.*). Many other oak species are carved, notably American white oak (*Quercus albus spp.*). They have similar properties but few show such pronounced "flare" marks on the quarter-sawn grain.

MATERIALS
• Abrasive papers, ranging from 80 to 300 grit

PREPARATION Use rasps or gouges to form the sculpture.

METHOD Smooth the surface with successively finer grades of abrasive, working with the grain. Work from coarse to fine, starting at 80 grit (if the initial surface is rough), or 180 grit (if the surface is already quite smooth). The final grade used will be governed by the degree of smoothness or shine required. A convenient alternative to abrasive paper is fine Webrax, an abrasive plastic matrix rather like a pan-scrubber, which tends to get into textured areas better than paper.

Oak (*Quercus robur or petraea spp.*): sealed and waxed tangential grain

The tangential surface of European oak shows a clear grain pattern of open pores and thin, dark lines. Very pale oak may finish best with bleached (white) wax, but a pale yellow wax, often called "clear" or "neutral," is usually safer.

MATERIALS
• Sanding sealer (bleached shellac in alcohol)
• Very fine abrasive paper, such as 240–300 grit
• Pale paste wax, a beeswax, and carnauba mix

PREPARATION Form the sculpture with rasps or gouges, and smooth to the desired degree with abrasive papers.

METHOD Apply sanding sealer thinly with a stiff brush or cloth and allow to dry. Rub down well with very fine abrasive paper, such as worn 240 grit. An open grain like oak sometimes benefits from a second light coat of sanding sealer, rubbed down when dry as before. Do not use wire wool on oak unless black patches and crevices are desired. Rub on pale paste wax with a cloth or use a stiff brush on rough wood or details. Leave for one to two hours and then buff up with a soft cloth.

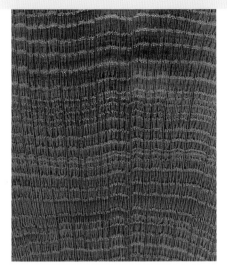

Oak (*Quercus robur* or *petraea* *spp.*): sealed and waxed end grain

The end grain of oak shows a clear grain pattern but not the irregular, silvery flare seen on a quarter-sawn surface. End grain is hard to work and very absorbent. It tends to absorb stained and other finishes, and so looks darker.

MATERIALS
• **Sanding sealer (bleached shellac in alcohol)**
• **Very fine abrasive paper, such as 240–300 grit**
• **Pale paste wax, a beeswax, and carnauba mix**

PREPARATION Carve the sculpture with rasps or gouges, and smooth to the preferred degree with abrasive papers.

METHOD Apply sanding sealer thinly with a stiff brush or cloth and allow to dry. Rub down well with very fine abrasive paper; worn 240 grit is often ideal. Do not use wire wool on oak unless black patches and crevices are desired. Use a cloth to rub on pale paste wax, or a stiff brush on rough wood or details. Leave for one to two hours and then buff up with a soft cloth.

Oak (*Quercus robur or petraea* *spp.*): sealed and waxed quarter grain

The quarter-sawn surface of European oak displays an irregular, silvery flare. This figuring is shared with few other woods, notably she-oak (*Casuarina spp.*) Other oaks, in particular American white and red oak, show such figuring to a much lesser degree. An oil finish may enhance the figuring more, but expect such an open-grained wood to absorb a lot of finish and hard work before yielding a soft sheen.

MATERIALS
• **Sanding sealer (bleached shellac in alcohol)**
• **Very fine abrasive paper, such as 240–300 grit**
• **Pale paste wax, a beeswax, and carnauba mix**

PREPARATION Use rasps or gouges to form the sculpture, and abrasive papers to smooth the wood to the desired degree.

METHOD Apply sanding sealer thinly with a stiff brush or cloth and allow to dry. Rub down well with very fine abrasive paper; such as worn 240 grit. An open grain like oak sometimes benefits from a second light coat of sanding sealer, rubbed down when dry as before. Do not use wire wool on oak unless black patches and crevices are desired. Rub on pale paste wax with a cloth or use a stiff brush. After one or two hours, buff up with a soft cloth.

Oak (*Quercus robur* or *petraea spp.*): fumed, sealed, and waxed tangential grain

Fuming permanently darkens oak, chestnut, and cherry. This sample is heavily fumed; paler effects result from shorter exposure. Ammonia solution can be painted on but it is messy. You can finish with liming wax for a "white-grain-on-black" effect. Ammonia is corrosive and very unpleasant if inhaled. Follow the manufacturer's safety precautions.

MATERIALS
• **Ammonia dissolved in water, at least 7 percent by weight**
• **Sanding sealer (bleached shellac in alcohol)**
• **Very fine abrasive paper, such as 240–300 grit**
• **Pale paste wax, a beeswax, and carnauba mix**

PREPARATION As page 77.

METHOD Place the sculpture in an airtight, clear plastic container that allows you to observe progress of the darkening. Pour ammonia solution into a shallow dish and place it in the container. Reseal the box immediately. When the desired effect is achieved, remove the sculpture and leave it for 24 hours to allow the ammonia to disperse. Apply sanding sealer thinly with a stiff brush or cloth and allow to dry. Rub down well with very fine abrasive paper. Use a cloth or a stiff brush to rub on pale paste wax. Leave for two hours and then buff with a soft cloth.

Oak (*Quercus robur* or *petraea spp.*): ebonized, sealed, and waxed tangential grain

This is the traditional process of blackening oak with iron acetate, followed by fuming. The result is black, with visible grain, and permanent. Ammonia is corrosive and very unpleasant if inhaled. Follow the manufacturer's safety precautions.

MATERIALS
• **Rusty iron nails**
• **Strong vinegar**
• **Ammonia dissolved in water, at least 7 percent by weight**
• **Sanding sealer (bleached shellac in alcohol)**
• **Very fine abrasive paper, such as 240–300 grit**
• **Pale paste wax, a beeswax, and carnauba mix**

PREPARATION As page 77. Place some rusty iron nails in strong vinegar for 24 hours.

METHOD Paint the wood with three coats of the prepared vinegar. Allow to dry. Place the sculpture in an airtight, clear plastic container. Pour ammonia solution into a shallow dish and place it in the container with the sculpture. Reseal immediately. When the desired effect is achieved, remove the sculpture and leave it for 24 hours. Apply sanding sealer thinly with a stiff brush or cloth and allow to dry. Rub down well with very fine abrasive paper. Rub on pale paste wax with a cloth or use a stiff brush. After two hours, buff up with a soft cloth.

Oak (*Quercus robur* or *petraea spp.*): sealed, limed, and waxed tangential grain

Traditionally, a lime paste was used to deter pests. A limed effect is now more conveniently achieved with white pigment in wax. The result is durable but quite easily removed from the surface with solvent. Any color of artists' oil paint or other oil-soluble pigment can be added to clear wax polish to fill the grain of open-pored woods.

MATERIALS
• **Sanding sealer (bleached shellac in alcohol)**
• **Very fine abrasive paper, such as 240–300 grit**
• **Stiff bronze or brass liming brush**
• **Liming wax**
• **Clear wax polish, a beeswax, and carnauba mix**

PREPARATION Carve the sculpture with rasps or gouges and smooth to the preferred degree with abrasive papers.

METHOD Apply sanding sealer thinly with a stiff brush or cloth and allow to dry. Rub down well with very fine abrasive paper; worn 240 grit is often ideal. Wire brush with the grain to open up the large pores. Use a cloth to rub liming wax into the pores and leave to partially dry. Wipe off any excess before the wax gets too hard. When fully dry, buff off, leaving wax only in the crevices and seal again. When dry, sand very lightly to remove the shine and then apply clear wax with a cloth and buff off.

Oak (*Quercus robur* or *petraea spp.*): sealed, grain-filled, and dyed tangential grain

The grain of open-pored woods can be filled with any type of colored filler. A stable filler that is not oily or waxy allows a transparent dye to be applied over it to yield a two-color finish. Use a dark cabinetmakers' grain filler or add oil paint to neutral filler.

MATERIALS
• **Sanding sealer (bleached shellac in alcohol)**
• **Very fine abrasive paper, such as 240–300 grit**
• **Stiff bronze or brass liming brush**
• **Grain filler**
• **Colored transparent wood dye or ink**
• **Clear paste wax, a beeswax, and carnauba mix**

PREPARATION Use rasps or gouges to form the sculpture, and abrasive papers to smooth the wood.

METHOD Apply sanding sealer thinly with a stiff brush or cloth and allow to dry. Rub down with very fine abrasive paper. Wire brush with the grain to open up the large pores. Rub grain filler into the pores and leave to dry completely. Sand the excess off with very fine abrasive, and seal lightly again. When dry, apply transparent wood dye or ink using a brush or cloth. Rub down again to remove the raised roughness. Use a cloth to rub on pale paste wax, or a stiff brush on rough wood or details. Leave for two hours and then buff with a soft cloth.

Mahogany (*Swietenia spp.*): sanded tangential grain

Mahogany refers to a range of soft, orange to red tropical woods. It is included here because of its color and carvability. No temperate wood really combines these qualities. Most mahoganies are from the genus *Swietenia*, but you will also find Sapele (*Entandrophragma cylindricum spp.*) and others sold under the same name. The samples used here are of Brazilian mahogany (*Swietenia krukovii spp.*). You may need to satisfy yourself (and customers) that any mahogany you use comes from a legal and/or morally defensible source.

MATERIALS
• **Abrasive papers, ranging from 80 to 300 grit**

PREPARATION Form the sculpture using rasps or gouges.

METHOD Smooth the surface with successively finer grades of abrasive, working with the grain. Work from coarse to fine, starting at 80 grit (if the initial surface is rough), or 180 grit (if the surface is already quite smooth). The final grade used will be governed by the degree of smoothness or shine required. A convenient alternative to abrasive paper is fine Webrax, an abrasive plastic matrix rather like a pan-scrubber, which tends to get into textured areas better than paper.

Mahogany (*Swietenia spp.*): sealed and waxed tangential grain

Mahogany is a fairly plain timber however it is cut. Some may show small, regular dark streaks. Sapele shows a wider range of figuring.

MATERIALS
• **Sanding sealer (bleached shellac in alcohol)**
• **Very fine abrasive paper, such as 240–300 grit**
• **Red-brown paste wax, a beeswax, and carnauba mix**

PREPARATION Use rasps or gouges to form the sculpture, and abrasive papers to smooth the wood to the desired degree.

METHOD Use a brush or cloth to thinly apply sanding sealer, and leave to dry. Rub down well with very fine abrasive paper; worn 240 grit is often ideal. A fairly open grain like this sometimes benefits from a second light coat of sealer, again rubbed down when dry. Use a cloth to rub on red-brown paste wax, or a stiff brush on rough wood or details. Leave for one to two hours and then buff up with a soft cloth.

Mahogany (*Swietenia spp.*): sealed and waxed end grain

Before finishing, the end grain of mahogany does not look very different from its long-grain surface. As with most lightwoods, however, it is very absorbent and may finish very much darker unless well-sealed.

MATERIALS
• Sanding sealer (bleached shellac in alcohol)
• Very fine abrasive paper, such as 240–300 grit
• Red-brown paste wax, a beeswax, and carnauba mix

PREPARATION Shape the sculpture with rasps or gouges, and smooth to the desired degree with abrasive papers.

METHOD Use a brush or cloth to thinly apply sanding sealer, and leave to dry. Rub down well with very fine abrasive paper; worn 240 grit is often ideal. Mahogany end grain usually benefits from a second coat of sealer, again sanded when dry. Rub on red-brown paste wax with a cloth, or a stiff brush on rough wood or details. After one or two hours, buff up with a soft cloth.

Mahogany (*Swietenia spp.*): "killed" with dichromate, sealed, and waxed tangential grain

Potassium dichromate (or bichromate) is a strong oxidizing agent that effectively "ages" the wood. The result is fairly shallow but permanent. Potassium dichromate is poisonous and very corrosive. Handle with rubber gloves, wear eye protection, and dispose of remains in plenty of water.

MATERIALS
• 2 percent solution of potassium dichromate in water
• Sanding sealer (bleached shellac in alcohol)
• Very fine abrasive paper, such as 240–300 grit
• Red-brown paste wax, a beeswax, and carnauba mix

PREPARATION As page 77.

METHOD Paint the finished surface generously with the dichromate solution. Leave for up to four hours, depending on the color required. Wash the solution off in plenty of clean water and then soak in two or three changes of water to remove the excess chemical. Allow to dry thoroughly. Use a brush to thinly apply sanding sealer and leave to dry. Rub down well with very fine abrasive paper; worn 240 grit is often ideal. Rub on red-brown paste wax with a cloth, or a stiff brush on rough wood or details. After one or two hours, buff up with a soft cloth.

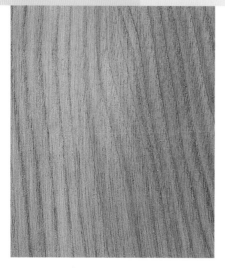

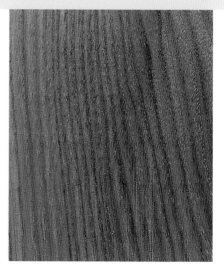

Butternut (*Juglans cinerea spp.*): sanded tangential grain

Like other *Juglans* species, butternut is an attractively grained timber with a cool brown tone. Unlike the others it is very soft and light. Having fairly large pores, it is possible to fill the grain with contrasting filler or wax, but the effect is not as striking as on oak or ash. Butternut is common in the eastern United States but seldom available elsewhere.

MATERIALS
Abrasive papers, ranging from 80 to 300 grit

PREPARATION Form the sculpture using rasps or gouges.

METHOD Smooth the surface with successively finer grades of abrasive, working with the grain. Work from coarse to fine, starting at 80 grit (if the initial surface is rough), or 180 grit (if the surface is already quite smooth). The final grade used will be governed by the degree of smoothness or shine required. A convenient alternative to abrasive paper is fine Webrax, an abrasive plastic matrix rather like a pan-scrubber, which tends to get into textured areas better than paper.

Butternut (*Juglans cinerea spp.*): sealed and waxed tangential grain

When cut along the grain (either tangentially or at right angles to the growth rings) butternut has an attractive and varied figuring. It varies considerably in its overall darkness and degree of figure.

MATERIALS
• **Sanding sealer (bleached shellac in alcohol)**
• **Very fine abrasive paper, such as 240–300 grit**
• **Medium-brown paste wax, a beeswax, and carnauba mix**

PREPARATION Use rasps or gouges to form the sculpture, and abrasive papers to smooth the wood to the desired degree.

METHOD Use a brush or cloth to thinly apply sanding sealer, and leave to dry. Rub down well with very fine abrasive paper; worn 240 grit is often ideal. Butternut usually benefits from a second and even third coat of sealer, again sanded when dry. Rub on medium-brown paste wax with a cloth, or a stiff brush on rough wood or details. After one or two hours, buff up with a soft cloth.

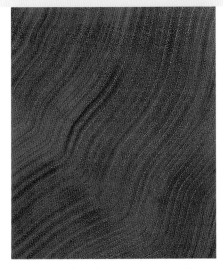

Butternut (*Juglans cinerea spp.*): sealed and waxed end grain

The end grain of butternut is very open and needs careful sealing if it is to take on a polish and not become dark with absorbed wax or oil.

MATERIALS
- Sanding sealer (bleached shellac in alcohol)
- **Very fine abrasive paper, such as 240–300 grit**
- **Medium-brown paste wax, a beeswax, and carnauba mix**

PREPARATION Form the sculpture using rasps or gouges, and smooth to the desired degree with abrasive papers.

METHOD Use a brush or cloth to thinly apply sanding sealer, and leave to dry. Rub down well with very fine abrasive paper; worn 240 grit is often ideal. Butternut usually benefits from a second and even third coat of sealer, again sanded when dry. Use a cloth to rub on medium-brown paste wax, or a stiff brush on rough wood or details. Leave for an hour or two and then buff the wax with a soft cloth.

Butternut (*Juglans cinerea spp.*): gesso-painted

Gesso is a traditional primer for all kinds of materials, absorbent and non-absorbent. A thick coat can provide surface texture, and a wide range of paints and varnishes can be used on top of the gesso. On very close-grained woods it may be wise to leave the surface slightly rough to aid the keying of the gesso. In the past a very thick form of gesso was used to model further detail on the surface of a wood sculpture that was to be entirely painted; such "pastillio work" has, in some cases, survived 600 years intact.

MATERIAL
- **Prepared artists' gesso**

PREPARATION Shape the sculpture with rasps or gouges, and smooth to the desired degree with abrasive papers.

METHOD Brush gesso onto the surface of the wood with a stiff brush, working it well into the grain. Leave to dry. Dried gesso can be sanded and carved with care if the surface needs further refinement.

Basswood (*Tilia americana*): sanded tangential grain

Basswood is one of a number of closely related *Tilia* species that are favored by sculptors. The wood is soft, yet supports detail. Above all else, it can be cut with sharp tools at practically any angle to the grain. It smoothes easily, is pale, and accepts finishes well. Perhaps its only shortcoming is a lack of prominent or attractive grain, but even this can be an advantage in detailed work. In Europe other species of *Tilia*, known there as Lime or Linden, have been a mainstay of woodsculptors, and continue to be so today.

MATERIALS
• Abrasive papers, ranging from 80 to 300 grit

PREPARATION Shape the sculpture with rasps or gouges.

METHOD Smooth the surface with successively finer grades of abrasive, working with the grain. Work from coarse to fine, starting at 80 grit (if the initial surface is rough), or 180 grit (if the surface is already quite smooth). The final grade used will be governed by the degree of smoothness or shine required. A convenient alternative to abrasive paper is fine Webrax, an abrasive plastic matrix rather like a pan-scrubber, which tends to get into textured areas better than paper.

Basswood (*Tilia americana*): sealed and waxed tangential grain

Basswood is practically featureless when cut in this plane. Sometimes pale gray streaking is evident. Bleached (white) wax affects the natural color least, but can show-white in rough areas. Golden-colored wax may serve better.

MATERIALS
• Sanding sealer (bleached shellac in alcohol)
• Very fine abrasive paper, such as 240–300 grit
• Pale paste wax, a beeswax, and carnauba mix

PREPARATION Shape the sculpture with rasps or gouges and smooth to the desired degree with abrasive papers.

METHOD Apply sanding sealer thinly with a stiff brush or cloth and allow to dry. Rub down with a very fine abrasive; worn 240 grit is often ideal. Use a cloth to rub on pale paste wax, or use a stiff brush on rough wood and details. Leave for an hour or two and then buff the wax with a soft cloth.

Basswood (*Tilia americana*): sealed and waxed end grain

The end grain of basswood is very absorbent and nearly always finishes considerably darker than the long-grain surfaces. Unlike most timbers, the end grain of linden is not too difficult to carve.

MATERIALS
- **Sanding sealer (bleached shellac in alcohol)**
- **Very fine abrasive paper, such as 240–300 grit**
- **Pale paste wax, a beeswax, and carnauba mix**

PREPARATION Carve the sculpture with rasps or gouges and smooth to the preferred degree with abrasive papers.

METHOD Apply sanding sealer thinly with a stiff brush or cloth and allow to dry. Rub down with a very fine abrasive paper before applying a second, light coat. Allow to dry and rub down as before. Rub on pale paste wax with a cloth or a stiff brush. Leave for an hour or two and then buff the wax with a soft cloth.

Basswood (*Tilia americana*): sealed and oiled quarter grain

Although not striking, basswood does show a dappled, slightly iridescent pattern on the quarter grain. Oil darkens the wood a little more than wax, but gives a more luminous finish.

MATERIALS
- **Sanding sealer (bleached shellac in alcohol)**
- **Very fine abrasive paper, such as 240–300 grit**
- **Finishing oil, such as Danish or tung oil**

PREPARATION Use rasps or gouges to form the sculpture, and abrasive papers to smooth the wood to the desired degree.

METHOD Use a stiff brush or cloth to thinly apply sanding sealer, and leave to dry. Rub down well with very fine abrasive paper; worn 240 grit is often ideal. Apply a light coat of finishing oil with a cloth and wipe off the excess. When fully dry, sand very gently to remove the slightly rough feel. Repeat at least once more, rubbing down the last coat for a matte finish, or polishing it with a cloth for a soft sheen.

SAFETY Cloths soaked in finishing oil can self-ignite if left bundled up or in close proximity to flammables. Always dispose of cloths immediately outdoors in a specified trash can.

Basswood (*Tilia americana*): tooled, sealed, and waxed tangential grain

Basswood is easily carved. It is also easily marked and bruised by careless use of tools and clamps. Any shape or size of gouge can be used for this effect, and the pattern of strokes can be varied to suit the surface being textured. An oiled finish may be preferred if the marks are very deep.

MATERIALS
• Medium-sweep carving gouge, such as No. 5 (15mm)
• Sanding sealer (bleached shellac in alcohol)
• Fine Webrax
• Pale paste wax, a beeswax, and carnauba mix

PREPARATION Carve the sculpture with rasps or gouges.

METHOD Cover the surface of the wood with overlapping, shallow gouge marks. With sharp tools no sanding should be needed, but the arises can be softened with fine abrasive paper if desired. Apply sanding sealer thinly with a stiff brush or rag and allow to dry. Rub down lightly with the finest Webrax since abrasive paper will not follow the hollows. Apply pale paste wax with a cloth or brush and buff up with a soft cloth after one to two hours.

Basswood (*Tilia americana*): punched and oiled tangential grain

Punching a soft timber like basswood crushes the fibers. The result is more rustic than on a harder wood but still provides a variation in texture and color.

MATERIALS
• 4 in (10cm) round nail with its point ground to a dome
• Finishing oil, such as Danish or tung oil
• Very fine abrasive paper, such as 240–300 grit

PREPARATION Use rasps or gouges to form the sculpture, and abrasive papers to smooth the wood to the desired degree.

METHOD Punch the wood surface by tapping the nail with a small hammer, spacing out the marks as desired. Apply a light coat of finishing oil with a stiff brush, dabbing off any excess with a cloth. When fully dry, sand very gently to remove the slightly rough feel on the raised surface. Repeat at least once more, rubbing down the last coat for a matte finish or polishing it with a cloth for a soft sheen.

SAFETY Cloths soaked in finishing oil can self-ignite if left bundled up or in close proximity to flammables. Always dispose of cloths immediately outdoors in a designated trash can.

Basswood (*Tilia americana*): rasped and oiled tangential grain

Rasping leaves the wood surface rough and open. This makes any finish, other than oil, rather difficult. Basswood can also be shaped and/or finished with a Surform or Microplane® blade. Both give a similar effect to rasping, with less tearing of fibers.

MATERIALS
• Coarse wood rasp
• Finishing oil, such as Danish or tung oil
•Very fine abrasive paper, such as 240–300 grit

PREPARATION Carve the sculpture with rasps or gouges, and smooth to the preferred degree with abrasive papers.

METHOD Once the shape has been defined make a final pass over the surface with the rasp, aligning the marks as desired. Oil lightly, repeating the process once or twice more when dry. Sanding of a rasped surface is not likely to prove useful or practical.

SAFETY Cloths soaked in finishing oil can self-ignite if left bundled up or in close proximity to flammables. Always dispose of cloths immediately outdoors in a designated trash can.

Basswood (*Tilia americana*): bleached, sealed, and waxed tangential grain

Peroxide bleaching removes all the color from a pale wood. Both sodium hydroxide and hydrogen peroxide are corrosive to skin and cloth. Wear gloves and eye protection, cover clothes, and wash brushes and swabs with plenty of water after use.

MATERIALS
• 10 percent solution of sodium hydroxide
• 100-volume hydrogen peroxide in water
• White vinegar (distilled malt vinegar)
• Sanding sealer (bleached shellac in alcohol)
• Very fine abrasive paper, such as 240–300 grit
• Pale paste wax, a beeswax, and carnauba mix

PREPARATION As page 77.

METHOD Using a cheap brush, paint the surface generously with sodium hydroxide. Leave for one hour and swab off any excess. Now paint with hydrogen peroxide solution and leave for 12 to 24 hours, refreshing the solution if it dries out. Once the desired color has been reached, swab off excess hydrogen peroxide and flood in several changes of white vinegar to neutralize. Wash in water and leave to dry thoroughly. Apply sanding sealer thinly with a stiff brush and allow to dry. Rub down well with very fine abrasive. Rub on pale paste wax with a cloth or use a stiff brush for details. Leave for two hours and then buff with a soft cloth.

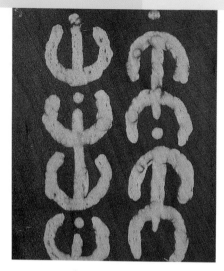

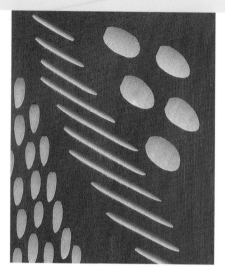

Basswood (*Tilia americana*): "batik" dyed, sealed, and waxed

This is a useful technique when small pieces need to be dyed, as it retains the natural color in certain areas. Beeswax can also be used as a mask. Apply it with a batik t'janting and keep the dye temperature below 176°F (80°C), or use a cold dye.

MATERIALS
• **Sanding sealer (bleached shellac in alcohol)**
• **Very fine abrasive paper, such as 240–300 grit**
• **Watercolor masking fluid**
• **Fabric dye for cotton**
• **Pale paste wax, a beeswax, and carnauba mix**

PREPARATION Use rasps or gouges to form the sculpture, and abrasive papers to smooth the wood to the desired degree.

METHOD Use a brush or cloth to thinly apply sanding sealer, and leave to dry. Rub down well with very fine abrasive paper, such as worn 240 grit. Paint masking fluid on the areas to be left undyed, and allow to dry. Make up the dye according to the manufacturer's instructions. Raise to near the boiling point and then immerse the carving for between two and 10 minutes. Remove and wash off excess dye in cold water. When dry, pick off the masking material. Seal again and rub down very lightly to remove the grain raised by the dying process. Use a cloth or stiff brush to rub on pale paste wax. Leave for one to two hours, and then buff up with a soft cloth.

Basswood (*Tilia americana*): "cameo-carved" and lacquered

This is a good technique for crisp, contrasting effects, although it is not very tolerant of mistakes and reworkings.

MATERIALS
• **Sanding sealer (bleached shellac in alcohol)**
• **Very fine abrasive paper, such as 240–300 grit**
• **Semi-opaque acrylic wood dye**
• **Carving gouges**
• **Cellulose lacquer (pastel/charcoal fixative)**

PREPARATION Use rasps or gouges to form the sculpture, and smooth to the preferred degree with abrasive papers.

METHOD Use a brush or cloth to thinly apply sanding sealer, and leave to dry. Rub down well with very fine abrasive paper; worn 240 grit is often ideal. Apply acrylic wood dye with a brush or cloth. When completely dry, carve through the color layer with gouges. Fix with either sprayed or brushed on cellulose lacquer.

Plywood: sanded

Plywood is manufactured by gluing together layers of veneer, each with its grain at right angles to its neighbor's. Quality varies enormously and sculptors are advised to work with high-grade birch ply, which is pale, consistent, and has few voids. The adhesive used in manufacture is also important. You can laminate precut sheets of plywood to give a rough shape and then work on this with hand or power tools.

MATERIALS
• **Sanding sealer (bleached shellac in alcohol)**
• **Very fine abrasive paper, such as 240–300 grit**
• **Pale paste wax, a beeswax, and carnauba mix**

PREPARATION Form the sculpture using rasps or gouges.

METHOD Smooth the surface with successively finer grades of abrasive, working with the grain. Work from coarse to fine, starting at 80 grit if the initial surface is rough, or 180 grit if the surface is already quite smooth. The final grade used will be governed by the degree of smoothness or shine required.

SAFETY Dust from the glue in plywood is a serious irritant, so wear a dust mask when cutting or sanding plywood.

Plywood: transparent-stained, sealed, and waxed

The stripes in plywood are clear enough to still be very obvious when stained; indeed many treatments emphasize the pattern because of differential absorption by the layers. Transparent stains are composed of very small particles that do not hide the grain of the wood. They are available dissolved in alcohol (spirit), turpentine (oil), and, rarely, in water.

MATERIALS
• **Transparent wood stain**
• **Sanding sealer (bleached shellac in alcohol)**
• **Very fine abrasive paper, such as 240–300 grit**
• **White paste wax, a beeswax, and carnauba mix**

PREPARATION Use rasps or gouges to form the sculpture, and abrasive papers to smooth the wood to the desired degree.

METHOD Use a brush or cloth to thinly apply sanding sealer, and leave to dry. Rub down well with very fine abrasive paper; worn 240 grit is often ideal. Rapidly and evenly brush on the well diluted stain. Try using a pad of cloth on flat areas. Allow to dry, and then seal with sanding sealer, sanding very lightly if needed to remove any raised grain. Rub on white paste wax with a cloth or a stiff brush. Leave for an hour or two and then buff the wax with a soft cloth.

Plywood: acrylic stained, sealed, and waxed

Water-soluble acrylic wood stains are now the most commonly available. They are composed of particles large enough to hide the grain of the wood, at least to some extent. The thicker they are applied, the more opaque they become.

MATERIALS
- **Acrylic wood stain (in water)**
- **Sanding sealer (bleached shellac in alcohol)**
- **Very fine abrasive paper, such as 240–300 grit**
- **Pale paste wax, a beeswax, and carnauba mix**

PREPARATION Form the sculpture using rasps or gouges, and smooth to the desired degree with abrasive papers.

METHOD Using a brush or cloth, thinly apply sanding sealer to the surface and leave to dry. Rub down well with very fine abrasive paper; worn 240 grit is often ideal. Rapidly and evenly brush on the well-diluted stain. Try using a pad of cloth on flat areas. Allow to dry and then seal with sanding sealer, sanding very lightly, if needed, to remove any raised grain. Rub on pale paste wax with a cloth or use a stiff brush. After an hour or two, buff the wax with a soft cloth.

Plywood: sealed, primed, and painted

Acrylic primer will completely hide the wood surface and can form a ground for practically any art medium. The primer is easily tinted with artists' acrylic paint to provide a colored ground. Sealing is advisable to separate the wood from the primer and to prevent it from soaking in.

MATERIALS
- **Sanding sealer (bleached shellac in alcohol)**
- **Very fine abrasive paper, such as 240–300 grit**
- **Acrylic primer**

PREPARATION Use rasps or gouges to form the sculpture, and abrasive papers to smooth the wood to the desired degree.

METHOD Apply sanding sealer thinly with a stiff brush or cloth and allow to dry. Rub down well with very fine abrasive paper; worn 240 grit is often ideal. Brush on as many coats of primer as needed, allowing each to dry.

Softwood: sanded quarter grain

The term "softwood" does not refer to texture. Broadly speaking, softwoods come from coniferous trees and have a clear alternation of soft and hard growth rings. This structure does not, on the whole, aid sculpting but it can give very striking effects, and softwoods are inexpensive and available. Many species of pine, fir, and spruce are available. For carving, white pine (*Pinus strobus spp.*) and slow-grown Austrian pine (*Pinus nigra spp.*) are good. Pitch pine (*Pinus rigida spp.*) has been chosen here because its structure shows well, and it is one of the more carvable wood types.

MATERIALS
• Abrasive papers, ranging from 80 to 300 grit

PREPARATION Shape the sculpture with rasps or gouges.

METHOD Smooth the surface with successively finer grades of abrasive, working with the grain. Work from coarse to fine, starting at 80 grit (if the initial surface is rough), or 180 grit (if the surface is already quite smooth). The final grade used will be governed by the degree of smoothness or shine required. A convenient alternative to abrasive paper is fine Webrax, an abrasive plastic matrix rather like a pan-scrubber, which tends to get into textured areas better than paper.

Softwood: sealed and waxed tangential grain

The tangential surface of all softwoods displays much broader stripes than when the same wood is cut across the growth rings (quarter grain).

MATERIALS
• **Sanding sealer (bleached shellac in alcohol)**
• **Very fine abrasive paper, such as 240–300 grit**
• **Pale paste wax, a beeswax, and carnauba mix**

PREPARATION Shape the sculpture with rasps or gouges, and smooth to the desired degree with abrasive papers.

METHOD Use a brush or cloth to thinly apply sanding sealer and allow to dry. Rub down well with very fine abrasive paper; worn 240 grit is often ideal. Use a cloth to rub on pale paste wax, or use a stiff brush on rough wood or details. Leave for an hour or two and then buff the wax with a soft cloth.

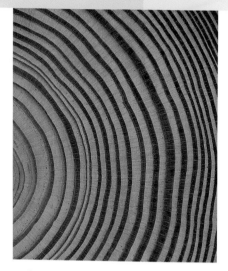

Softwood: sealed and waxed end grain

The end grain of all softwoods is very porous, due to the open nature of the soft growth rings. It can be difficult to smooth these areas without making valleys of the soft bands. A firm support when using the abrasive helps if you want to avoid such ridges.

MATERIALS
- **Sanding sealer (bleached shellac in alcohol)**
- **Very fine abrasive paper, such as 240–300 grit**
- **Pale paste wax, a beeswax, and carnauba mix**

PREPARATION Use rasps or gouges to form the sculpture, and abrasive papers to smooth the wood to the desired degree.

METHOD Use a brush or cloth to thinly apply sanding sealer, and leave to dry. Rub down well with very fine abrasive paper; worn 240 grit is often ideal. Softwood is very open-grained and benefits from a second, and even a third light coat of sealer on the end grain. Rub down with abrasive paper between coats and after the final coat. Use a cloth or stiff brush to rub on pale paste wax. After one or two hours, buff up with a soft cloth.

Softwood: colored wax on tangential grain

Colored wax is quick and convenient to use but it does have its disadvantages. If the wood is sealed first, very little color will be taken up. If it is not sealed, it is difficult to remove or modify afterward. A surface colored in this way may also stain anything left in contact with it, perhaps for months after finishing. Any oil-soluble color can be used in place of artists' oil paint. A range of lightfast browns is made for woodworkers, but artists' oils offer the full gamut of colors based on high-quality pigments. Ready-colored wax polish also has much the same effect.

MATERIALS
- **Artists' oil paint**
- **Bleached (white) paste wax, a beeswax, and carnauba mix**

PREPARATION Form the sculpture using rasps or gouges and use abrasive papers to smooth to a fine finish, since waxing rough wood is difficult and seldom looks satisfactory.

METHOD Mix a small amount of artists' oil paint into some bleached (white) paste wax. Try between 2 percent and 10 percent of oil paint to wax. Rub on the colored wax using a cloth or a stiff brush on rough wood and details. Leave for an hour or two and then buff the wax with a soft cloth.

Softwood: burned, wire-brushed, sealed, and oiled quarter grain

When heavily burned, the softer summer growth rings in softwood are more affected than the harder bands, despite the harder bands (which contain more resin) appearing to blacken first. Blackening caused by burning is permanent.

MATERIALS
- **Blowtorch, butane or propane/butane fired**
- **Stiff wire brush**
- **Sanding sealer (bleached shellac in alcohol)**
- **Finishing oil, such as Danish or tung oil**
- **Fine Webrax**

PREPARATION Use rasps or gouges to form the sculpture, and abrasive papers to smooth the wood to the desired degree. For this effect you do not need to work to a fine finish.

METHOD Play the blowtorch evenly over the wood, aiming to burn well into the wood. Avoid setting the wood alight, but if it does catch, extinguish the flames immediately. When cool, brush vigorously in the direction of the grain to remove the charred material. When satisfied with the effect, lightly apply sanding sealer with a brush or cloth to immobilize the remaining black. Apply a light coat of finishing oil with a stiff brush, dabbing off any excess with a cloth. Apply a second coat when the first is dry. When this is dry, rub down lightly with the finest Webrax.

Softwood: singed, stained, and oiled tangential grain

With the delicate use of a blowtorch it is possible to blacken the hard growth rings in softwood, leaving the less resinous parts their natural color.

MATERIALS
- **Blowtorch, butane or propane/butane fired**
- **Sanding sealer (bleached shellac in alcohol)**
- **Very fine abrasive paper, such as 240–300 grit**
- **Colored transparent wood dye or ink**
- **Finishing oil, such as Danish or tung oil**

PREPARATION Form the sculpture using rasps or gouges, and smooth to the desired degree with abrasive papers.

METHOD Play the blowtorch over the sanded wood surface until the soft layers darken as required, remembering to keep the torch moving. Lightly apply sanding sealer with a brush or cloth to immobilize the remaining singing, then sand very lightly. Apply transparent colored wood dye with a brush or cloth and allow to dry. Apply a light coat of finishing oil with a cloth or brush and wipe off the excess. When fully dry, sand very gently to remove the slightly rough feel. Repeat at least once more, rubbing down the last coat for a matte finish or polishing it with a cloth for a soft sheen.

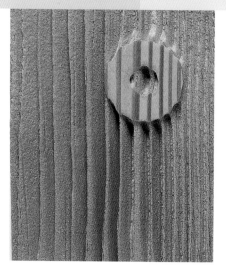

Softwood: masked and sandblasted quarter grain

Typical softwoods, like this pitch pine, are worn into deep furrows by blasting, due to the relative softness of the summer growth. Such erosion highlights the angle at which the grain is intercepted on any particular part of the sculpture.

MATERIALS
- **Resilient material for masking**
- **Professional sandblasting equipment**
- **Fine Webrax**

PREPARATION Form the sculpture with rasps or gouges, and smooth to the preferred degree with abrasive papers.

METHOD Stick the masking material—steel washers were used here—to the wood surface firmly with "rubbery" glue. Blast with fine grit to the desired depth. Clean well with a fine wire brush to remove the grit, then remove the masking and touch up masked areas if required. Sand very gently with fine Webrax to remove the slightly rough feel.

Softwood: sandblasted and varnished tangential grain

The shallow angle at which the growth rings are cut in a tangential sample creates a surface of broad ledges when blasted. Varnish suffers from a bad reputation, but modern water-based varnishes are quite unlike the syrupy products of the past. However, do not make the common mistake of assuming that varnish is a good outdoor finish. Although initially waterproof, strong sun will degrade it and lead to problems with peeling. It is better to use oil outdoors.

MATERIALS
- **Professional sandblasting equipment**
- **Water-based wood varnish, (here semi-matte)**

PREPARATION Use rasps or gouges to form the sculpture, and abrasive papers to smooth the wood to the desired degree.

METHOD Blast with fine grit to the desired depth, and then clean well with a fine wire brush to remove the grit. Apply a light coat of water-based varnish with a soft brush. Repeat if necessary after the allotted retouching time indicated by the manufacturer—if left for too long, the second layer may not key well to the first.

European walnut (*Juglans regia spp.*): sanded tangential grain

Walnut (sometimes called French, English, or Italian) is a fairly hard wood with a smooth texture and interesting and varied figuring. Sometimes walnut is steamed before drying. This evens out the color for cabinet-making and veneers, but reduces the definition of any figuring and affects the texture in a way that many carvers dislike.

MATERIALS
• **Abrasive papers, ranging from 80 to 300 grit**

PREPARATION Form the sculpture using rasps or gouges.

METHOD Smooth the surface with successively finer grades of abrasive, working with the grain. Work from coarse to fine, starting at 80 grit (if the initial surface is rough), or 180 grit (if the surface is already quite smooth). The final grade used will be governed by the degree of smoothness or shine required. A convenient alternative to abrasive paper is fine Webrax, an abrasive plastic matrix rather like a pan-scrubber, which tends to get into textured areas better than paper.

European walnut (*Juglans regia spp.*): sealed and waxed tangential grain

This sample shows why walnut has achieved and retained such popularity as a decorative wood. Dark wax is used here to accentuate the grain. Pale wax can form white flecks in the grain, rough spots, and corners.

MATERIALS
• **Sanding sealer (bleached shellac in alcohol)**
• **Very fine abrasive paper, such as 240–300 grit**
• **Dark paste wax, a beeswax, and carnauba mix**

PREPARATION Shape the sculpture with rasps or gouges, and smooth to the desired degree with abrasive papers.

METHOD Use a brush or cloth to thinly apply sanding sealer, and leave to dry. Rub down well with very fine abrasive paper, such as worn 240 grit. Use a cloth to rub on dark paste wax, or a stiff brush on rough wood or details. Leave for one to two hours and then buff up with a soft cloth.

European walnut (*Juglans regia spp.*): sealed and waxed end grain

The end grain of walnut is very dark and difficult to carve. Dark wax is used here to accentuate the grain. Pale wax can cause white flecks to appear in the grain at rough spots.

MATERIALS
- Sanding sealer (bleached shellac in alcohol)
- Very fine abrasive paper, such as 240–300 grit
- Dark paste wax, a beeswax, and carnauba mix

PREPARATION Use rasps or gouges to form the sculpture, and abrasive papers to smooth the wood to the desired degree.

METHOD Use a brush or cloth to thinly apply sanding sealer, and leave to dry. Rub down well with very fine abrasive paper; worn 240 grit is often ideal. A second coat of sealer may be worthwhile if you do not want the end grain to darken too much. Again, sand when dry. Rub on dark paste wax with a cloth or stiff brush. After one or two hours, buff up with a soft cloth.

European walnut (*Juglans regia spp.*): tooled, sealed, and waxed

The darker a finish the less prominent any surface features appear because the tonal range between highlights and shadows is smaller for dark surfaces. Any shape or size of gouge can be used for this effect, and the pattern of strokes can be varied to suit the surface being textured. An oiled finish may be preferred if the marks are very deep. Compare the same tooling on walnut and linden.

MATERIALS
- Medium-sweep carving gouge, such as No. 5 (15mm)
- Sanding sealer (bleached shellac in alcohol)
- Fine Webrax
- Dark paste wax, a beeswax, and carnauba mix

PREPARATION Shape the sculpture with rasps or gouges.

METHOD Cover the surface of the wood with overlapping, shallow gouge marks. With sharp tools no sanding should be needed, but the arises can be softened with fine abrasive paper if desired. Apply sanding sealer thinly with a stiff brush or cloth and allow to dry. Rub down lightly with the finest Webrax, since abrasive paper will not follow the hollows. Apply dark paste wax with a cloth or brush and buff up with a soft cloth after one to two hours.

European walnut (*Juglans regia spp.*): masked, sandblasted, and oiled tangential grain

Unlike softwoods, hardwoods erode fairly evenly when blasted with fine grit.

MATERIALS
- **Resilient material for masking**
- **Professional sandblasting equipment**
- **Finishing oil, such as Danish or tung oil**
- **Fine Webrax**

PREPARATION Carve the sculpture with rasps or gouges, and smooth to the preferred degree with abrasive papers.

METHOD Stick the masking material—steel washers were used here—to the wood surface firmly with "rubbery" glue. Blast with fine grit to the desired depth. Clean well with a fine wire brush to remove the grit, then remove the masking and touch up masked areas if required. Apply a light coat of finishing oil with a stiff brush, dabbing off any excess with a cloth. When fully dry, sand very gently with fine Webrax to remove the slightly rough feel. Repeat at least once more, rubbing down the last coat for a matte finish or polishing it with a cloth for a soft sheen.

European walnut (*Juglans regia spp.*): oil-gilded tangential grain

Gilding gives a unique finish that cannot be reproduced with gold paints or lacquers.

MATERIALS
- **Sanding sealer (bleached shellac in alcohol)**
- **Very fine abrasive paper, such as 240–300 grit**
- **Artists' acrylic paint**
- **Gold size**
- **Gold leaf**

PREPARATION Shape the sculpture with rasps or gouges, and smooth to the desired degree with abrasive papers.

METHOD Apply sanding sealer thinly with a stiff brush or cloth and allow to dry. Rub down well with very fine abrasive paper; worn 240 grit is often ideal. Brush on a layer of artists' acrylic paint. When dry, apply a thin layer of gold size. Leave for the specified drying time, then invert the gold leaf on its backing sheet and press down well onto the size. Patch any gaps and smooth with a dry cotton swab. Wear through to the undercoat on the arises if an antique effect is preferred.

American black walnut (*Juglans nigra spp.*): sanded tangential grain

Black walnut is a medium hard timber that carves well and takes a fine finish. Although darker and less figured, black walnut is sometimes used in place of European walnut because it is available in larger, defect-free pieces and is often considerably less expensive.

MATERIALS
• Abrasive papers, ranging from 80 to 300 grit

PREPARATION Form the sculpture using rasps or gouges.

METHOD Smooth the surface with successively finer grades of abrasive, working with the grain. Work from coarse to fine, starting at 80 grit (if the initial surface is rough), or 180 grit (if the surface is already quite smooth). The final grade used will be governed by the degree of smoothness or shine required. A convenient alternative to abrasive paper is fine Webrax, an abrasive plastic matrix rather like a pan-scrubber, which tends to get into textured areas better than paper.

American black walnut (*Juglans nigra spp.*): sealed and waxed tangential grain

The full richness of black walnut is only revealed when it is well smoothed and finished with oil, wax, or another kind of polish. Dark wax is used here to accentuate the grain. Pale wax can cause white flecks to form in the grain.

MATERIALS
• Sanding sealer (bleached shellac in alcohol)
• Very fine abrasive paper, such as 240–300 grit
• Dark paste wax, a beeswax, and carnauba mix

PREPARATION Use rasps or gouges to form the sculpture, and abrasive papers to smooth the wood to the desired degree.

METHOD Use a brush or cloth to thinly apply sanding sealer, and leave to dry. Rub down well with very fine abrasive paper; worn 240 grit is often ideal. Use a cloth to rub on dark paste wax, or a stiff brush on rough wood and details. After one or two hours, buff up with a soft cloth.

American black walnut (*Juglans nigra spp.*): sealed and waxed end grain

The end grain of black walnut is very dark and rather difficult to carve.

MATERIALS
• Sanding sealer (bleached shellac in alcohol)
• Very fine abrasive paper, such as 240–300 grit
• Dark paste wax, a beeswax, and carnauba mix

PREPARATION Carve the sculpture with rasps or gouges, and smooth to the desired degree with abrasive papers.

METHOD Use a brush or cloth to thinly apply sanding sealer, and leave to dry. Rub down well with very fine abrasive paper; worn 240 grit is often ideal. Rub on dark paste wax with a cloth or use a stiff brush for details. Leave for an hour or two and then buff the wax with a soft cloth.

American black walnut (*Juglans nigra spp.*): bleached, sealed, and waxed tangential grain

Peroxide bleaching can never remove all the color from a dark wood such as walnut. See page 87 for an important safety note.

MATERIALS
• 10 percent solution of sodium hydroxide
• 100-volume hydrogen peroxide in water
• White vinegar (distilled malt vinegar)
• Sanding sealer (bleached shellac in alcohol)
• Very fine abrasive paper, such as 240–300 grit
• Pale paste wax, a beeswax, and carnauba mix

PREPARATION As page 77.

METHOD Using a cheap, white hog brush, paint the surface generously with sodium hydroxide. Leave for about one hour and swab off any excess. Now paint with plenty of hydrogen peroxide solution and leave for 12 to 24 hours, refreshing the solution if it dries out. Once the desired color has been reached, swab off excess hydrogen peroxide and flood in several changes of white vinegar to neutralize the soda. Wash in water and leave to dry thoroughly. Apply sanding sealer thinly with a stiff brush or cloth and allow to dry. Rub down well with very fine abrasive paper; worn 240 grit is often ideal. Rub on pale paste wax with a cloth or stiff brush. Leave for one to two hours and then buff up with a soft cloth.

Inspirational pieces

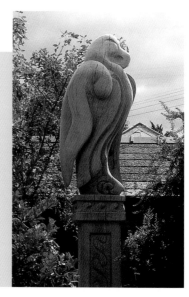

PHOENIX
KEN SMITH

Carved by chainsaw from a single beech log, the surface has then been more carefully formed with a sanding disc on an angle grinder. The textured carvings on the base were done by hand with a gouge. When working on a large scale outdoors, the bold, simple lines of the sculpture make an impression among the plants and buildings surrounding it.

SEEING A JEWEL HANG
IN GHASTLY NIGHTS
STEFANIE ROCKNAK

Here is an intensely realistic sculpture where the surface of the wood has been sanded and oiled to such a fine finish that it resembles skin. The lifelike color and grain, and the way the muscles and bones appear to press out from beneath the skin-like surface emphasize this interweaving of human form and natural material.

MERMAID
ELONA BENNETT

Carved from the root of a cherry tree, the inspiration for this piece obviously came from the spiraling, twisting, and watery shapes of the wood. After carving, the piece was finished with a riffler and sandpaper before polishing with beeswax.

FEATHER TOWER
MARTIN HERON

A hollow oak log is turned into an impressive sculpture by using the remaining wood to create a spiraling chain of feathers. By carving between the feathers, we can see through the piece and into the inner curving surface on the opposite side. The chainsaw is a remarkably versatile tool. It is fast and allows a sculptor to tackle large and intricate pieces such as this in a relatively short space of time. It is also well known to be the most dangerous of handheld power tools, so make sure you have had proper instruction before using one. An angle grinder was used to sand the quills and, at this stage, the wood is untreated.

GEORGE
STEFANIE ROCKNAK

In this piece, the features and identity of "George" shine out through the highly textured surface. The oak is carved by hand and the marks of the gouges are left clearly visible, adding a powerful energy to the already concentrated features of the figure.

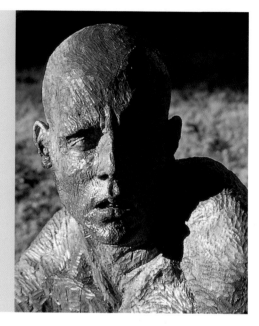

TREE PYTHON
BILL PRITCKETT

This life-size snake, and the branch it is hanging on, are carved from laminated plywood. It makes a striking impression, coming to life through the exposed grain of the wood. By finely sanding, oiling, and waxing the surface to a high sheen, the heavy muscularity and sinuousness of the python is emphasized.

PREGNANT
ELONA BENNETT

The rich, warm color of this fruitwood works well with the full, convex forms of a pregnant female torso. The sanded and polished surface is finished with beeswax, creating a form bursting with life and contained energy.

FOREST STATION
WILLIAM FAIRBANK

Carved in such a way that we are not sure whether it is natural or man-made, this sculpture catches our attention and then draws us into a mysterious inner space with its energy lines. This sculpture is intended to be touched and is protected by finishing with Danish oil which hardens to a tough surface.

Metal

There are a multitude of differing patination effects that can be applied to non-ferrous metals. The swatches in this section are by no means an exhaustive range. Instead the instructions illustrate ways to obtain green or brown patinas on bronze, copper, and brass. For the bronze examples, the patination has been obtained on a cast bronze surface, so these techniques would be of most interest to sculptors who model in clay and cast in bronze. The patinations applied to brass and copper have been obtained on sheet material, these would be of interest to sculptors making constructed work, although they can also be used on a cast bronze surface. In the bronze section, the ingredients and their applications are varied and convoluted, and so suitable for the experienced sculptor. In the brass and copper sections, the range of chemicals used has been kept to a minimum. The results you obtain will vary depending on the type of surface you are applying them to, the surrounding temperature, and, of course, the degree of experience of the sculptor.

Brazing

Brazing is a technique that uses molten brass to join two pieces of mild steel together at a low temperature. It is especially suitable for thin sheet steel and small-diameter steel rod and bar, which would be more likely to burn away or buckle under the higher temperature used in welding. Brazing makes a strong joint, though not as strong a joint as a welded joint. The sculpture being made here is a fish that forms part of a wall-based sculpture. The flame of the torch is used to cut out shapes from a sheet of steel. The parts of the fish are then brazed together. Molten brass is also used to form a decorative effect.

YOU WILL NEED:

- Coveralls or a boiler suit, heavy-duty boots or shoes, leather gloves, a leather apron, and welding goggles
- Oxygen cylinder and regulator
- Acetylene cylinder and regulator
- Cylinder wrench
- Torch and hoses
- Welding nozzles
- Spark lighter
- Cutting attachment
- Chalk
- Sheet steel
- Wire brush, wire wool, or file
- ¼-inch (6mm) steel rod
- Brass rod
- Powdered flux

SAFETY

- When using acetylene equipment adequate safety precautions are essential. Wear heavy shoes, coveralls or a boiler suit, leather gloves, a leather apron, and welding goggles.
- Keep a bucket of water handy.
- Work on a steel bench or a steel surface, not a wooden one, and beware of touching any steel. If possible, work above a concrete floor.
- Wear leather gloves throughout the entire procedure: the steel may not be red-hot, but it retains heat for some time.
- Work in a well-ventilated area, away from flammable items.

THE HEAT SOURCE

The heat source used is the combination of two gases; oxygen and acetylene (oxyacetylene)—acetylene being the flammable gas. The gases are stored in cylinders, that have an on/off valve operated by a cylinder wrench. Mounted on the top of each cylinder are two gauges and a regulator valve. One gauge indicates the pressure of gas in the cylinder; the other indicates the pressure of the gas leaving the cylinder to the torch. Oxygen is denoted by the color green (or blue) and acetylene by the color red. Each cylinder is connected to the torch by a rubber hose. The torch itself has two valves, one red (acetylene) and the other green or blue (oxygen) for controlling the mixture of gases for the correct flame. The size of the torch nozzle determines the intensity of the flame. As a guide, a small nozzle is suitable for brazing, while larger ones are suitable for welding. The gas pressure you require will depend on the nozzle size and the thickness of the steel being joined. Always read the instruction manual carefully.

1 Using chalk, mark the part of the design for brazing on the sheet steel. Carefully follow the chalk outline with the flame until the shape is completely cut out from the steel.

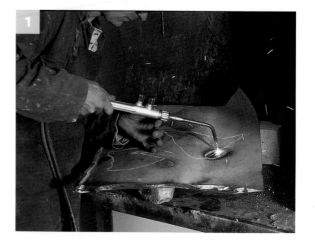

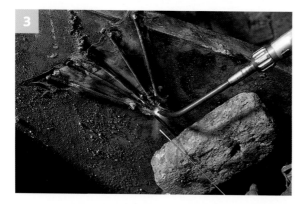

2 A good brazed joint depends on both of the surfaces being clean; so clean the surfaces with a wire brush, wire wool, or a file.

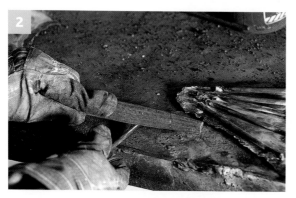

3 The pieces of ¼-inch (6mm) steel rod in the tail section of the fish are held in position by applying molten brass. Dip a brass rod into the powdered flux to stop oxidization. Apply heat evenly to the area around the two pieces of steel to be joined (there should be a slight gap between them) until they reach red heat. At the same time, introduce the brass rod into the outer flame. When the steel reaches red heat (the melting point of brass), bring the brass rod into the area to be joined. The heat generated will enable the brass to melt and flow in and around the joint. Withdraw the rod and turn off the gas. As the joint cools, so does the brass which holds the two pieces of steel together.

4 Use the same technique to braze together sections of steel rod, or more steel rod and sheet steel. The ¼-inch (6mm) steel rod is easily curved by hand.

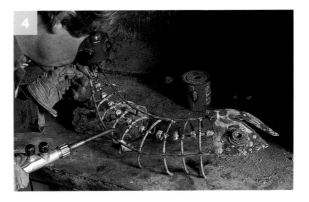

5 Heat up an area of sheet steel and brass rod, and drop molten brass onto the surface of the steel.

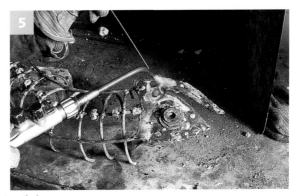

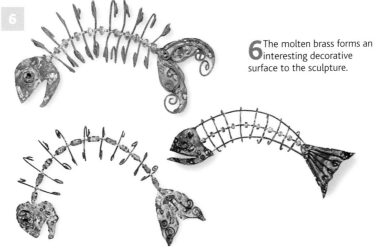

6 The molten brass forms an interesting decorative surface to the sculpture.

BRONZE

These patinations have been obtained on a cast bronze surface which has an uneven quality giving the chemicals something to "bite" into. It is essential that the metal surface is degreased immediately prior to the application of the chemicals or the patination will be inconsistent. This can be carried out with a commercially available degreasing agent, followed by a thorough rinsing with water.

The tools and materials used in patination can present a risk, but with safe and proper handling that risk is minimized. Always work in a well-ventilated area and wear gloves, protective clothing and footwear, a respiratory mask, and face shield when working with chemicals. Familiarize yourself with and adhere to any specific health and safety advice that accompanies the chemicals that you use. Always wear leather gloves and a face shield when using a gas torch.

Patchy green patina

This technique involves the application of a paste to the bronze over a period of days.

MATERIALS
- **20g copper sulfate**
- **20g copper acetate**
- **10g ammonium chloride**
- **Acetic acid (6% solution)**
- **Beeswax**
- **Turpentine**

PREPARATION Cast the sculpture in bronze and thoroughly degrease the surface.

METHOD Taking the necessary safety precautions, pour the copper sulfate, copper acetate, and ammonium chloride into a mortar and add a small amount of acetic acid. Grind the ingredients with a pestle into a smooth paste. Keep adding small amounts of acetic acid until the mix has a creamy consistency. Brush the sculpture with a thick coat of paste. Leave for 24 hours, then rinse off the paste residue under running water with a brush. Let the sculpture dry, and then use a cloth to apply a thin layer of paste and leave for 24 hours. Repeat the process, adding thin layers of paste, until the desired effect is obtained. Gently melt enough beeswax to cover the sculpture. Turn the heat off before removing the lid from a bottle of turpentine. Slowly add turpentine to the wax until you have a smooth paste. Apply the beeswax with a soft cloth to seal the surface and prevent further chemical reactions.

Green patina

This technique is a time-consuming process and requires patience and careful monitoring as the patina is slow to develop.

MATERIALS
• 200g copper nitrate
• 200g sodium chloride
• 32 fl. oz (1l) water
• Beeswax
• Turpentine

PREPARATION Cast the sculpture in bronze. Thoroughly degrease the surface, and then rinse off the degreasing agent with water.

METHOD Taking the necessary safety precautions, dissolve the copper nitrate and sodium chloride in water. Using a soft cloth, dab the solution all over the surface of the sculpture and allow it to dry naturally. Repeat this procedure twice a day for five consecutive days. Leave the sculpture to dry thoroughly for at least another five days. This may take slightly longer in a damp environment. During this time, the green patina will start to build up and will continue to do so as long as the surface remains moist. Apply a beeswax and turpentine mixture to seal the surface and to prevent a further chemical reaction by following the instructions on page 108.

Blue-green patina on black ground

An interesting blue-green patina is produced in this example, through which you can see the black ground. When using this technique, make sure you do so in a well-ventilated area.

MATERIALS
• 100g copper nitrate
• 40cm³ nitric acid (70% solution)
• 32 fl. oz (1l) water
• Gas torch
• Beeswax
• Turpentine

PREPARATION Cast the sculpture in bronze. Thoroughly degrease the surface of the bronze, and then rinse off the degreasing agent with water.

METHOD Taking the necessary safety precautions, dissolve the copper nitrate and nitric acid in water. Apply heat with the gas torch evenly over the surface of the bronze, and then brush on a thin coat of the solution. Apply heat evenly over the surface again until it turns from brown to black. Continued heating combined with the stippling on of more solution will establish a dense black ground. To achieve a consistent blue-green patina on top, continue applying heat while stippling on more solution with a very dry brush. Once the surface has cooled, apply a beeswax and turpentine mixture by following the instructions on page 108.

Cold green patina

This technique involves the cold application of the patination chemicals to produce a thin, green patina. This finish takes at least 15 days to achieve so patience is necessary.

MATERIALS
- 10g ammonium chloride
- 10g ammonium acetate
- 32 fl. oz (1l) water
- Beeswax
- Turpentine

PREPARATION Cast the sculpture in bronze. Thoroughly degrease the surface, and then rinse off the degreasing agent with water.

METHOD Following the required safety precautions, dissolve the ammonium chloride and ammonium acetate in water. Brush the solution onto the surface of the sculpture and allow it to dry. Repeat this procedure twice a day over the next 10 consecutive days. Allow the sculpture to dry thoroughly for another five days. This may take slightly longer in a damp environment. Over this time, the patina will develop on the surface of the sculpture. When no further patina has developed, apply a beeswax and turpentine mixture by following the instructions on page 108.

Green patina on brown ground

After establishing a brown ground, with the application of the solution and heat, a green patina is formed on top.

MATERIALS
- 100g copper nitrate
- 10cm³ hydrochloric acid (35% solution)
- 32 fl. oz (1l) water
- Gas torch
- Beeswax
- Turpentine

PREPARATION Cast the sculpture in bronze. Thoroughly degrease the surface, and then rinse off the degreasing agent with water.

METHOD Taking the necessary safety precautions, dissolve the copper nitrate and hydrochloric acid in water. Apply heat evenly over the surface of the bronze with a gas torch, and then brush on a thin layer of the chemical solution. Continue to apply even heat and thin applications of the solution until the surface starts to darken and forms a brown patination. Stipple on the solution with a nearly dry brush while continuing to heat the surface and the green patination will start to establish itself. Once the surface has cooled, apply a beeswax and turpentine mixture by following the instructions on page 108.

Speckled blue-green patina

This technique produces a very fine-speckled blue-green patina on the surface. This technique should be undertaken with care in a well-ventilated area, avoiding inhalation of the fine spray that is produced.

MATERIALS
- 80g copper nitrate
- 32 fl. oz (1l) water
- 3cm³ ammonia (28% solution)
- Fine spray nozzle
- Beeswax
- Turpentine

PREPARATION Cast the sculpture in bronze. Thoroughly degrease the surface, and then rinse off the degreasing agent with water.

METHOD Following the necessary safety precautions, dissolve the copper nitrate in water and add the ammonia. Using a fine spray nozzle, spray the surface of the sculpture. Aim for a very fine surface coating, avoiding drips and puddling. Leave to dry and repeat this procedure twice a day for the next three consecutive days. Leave to dry thoroughly for at least seven days. Once dry, apply a beeswax and turpentine mixture by following the instructions on page 108.

Patchy green patina on brown ground

In this example, the application of a paste produces patches of green patina on a brown ground. When brushing off the dry residue be sure to wear a respirator mask with a fine dust filter.

MATERIALS
- 20g copper nitrate
- 16g sodium chloride
- 12g potassium hydrogen tartrate
- 4g ammonium chloride
- Water
- Beeswax
- Turpentine

PREPARATION Cast the sculpture in bronze. Thoroughly degrease the surface of the bronze, and then rinse off the degreasing agent with water.

METHOD Following the necessary safety precautions, pour the copper nitrate, sodium chloride, potassium hydrogen tartrate, and ammonium chloride into a mortar. Use a pestle and a little water to grind these constituents into a creamy paste. Using a soft brush, coat the surface of the sculpture with the paste and leave it to dry. Drying time will take approximately four hours. When dry, brush off the dried paste with a bristle brush. Wash the sculpture thoroughly in water and allow it to dry. During this time, a thin, green patina will form on a brown ground. Apply a beeswax and turpentine mixture by following the instructions on page 108.

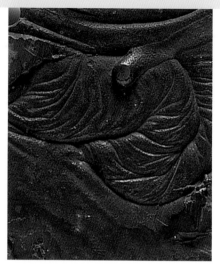

Blue-green patina on light brown ground

The application of paste over a few days will produce this interesting blue-green patina on a light brown ground.

MATERIALS
- 30g copper acetate
- 15g copper carbonate
- 30g ammonium chloride
- 2cm³ hydrochloric acid (18% solution)
- Water
- Beeswax
- Turpentine

PREPARATION Cast the sculpture in bronze. Thoroughly degrease the surface.

METHOD Taking the necessary safety precautions, pour the copper acetate, copper carbonate, and ammonium chloride into a mortar. Add the hydrochloric acid and a little water and use the pestle to grind these constituents into a creamy paste. Apply with a soft brush and leave overnight to dry. Remove the dried paste with a bristle brush. Repeat the whole procedure until a brown ground has developed. Use water to thin the paste out a little then repeat the procedure again, except this time use a soft brush to dispose of the dried paste. When you are satisfied with the effect leave the sculpture to dry thoroughly before applying a beeswax and turpentine mix following the instructions on page 108.

Brown patina

This technique produces a consistent dark brown patina.

MATERIALS
- 5g ammonium chloride
- 5g sodium chloride
- 1l water
- Gas torch
- Beeswax
- Turpentine

PREPARATION Cast the sculpture in bronze. Thoroughly degrease the surface of the bronze prior to chemical application, then rinse off the degreasing agent with water.

METHOD Following the necessary safety precautions, dissolve the ammonium chloride and sodium chloride in the water and allow to stand overnight. Apply heat evenly over the surface of the bronze with a gas torch, then dip a cloth in the chemical solution and dab it onto the bronze. Repeat this procedure and the surface will start to darken. When the desired effect is achieved, allow the sculpture to cool. Apply a beeswax and turpentine mix following the instructions on page 108.

Red-brown patina

In this example, a very interesting red-brown patination is obtained by applying the patinating solution to the sculpture with a fine wire brush.

MATERIALS
- 10g ferric nitrate
- 32 fl. oz (1l) water
- Gas torch
- Fine wire brush
- Beeswax
- Turpentine

PREPARATION Cast the sculpture in bronze. Thoroughly degrease the surface, and then rinse off the degreasing agent with water.

METHOD Following the required safety precautions, dissolve the ferric nitrate in water. Apply heat evenly with a gas torch over the surface of the bronze, then dip a fine wire brush in the chemical solution and apply it to the bronze using a circular motion. When the surface is red-brown in color, dip a cloth in the solution and lightly dab the surface. Allow the sculpture to cool and dry completely. Apply a beeswax and turpentine mixture by following the instructions on page 108.

Dark brown patina

This technique produces a very dark brown, almost black, patination. Be sure to carry out this procedure in a well-ventilated area.

MATERIALS
- 50g ferric nitrate
- 6g sodium thiosulfate
- 32 fl. oz (1l) water
- Gas torch
- Beeswax
- Turpentine

PREPARATION Cast the sculpture in bronze. Thoroughly degrease the surface, and then rinse off the degreasing agent with water.

METHOD Taking the necessary safety precautions, dissolve the ferric nitrate and sodium thiosulfate in water. Evenly apply heat with a gas torch over the surface of the bronze, then dip a cloth in the chemical solution and dab it onto the bronze. By careful dabbing, you will be able to control the consistency of the patination as the surface changes to a dark brown. Allow the sculpture to cool and dry completely. Apply a beeswax and turpentine mixture by following the instructions on page 108.

BRASS

The following examples have been obtained on sheet metal. It has been rolled in the mill to produce an even thickness and a consistently smooth surface. It is this surface consistency that can sometimes prove a hindrance to an effective patination. The lack of "bite" in the surface can be rectified, however, by treating the surface with an abrasive, such as fine pumice powder or a very fine abrasive sheet.

Green patina

In this example, beeswax has been applied over half of the surface to indicate how the wax darkens the patination.

MATERIALS
- **500g copper nitrate**
- **84 fl.oz (2.5l) water**
- **Gas torch**
- **Beeswax**
- **Turpentine**

PREPARATION Thoroughly degrease the surface of a brass sheet before rinsing off the degreasing agent with water.

METHOD Taking the necessary safety precautions, add the copper nitrate to water, ensuring that the copper nitrate is fully dissolved before use. Apply heat evenly with a gas torch over the surface of the brass, then brush on the copper nitrate solution. Evenly apply heat again until the surface turns black. Brush on more of the copper nitrate solution until the surface turns green—the effect obtained will depend on the amount of copper nitrate applied. Once the surface has cooled, apply a beeswax and turpentine mixture by following the instructions on page 108.

Dappled green patina

In this example, an interesting dappled effect is obtained. It is important not to overdo the flicking here since it can easily get out of hand, and rather than having a sparsely covered surface, you can end up covering the entire surface.

MATERIALS
- 500g copper nitrate
- 84 fl.oz (2.5l) water
- Gas torch
- Beeswax
- Turpentine

PREPARATION Thoroughly degrease the surface of a brass sheet before rinsing off the degreasing agent with water.

METHOD Following the required safety precautions, add the copper nitrate to water, ensuring that the copper nitrate is fully dissolved before use. Apply heat evenly with a gas torch over the surface of the brass, then brush on the copper nitrate solution. Evenly apply heat again until the surface turns black. Dip the brush in the copper nitrate solution and flick the chemical over the surface of the sculpture to produce spots of green—the effect obtained will depend on the amount of copper nitrate applied. Once the surface has cooled, apply a beeswax and turpentine mixture by following the instructions on page 108.

Stippled green patina

The stippling effect obtained in this example allows you to have more control over the final result while still allowing you to achieve a random look.

MATERIALS
- 500g copper nitrate
- 84 fl.oz (2.5l) water
- Gas torch
- Beeswax
- Turpentine

PREPARATION Thoroughly degrease the surface of a brass sheet before rinsing off the degreasing agent with water.

METHOD Taking the necessary safety precautions, add the copper nitrate to water, ensuring that it is fully dissolved before use. Evenly apply heat with a gas torch over the surface of the brass, then brush on the copper nitrate solution. Apply heat again until the surface turns black. Dip the brush in the copper nitrate solution and gently shake off the excess back into the container. Hold the brush vertically, above the surface of the sculpture, and apply the copper nitrate solution with a stippling action across the entire surface. Reload the brush when necessary. The effect obtained will depend on the amount of copper nitrate applied. Once the surface has cooled, apply a beeswax and turpentine mixture by following the instructions on page 108.

Black patina

A thin black patina is obtained in this example, which allows the color of the brass to show through.

MATERIALS
- 50g potassium polysulfide
- 1l water
- Gas torch
- Beeswax
- Turpentine

PREPARATION Thoroughly degrease the surface of a brass sheet and rinse off the degreasing agent with water.

METHOD Following the required safety precautions, make a liver of sulfur solution by adding the potassium polysulfide to the water, ensuring that the potassium polysulfide is fully dissolved before use. Apply heat evenly over the surface of the brass with a gas torch, then brush on the liver of sulfur solution until the surface starts to turn black. Once the surface has cooled, apply a beeswax and turpentine mix following the instructions on page 108.

Red-brown patina

In this example a thin reddish-brown patina is obtained that complements the coloring of the brass that shows through the surface.

MATERIALS
- 50g ferric nitrate
- 1l water
- Gas torch
- Beeswax
- Turpentine

PREPARATION Degrease the surface of a brass sheet and rinse off the degreasing agent with water.

METHOD Taking the necessary safety precautions, add the ferric nitrate to the water, ensuring that the ferric nitrate is fully dissolved before use. Apply heat evenly over the surface of the brass with a gas torch, then brush on the ferric nitrate solution until the red coloring just starts to develop. When the surface has thoroughly cooled apply a beeswax and turpentine mix following the instructions on page 108.

COPPER

The following examples have been obtained on sheet metal. Sheet material responds very well to more aggressive surface treatments, such as using a hammer to produce a hammered effect and there are ranges of different shaped punches that can be used to produce a variety of surface effects.

Green patina

In this example, the beeswax and turpentine mixture has been applied to half of the surface to indicate the effect that addition of the wax has on the final coloring.

MATERIALS
- **500g copper nitrate**
- **118 fl. oz (3.5l) water**
- **50g potassium polysulfide**
- **Gas torch**
- **Beeswax**
- **Turpentine**

PREPARATION Thoroughly degrease the surface of a copper sheet.

METHOD Taking the necessary safety precautions, add the copper nitrate to 64 fl.oz (2.5l) water, ensuring that it is fully dissolved before use. Make up a liver of sulfur solution by adding the potassium polysulfide to 32 fl.oz (1l) of water, again ensuring that the chemical is fully dissolved. Apply heat evenly with a gas torch over the surface of the copper, and then brush on the copper nitrate solution. Apply heat again until the surface turns black. Brush on more of the copper nitrate solution until the surface turns green—the effect obtained will depend on the amount of copper nitrate applied. Stipple on a light coating of liver of sulfur solution to darken the surface of the green patina. Once the surface has cooled, apply a beeswax and turpentine mixture by following the instructions on page 108.

Hammered green patina 1

Since copper is a relatively soft metal, you can hammer the surface to enhance the patination that is applied.

MATERIALS
- 500g copper nitrate
- 84 fl.oz (2.5l) water
- Gas torch
- Wire wool
- Beeswax
- Turpentine

PREPARATION Repeatedly hit the surface of a copper sheet with a ball-ended hammer to produce an all-over hammered surface. Thoroughly degrease the surface of the copper and rinse off the degreasing agent with water.

METHOD Following the necessary safety precautions, add the copper nitrate to water, ensuring that it is fully dissolved before use. Evenly apply heat with a gas torch over the surface of the copper, and then brush on the copper nitrate solution. Apply heat evenly again until the surface turns black. Brush on more of the copper nitrate solution until the surface turns green—the effect obtained will depend on the amount of copper nitrate applied. Allow this to cool and then rub over the surface with wire wool, which will remove the patina from the raised areas of the surface and reveal the copper. Apply a beeswax and turpentine mixture by following the instructions on page 108.

Hammered green patina 2

In this example, the hammered surface of the copper is used to create an effect that involves the careful application of the patination chemical.

MATERIALS
- 500g copper nitrate
- 84 fl.oz (2.5l) water
- Gas torch
- Beeswax
- Turpentine

PREPARATION Repeatedly hit the surface of a copper sheet with a ball-ended hammer to produce an all-over hammered surface. Thoroughly degrease the surface of the copper before rinsing off the degreasing agent with water.

METHOD Following the necessary safety precautions, add the copper nitrate to water, ensuring that it is fully dissolved before use. Apply heat evenly with a gas torch over the surface of the copper, and then brush on the copper nitrate solution. Apply heat evenly over the surface again until it turns black. Load the brush with copper nitrate solution and lightly brush it over the surface so that only the raised areas are coated. These areas will turn green. Once the surface has thoroughly cooled, apply a beeswax and turpentine mixture by following the instructions on page 108.

Red-brown patina

The red-brown patina obtained here provides a subtle complement to the red-brown coloring of the copper, which still shows through.

MATERIALS
- 50g ferric nitrate
- 1l water
- Gas torch
- Beeswax
- Turpentine

PREPARATION Degrease the surface of a copper sheet and rinse off the degreasing agent with water.

METHOD Taking the necessary safety precautions, add the ferric nitrate to the water, ensuring that the ferric nitrate is fully dissolved before use. Evenly apply heat over the surface of the copper with a gas torch, then brush on the ferric nitrate solution. Apply heat evenly again until the surface turns red-brown to your requirements. Allow the surface to cool before applying a beeswax and turpentine mix following the instructions on page 108.

Dense black patina

The density of the black patination you obtain with this method is dependent on the amount of heat applied to the surface of the sculpture, so the more heat the denser the surface.

MATERIALS
- 500g copper nitrate
- 2.5l water
- Gas torch
- Beeswax
- Turpentine

PREPARATION Thoroughly degrease the surface of a copper sheet and rinse off the degreasing agent with water.

METHOD Following the necessary safety precautions, add the copper nitrate to the water, ensuring that the copper nitrate is fully dissolved before use. Evenly apply heat over the surface of the copper with a gas torch, then brush on the copper nitrate solution. Apply heat again until the surface turns black. Once the surface has cooled, apply a beeswax and turpentine mix following the instructions on page 108.

Inspirational pieces

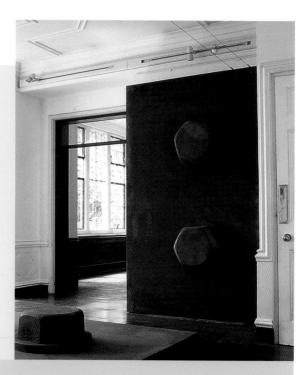

FIXING BLOCKS
RICHARD TRUPP

A simple but striking concept. The massive cast-iron bolt heads are attached to sheet steel and the surfaces have oxidized to a rich brown color, allowing the viewer a close-up experience of the untreated metal surface. This is a site-specific piece. By bringing such large steel constructions, which one might otherwise only experience in the structure of a bridge or ship, into an indoor environment, the power and strength of steel, and specifically the bolt heads and their ability to hold together gigantic forces, become a tangible experience.

COMPOSITION II
ROBERT HAGUE

A wall-mounted steel sculpture that has been shot-blasted, galvanized with molten zinc, and then painted and varnished with artists' acrylic paints to create a rich and subtle surface effect. The composition of colored shapes and lines has the clarity and precision that approaches a visual equivalent of musical composition.

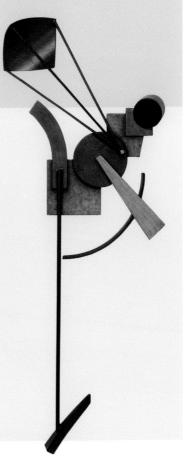

ADAM
GEORGE TKABLADZE

This thin, elongated figure has a monumental quality although only 7 in (18cm) high. The surface of the bronze retains the sensitive modeling done by the hands of the artist in the original wax, and although simplified, the forms capture a recognizable human gesture and expression.

Sleeping Beauty
Janice Trimpe

The bronze in this sculpture has been treated with colored patinas that emphasize its lifelike qualities, the skin tone, and the colors of the cloth and clothing. The blue cloth has been treated very sensitively, allowing the folds to come through as natural bronze color. The smoothly modeled forms of the body contrast with the rough textures of the pillow and bed and provide a quiet background against which the figure stands out.

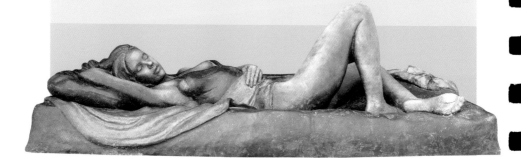

The Great Dominions
Miles Halpin

The steel in this piece has been ground until it becomes hard and brittle and can be cracked to create a lively edge. A round wire brush on a drill is used to create the striped surfaces that

change from light to dark, depending on where you are standing. Mild steel allowed to rust and darker, welded rays add another layer to this richly textured piece. This sculpture shows the wide range of effects that can be achieved with steel when you have an open mind and are willing to experiment with the material and are prepared to use conventional techniques in new ways.

THE ENTERTAINER
JOHN KENNEDY

Full of lively movements while balancing on one leg, this sculpture gives the impression of being about to spring into life, throwing and catching the juggling balls. The surfaces are modeled in the original clay and worked with chasing tools to show the twisting, flowing surfaces that, when cast into bronze, are enhanced by the play of light and shadow. This sculpture is designed to be placed on a rotating base and be seen from many different views.

BEDEVIL
ROBERT HAGUE

First formed and welded together in steel, this piece has been molded in rubber and then cast in silicon bronze. A compact, energetic sculpture, it uses a dynamic interaction of rounded and straight forms—the sphere and the square. The twisting wave-like form creates an energy that then seems to shoot down along the diagonal. The surface is finished with tan boot polish.

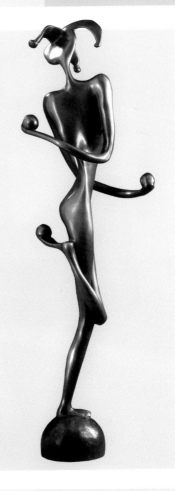

Echo
Ron Wood

The highly polished surface of this bronze piece catches and reflects the light, creating other interesting shapes on the sculpture surface. The rounded, fluid forms are enhanced and highlighted by the light and dark patches. The inner space gives the impression of a mouth or an open sound, while the way that the two forms are obviously the same but mounted so that they are seen from different sides, makes clever use of the sculpture's three-dimensional quality to express the echo theme.

BIAS IX
ROBERT HAGUE

Formed in mild steel and welded together, this piece has then been spray-painted with acrylic lacquer to create a very smooth and shiny surface that gives an industrial, manufactured impression. Clean lines, highlighted with black paint, emphasize the movement and the relationship between the two parts of the sculpture—the diagonal part more active and the upright part, with its large concave surfaces, watching and listening.

THE SHELL
GLENIS DEVEREUX

This lifelike sculpture of a woman holding and contemplating a shell is brought to life by the way the surface is smoothed and polished to create a gentle, liquid sheen. This works beautifully with the beach theme, the stretched bathing costume and smooth hat, and our expectations of a seashore environment.

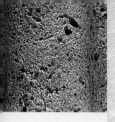

Fired clay

The swatches for this section include a variety of surface effects that can be used when making a clay sculpture that will be fired in a kiln. These effects are primarily suitable for a sculpture that is going to be slab-built, meaning that the effect is created on slabs of clay that are then formed into a sculpture.

The swatches showing additions to the clay body prior to forming the sculpture produce extremely interesting effects. You may find that you get a different effect each time due to the vagaries of the kiln, but the results will not be disappointing. For the examples of surface effects that can be achieved after firing, try experimenting also with the effects in the plaster section of this book (see pages 170-195).

Although the clay used in these swatches is white earthenware clay, the treatments can be used with other types of clay. An important proviso is that the clay has enough structure to support the sculptural form that you are building.

Modeling clay

Small clay sculptures can be modeled without the use of an armature. The modeling process involves pinching the material into the basic form, adding material, and carving detail. The clay used for this technique is a mixture of a white firing clay with a grogged stoneware body for strength, and porcelain to refine and whiten the body.

YOU WILL NEED:

- Clay
- Weighing scales
- Plaster bat
- Hole cutter
- Wooden spatula
- Rubber and metal kidneys
- Thin plastic

- Knife
- Toothbrush
- Wooden modeling tools
- Hair-dryer
- Paper and pencil
- Scissors
- Potter's knife
- Plastic rib
- Potter's pin

1 Weigh out 8oz (225g) of clay, then pinch it into an egg shape. Pierce a hole in one end of the "egg" and, using a wooden spatula, start to paddle the basic shape of the sculpture. For this bird, the clay was paddled into a body with five sides: the base; the side walls, narrowing up from the base to form a backbone ridge across the top; and two "V"-shaped ends, with the head slightly lower than the tail.

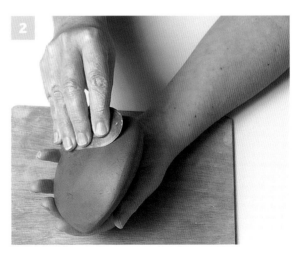

2 When the shape is formed, fill the hole with soft clay and smooth the body with a rubber kidney.

3 Put the body to one side on a sheet of thin plastic. Pinch out the appendages from more pieces of clay. In this case, the bird's head was formed from a tiny ball of clay, which was first made into a cup shape, then paddled to make a ridge that follows the line of the bird's back.

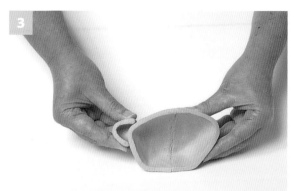

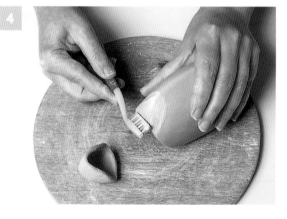

4 When the addition is the right shape, hold it against the main clay body at various angles to find the best position. While the piece is against the body, mark the spot where it will be attached by lightly scoring with a knife around the smaller piece onto the body. Remove the addition and score into its rim. Dip a toothbrush in water and brush this over the marked area on the body to form slip, a watery clay. Do the same with the rim of the addition.

5 Fit the addition onto the body, keeping the ridges in line. Roll a thin, soft coil of clay and secure it around the joint, then blend it into both the head and the body using a wooden modeling tool. Neaten the joint with a metal kidney, and then smooth the area over with a rubber kidney. Support the underside of the addition while the top is modeled, and hold the body securely to prevent distorting the shape.

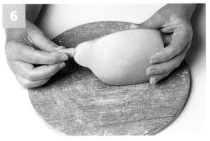

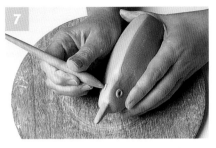

6 Model a small amount of clay into a beak shape and mark its position on the head. Score and slip the beak and the head, then fix the beak into place. Use a minute coil of soft clay to cover the joint of the beak to the head, and blend it in well with a wooden modeling tool. Smooth around the area with extreme care, using your finger.

7 Firm up the clay a little, using a hair-dryer, to prevent any distortion when handling. Take care not to overdry the beak—because it is thin it will dry faster than the rest of the body. To make eyes, roll two minute balls of clay and use a little slip to fix them in place on either side of the head. Flatten the eyes slightly, then use a modeling tool or pencil to create a hollow in the center of each one.

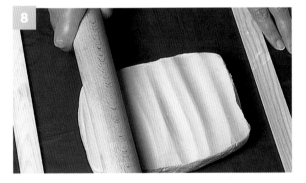

8 Slabbing is another technique for making appendages. Place a slab of clay on some thin plastic and use a rolling pin to roll it to the same thickness as the pinched sections. Lift the clay away from the plastic and place it on the absorbent plaster bat. Leave the slab to become almost leather-hard—where it still has some flexibility but will maintain its shape when held upright.

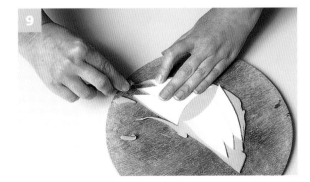

9 On a sheet of paper, draw a template for the slabbed addition, (in this case wing feathers), checking that the proportions are accurate for the size of the body. Cut out the templates. Position them on the slab and cut carefully around the shapes with a potter's knife.

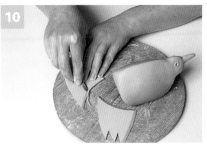

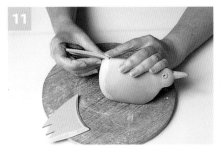

10 Miter the slab sections along the shorter, upper edge by holding the knife at an acute angle to allow them to fit around the shape of the body. Keep the point on the work surface and cut the clay, taking care to avoid the fingers that are holding the slab in place on the bat. Check that the mitered edges fit correctly where they join the body.

11 Hold the slab sections against the body and mark their positions with the knife. Score and slip the marked positions and the mitered edges. Then fix them in place on the body, gently squeezing out any excess slip and trapped air in the process. Pinch the upper ridge edges together, again squeezing out any excess slip and air. Run your finger along the joint to soften the edge in keeping with the rest of the body.

12 Reinforce the joints on the outside of the body with a thin coil of soft clay. Blend the coil in well, using a wooden modeling tool, then smooth over the area with a metal kidney. Remove any unsightly ridges along the joint and smooth over the area with a rubber kidney.

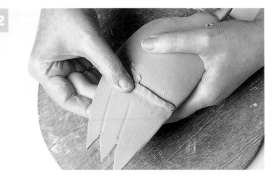

13 Turn the piece over and, holding it securely in your hand, reinforce the underside joints with a soft coil of clay. Ease the coil into place with your finger, being careful not to part the joints. Use a wooden tool to blend the coil into the awkward angles. Scrape away any surplus clay with the same tool, then smooth over the joints with your finger.

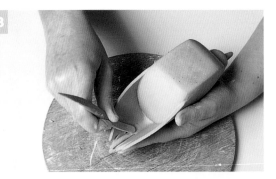

14 Use a small plastic rib or modeling tool to carve the details. Score two lines from the body along the tail to mark the space between the feathers. Carve the clay from underneath each line to make a slight groove. Support the feathers on the underside, while you carve the details, to prevent the slabs from distorting.

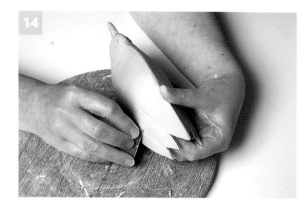

15 Pierce a hole in each eye with a potter's pin to allow the release of air from the head during firing. Also make a discreet hole in the main body (because this is a separate cavity). All pinched additions must be pierced separately, unless there is a hole between the addition and the main part, because trapped air can cause explosions.

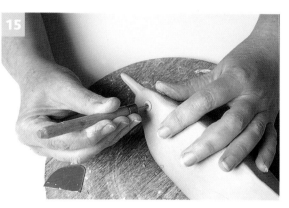

16 The sculpture can now be decorated and fired.

FIRED CLAY

The following samples show effects produced by surface textures, additions to the clay body, and treatments after firing.

PREPARATION Wedging clay prior to forming a sculpture is an essential prerequisite for any clay work that will be fired in a kiln. It will ensure the even distribution of the moisture content and expel any air pockets. Once the clay has been thoroughly wedged, you can be confident that it will survive the firing process without incurring any damage. This procedure is necessary for whatever type of clay is chosen to use to make the sculpture.

METHOD Roll out the clay to a ½ in (1.5cm) thickness and cut into slabs of 4 x 2-½ in (10 x 6cm), or a size to suit your needs. Store the slabs under polyethylene until required. Once the sculpture has been formed, leave it to dry out, then fire in a kiln to 1832°F (1000°C).

Sandpaper

You can use any grade of sandpaper for this technique; the coarser the grade, the rougher the surface of the clay will be.

MATERIAL
- **4 x 4 in (10 x 10cm) sheet of P60 sandpaper**

PREPARATION After wedging the clay, roll it out to a thickness of ½ in (1.5cm) and cut it into slabs of 4 x 2-½ in (10 x 6cm), or a size to suit your needs.

METHOD Take the sheet of sandpaper and place it, rough side down, on a slab of clay. Gently press it onto the surface. Carefully lift the sandpaper up and away from the clay, revealing the textured surface. Store the clay under polyethylene with the textured surface face up until required. When the sculpture has been formed, leave it to dry out, and then fire in a kiln to 1832°F (1000°C).

Pan scrubber

An alternative to this technique is to use other abrasive cleaning implements, or try using textured sponges.

MATERIAL
- **Pan scrubber**

PREPARATION Wedge the clay and roll it out to a thickness of ½ in (1.5cm). Cut it into 4 x 2-½ in (10 x 6cm) slabs, or a size to suit your needs.

METHOD Place a pan scrubber on a slab of clay and gently press it onto the surface. Carefully lift the pan scrubber up and away from the clay, revealing the textured surface. Store the clay under polyethylene with the textured surface face up until required. Once the sculpture has been formed, leave it to dry, and then fire in a kiln to 1832°F (1000°C).

Copper wire

For this effect, you can use any type of wire and experiment with different thicknesses of wire. You can even try mixing them together.

MATERIAL
• Copper wire

PREPARATION After wedging the clay, roll it out to a thickness of ½ in (1.5cm) and cut it into slabs of 4 x 2-½ in (10 x 6cm), or a size to suit your needs.

METHOD Place lengths of copper wire on a slab of clay and gently press them onto the surface. Carefully lift the copper wire away from the clay to reveal the textured surface. Store the clay under polyethylene, keeping the textured surface face up until required. Once the sculpture has been formed, leave it to dry out, and then fire in a kiln to 1832°F (1000°C).

String

There are many different sizes and grades of string, twine, and rope, each of which has the potential to give a variety of interesting textures.

MATERIAL
• String

PREPARATION Wedge the clay and roll it out to a thickness of ½ in (1.5cm). Cut it into 4 x 2-½ in (10 x 6cm) slabs, or a size to suit your requirements.

METHOD Place lengths of string on a slab of clay and gently press them onto the surface. Carefully lift the strings up and away from the clay, revealing the textured surface. Store the clay under polyethylene with the textured surface face up until required. Once the sculpture has been formed, leave it to dry, and then fire in a kiln to 1832°F (1000°C).

Wire wool

An alternative to this technique would be to use a ball of knitting yarn.

MATERIAL
• Wire wool

PREPARATION Wedge the clay and roll it out to a thickness of ½ in (1.5cm). Cut it into slabs of 4 x 2-½ in (10 x 6cm), or a size to suit your needs.

METHOD Place a handful of wire wool on a slab of clay and gently press it onto the surface. Carefully lift the wire wool away from the clay, revealing the textured surface. Store the clay under polyethylene, keeping the textured surface face up until required. Once the sculpture has been formed, leave it to dry out, and then fire in a kiln to 1832°F (1000°C).

Long bristle brush

For similar effects, you can use the bristles from a wide variety of brushes, such as nailbrushes, toothbrushes, and hairbrushes.

MATERIAL
• Long bristle brush

PREPARATION After wedging the clay, roll it out to a thickness of ¹/₂ in (1.5cm) and cut it into slabs of 4 x 2-¹/₂ in (10 x 6cm), or a size to suit your needs.

METHOD Position a long bristle brush on a slab of clay and gently press it onto the surface. Carefully lift the brush up to reveal the textured surface. Store the clay under polyethylene with the textured surface face up until required. When the sculpture has been formed, leave it to dry out, and then fire in a kiln to 1832°F (1000°C).

Scrubbing brush bristles

Tying twigs and small brushes into bundles will provide an alternative method of creating interesting surface textures.

MATERIAL
• Scrubbing brush

PREPARATION Wedge the clay and roll it out to a thickness of ¹/₂ in (1.5cm). Cut it into slabs of 4 x 2-¹/₂ in (10 x 6cm), or a size to suit your needs.

METHOD Take a scrubbing brush and place it, bristles down, on a slab of clay. Gently press the bristles onto the surface of the clay. Carefully lift the scrubbing brush away from the clay, revealing the textured surface. Store under polyethylene, keeping the textured surface face up, until required. Once the sculpture is formed, leave to dry out, and then fire in a kiln to 1832°F (1000°C).

Open-weave dishcloth

For this effect you can use any open-weave fabric or knitwear.

MATERIAL
• **Open-weave dishcloth**

PREPARATION Wedge the clay and roll it out to a thickness of ¹/₂ in (1.5cm). Cut it into 4 x 2-¹/₂ in (10 x 6cm) slabs, or a size to suit your requirements.

METHOD Place an open-weave dishcloth on a slab of clay and gently press it onto the surface. Carefully lift the cloth up and away from the clay, revealing the textured surface. Store the clay under polyethylene with the textured surface face up until required. Once the sculpture has been formed, leave it to dry out, and then fire in a kiln to 1832°F (1000°C).

Paper towel

Paper towels can now be found with a variety of distinctive and interesting textures that can be used on clay.

MATERIAL
• Paper towel

PREPARATION After wedging the clay, roll it out to a thickness of ½ in (1.5cm) and cut it into slabs of 4 x 2-½ in (10 x 6cm), or a size to suit your needs.

METHOD Take a sheet of paper towel and place it on a slab of clay. Gently press the paper onto the surface. Carefully lift the paper towel up and away from the clay to reveal the textured surface. Store the clay under polyethylene, keeping the textured surface face up, until required. Once the sculpture has been formed, leave it to dry out, and then fire in a kiln to 1832°F (1000°C).

Cheesecloth

Cheesecloth or any lightly woven fabric, or an old item of clothing, can make interesting impressions of fabric weaves.

MATERIAL
• 6 x 6 in (15 x 15cm) piece of cheesecloth

PREPARATION Wedge the clay and roll it out to a thickness of about ½ in (1.5cm). Cut it into 4 x 2-½ in (10 x 6cm) slabs, or a size to suit your needs.

METHOD Place a cheesecloth square on a slab of clay and gently press it onto the surface. Carefully lift the cheesecloth away from the clay, revealing the textured surface. Store the clay under polyethylene with the textured surface face up, until required. Once the sculpture has been formed, leave it to dry out, and then fire in a kiln to 1832°F (1000°C).

Bubble wrap

Bubble wrap is available in many different designs, each with a different size of bubble, so there is plenty of scope for experimentation here.

MATERIAL
• Bubble wrap

PREPARATION Wedge the clay and roll it out to a thickness of ½ in (1.5cm). Cut it into slabs of 4 x 2-½ in (10 x 6cm), or a size to suit your needs.

METHOD Position a sheet of bubble wrap on a slab of clay and gently press it onto the surface. Carefully lift the bubble wrap up and away from the clay to reveal the textured surface. Store the clay under polyethylene, keeping the textured surface face up, until required. Once the sculpture is formed, leave it to dry, and then fire in a kiln to 1832°F (1000°C).

Scrunched polyethylene

This technique allows you to create an interesting surface that is entirely dependent on chance, so you will get a different effect each time.

MATERIAL
• **Polyethylene bag**

PREPARATION Wedge the clay and roll it out to a thickness of ½ in (1.5cm). Cut it into slabs of 4 x 2-½ in (10 x 6cm), or a size to suit your needs.

METHOD Take a polyethylene bag and scrunch it up. Place it on the slab of clay and gently press it onto the surface. Lift the bag away from the clay, revealing the textured surface. Store the clay under polyethylene with the textured surface face up, until required. Once the sculpture has been formed, leave it to dry out, and then fire in a kiln to 1832°F (1000°C).

Sink plug chain

The list of types of chain is endless; bicycle, necklace, bracelet, padlock, security. Make full use of this variety to produce a range of interesting surfaces incorporated in one sculpture.

MATERIAL
• **Sink plug chain**

PREPARATION Wedge the clay and roll it out to a thickness of ½ in (1.5cm). Cut it into 4 x 2-½ in (10 x 6cm) slabs, or a size to suit your requirements.

METHOD Place a sink plug chain on a slab of clay and gently press it onto the surface. Lift the chain away from the clay to reveal the texture. Repeat this procedure until the surface is covered with the desired texture. Store the clay under polyethylene with the textured surface face up, until required. Once the sculpture is formed, leave it to dry, and then fire in a kiln to 1832°F (1000°C).

Cog

With the advent of the digital age, now is the time to dismantle those old clocks and extricate the variety of cogs.

MATERIAL
• **Cogwheel**

PREPARATION After wedging the clay, roll it out to a thickness of ½ in (1.5cm) and cut it into slabs of 4 x 2-½ in (10 x 6cm), or a size to suit your needs.

METHOD Position a cogwheel on a slab of clay and gently press it onto the surface. Carefully lift the cogwheel up and away from the clay. Repeat this procedure until the surface is covered with the desired texture. Store the clay under polyethylene, keeping the textured surface face up, until required. When the sculpture has been formed, leave it to dry out, and then fire in a kiln to 1832°F (1000°C).

Metal kidney

The different sizes of metal kidney tools in your studio can be put to a use other than smoothing a surface.

MATERIAL
• **Metal kidney**

PREPARATION Wedge the clay and roll it out to a thickness of roughly ½ in (1.5cm). Cut it into 4 x 2-½ in (10 x 6cm) slabs, or a size to suit your requirements.

METHOD Take a metal kidney and place its side on a slab of clay. Gently press it onto the surface of the clay. Carefully lift the metal kidney up and away from the clay. Repeat this procedure until the surface is covered with the desired texture. Store the clay under polyethylene, keeping the textured surface face up, until required. Once the sculpture is formed, leave it to dry, and then fire in a kiln to 1832°F (1000°C).

Saw blade

Old hacksaw and bandsaw blades are suitable for use here.

MATERIAL
• **Saw blade**

PREPARATION After wedging the clay, roll it out to a thickness of ½ in (1.5cm) and cut it into slabs of 4 x 2-½ in (10 x 6cm), or a size to suit your needs. Cut the saw blade into 4 in (10cm) lengths.

METHOD Drag a length of saw blade across the surface of a slab of clay and gently press onto it. Repeat this procedure until the surface is covered with the desired texture. Store the clay under polyethylene, keeping the textured surface face up, until required. When the sculpture has been formed, leave it to dry out, and then fire in a kiln to 1832°F (1000°C).

Grater

As well as using the different sizes and types of grater, you can also use pastry cutters and decorating tools.

MATERIAL
• **Cheese grater**

PREPARATION Wedge the clay and roll it out to a thickness of ½ in (1.5cm). Cut it into roughly 4 x 2-½ in (10 x 6cm) slabs, or a size to suit your needs.

METHOD Take a cheese grater and place it on a slab of clay. Gently press it onto the surface of the clay. Carefully lift the cheese grater up and away from the clay, revealing the textured surface. Store the clay under polyethylene with the textured surface face up until required. Once the sculpture has been formed, leave it to dry, and then fire in a kiln to 1832°F (1000°C).

Metal grid

Rather than struggle with a large sheet, cut a manageable size from the sheet beforehand. Consider trying the various types of chain link fencing available.

MATERIAL
• Metal grid

PREPARATION Wedge the clay and roll it out to a thickness of ½ in (1.5cm). Cut it into slabs of 4 x 2-½ in (10 x 6cm), or a size to suit your needs.

METHOD Place a piece of metal grid on a slab of clay and gently press it onto the surface. Carefully lift the metal grid up and away from the clay to reveal the textured surface. Store the clay under polyethylene with the textured surface face up, until required. Once the sculpture has been formed, leave it to dry out, and then fire in a kiln to 1832°F (1000°C).

Aluminum tread plate

Although these tread plates usually have a standard pattern, it is possible to find variations of this norm.

MATERIALS
• Aluminum tread plate
• Vegetable oil

PREPARATION After wedging the clay, roll it out to a thickness of ½ in (1.5cm). Cut it into slabs of 4 x 2-½ in (10 x 6cm), or a size to suit your needs.

METHOD Lightly rub over the aluminum tread plate with vegetable oil to ease the removal of the clay slab. Place a slab of clay on the surface of the aluminum tread plate. Use a roller to apply a gentle and even pressure over the surface of the slab. Taking one end of the slab, immediately peel it from the tread plate. Store the clay under polyethylene, keeping the textured surface face up, until required. When the sculpture has been formed, leave it to dry out, and then fire in a kiln to 1832°F (1000°C).

Decorative glass

There are a wide variety of decorative glass designs available. It is worth asking a glass merchant for any offcuts of this type of glass.

MATERIALS
• Decorative glass pane
• Vegetable oil

PREPARATION Wedge the clay and roll it out to a thickness of ½ in (1.5cm). Cut it into roughly 4 x 2-½ in (10 x 6cm) slabs, or a size to suit your requirements.

METHOD Lightly rub over the glass pane with vegetable oil to ease the removal of the clay slab. Place a slab on the surface of the glass. Use a roller to apply gentle and even pressure over the surface of the slab. Taking one end of the slab, immediately peel it from the glass. Store the clay under polyethylene with the textured surface face up until required. Once the sculpture has been formed, leave it to dry out, and then fire in a kiln to 1832°F (1000°C).

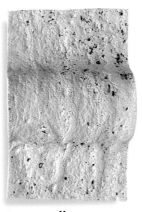

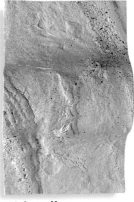

Pebble dash

A pebble-dash effect can be created by pouring plaster into a 6 x 6 in (15 x 15cm) mold. Embed small pebbles into the plaster just before it is about to go off, ensuring that the pebbles protrude above the surface.

MATERIAL
• Pebble-dash wall or homemade pebble dash

PREPARATION Wedge the clay and roll it out to a thickness of $\frac{1}{2}$ in (1.5cm). Cut it into 4 x 2-$\frac{1}{2}$ in (10 x 6cm) slabs, or a size to suit your requirements.

METHOD Place a slab of clay on the pebble-dash surface. Gently push the clay down and apply an even pressure over the surface of the slab. Take one end of the slab and immediately peel it from the pebble dash. Store the clay under polyethylene, keeping the textured surface face up, until required. Once the sculpture is formed, leave it to dry, and then fire in a kiln to 1832°F (1000°C).

Stone wall

A very credible stone-wall effect can be created by laying a variety of stones on your workbench. Arranged to your design, this will enable you to create a variety of textures from the same source.

MATERIAL
• Stone wall or stone-wall effect

PREPARATION Wedge the clay and roll it out to a thickness of $\frac{1}{2}$ in (1.5cm). Cut it into roughly 4 x 2-$\frac{1}{2}$ in (10 x 6cm) slabs, or a size to suit your needs.

METHOD Place a slab of clay on the stone wall or similar surface. Gently push the clay down and apply an even pressure over the surface of the slab. Taking one end of the slab, immediately peel it from the stone surface. Store the clay under polyethylene with the textured surface face up, until required. Once the sculpture has been formed, leave it to dry, and then fire in a kiln to 1832°F (1000°C).

Brick wall

You can create your own brick wall with different types of bricks by arranging them in the configuration of a wall on your workbench.

MATERIAL
• Brick wall or brick-wall effect

PREPARATION After wedging the clay, roll it out to a thickness of $\frac{1}{2}$ in (1.5cm). Cut it into slabs of 4 x 2-$\frac{1}{2}$ in (10 x 6cm), or a size to suit your needs.

METHOD Position a slab of clay on a brick wall or simulated effect. Gently push the clay down and apply an even pressure over the surface of the slab. Take one end of the slab and immediately peel it away from the brick. Store the clay under polyethylene with the textured surface face up, until required. Once the sculpture has been formed, leave it to dry, and then fire in a kiln to 1832°F (1000°C).

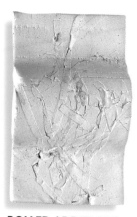

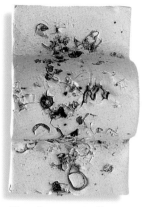

ROLLED ADDITIONS

These following additions are rolled onto the clay. Extra care should always be taken when firing these swatches in the kiln as fumes may be produced.

Shredded paper

A good source of shredded paper is your local recycling facility or a large office complex.

MATERIAL
• Shredded paper

PREPARATION After wedging the clay, roll it out to a thickness of ½ in (1.5cm). Cut it into slabs of 4 x 2-½ in (10 x 6cm), or a size to suit your needs.

METHOD Sprinkle shredded paper over the surface of a slab of clay, and then go over it with a roller, ensuring that the paper is embedded into the clay. Once the sculpture has been formed, leave it to dry out, and then fire in a kiln to 2102°F (1150°C).

Wire wool

Wire wool is available in various grades, each of which will give a slight variation of the effect obtained here.

MATERIAL
• Wire wool

PREPARATION Wedge the clay and roll it out to a thickness of ½ in (1.5cm). Cut it into roughly 4 x 2-½ in (10 x 6cm) slabs, or a size to suit your requirements.

METHOD Position balls of wire wool on the surface of a slab of clay and work over them with a roller, ensuring that the wire wool is embedded into the clay. When the sculpture has been formed, leave it to dry out, and then fire in a kiln to 2102°F (1150°C).

Aluminum grindings

A local engineering firm will be a useful source for this material. Always wear protective gloves when handling metal grindings.

MATERIAL
• Aluminum grindings

PREPARATION Wedge the clay and roll it out to a thickness of ½ in (1.5cm). Cut it into slabs of 4 x 2-½ in (10 x 6cm), or a size to suit your needs.

METHOD Sprinkle the aluminum grindings over the surface of a slab of clay, then go over them with a roller, ensuring that the aluminum grindings are embedded in the clay. Once the sculpture has been formed, leave it to dry out, and then fire in a kiln to 2102°F (1150°C).

Copper wire

Try using other types of wire, such as galvanized binding wire, fuse wire, or even soldering wire.

MATERIAL
• Copper wire

PREPARATION Wedge the clay and roll it out to a thickness of ½ in (1.5cm). Cut it into 4 x 2-½ in (10 x 6cm) slabs, or a size to suit your requirements.

METHOD Place lengths of copper wire on the surface of a slab of clay, then go over it with a roller, ensuring that the wire is embedded into the surface of the clay. Once the sculpture is formed, allow it to dry out, and then fire in a kiln to 2102°F (1150°C).

Sharp sand

Always dry out the sand first before you add it to the clay. Do this by spreading it out on a tray and leaving it out in the sun until the moisture has evaporated.

MATERIAL
• Sharp sand

PREPARATION After wedging the clay, roll it out to a thickness of ½ in (1.5cm). Cut it into slabs of 4 x 2-½ in (10 x 6cm), or a size to suit your needs.

METHOD Sprinkle sharp sand over the surface of a slab of clay and go over it with a roller, ensuring that the sharp sand is embedded into the clay. Once the sculpture has been formed, allow it to dry out, and then fire in a kiln to 2102°F (1150°C).

Small pebbles

Wash the pebbles before use to get rid of any impurities, then spread them out on a tray and leave them to dry in the sun.

MATERIAL
• Small pebbles

PREPARATION Wedge the clay and roll it out to a thickness of ½ in (1.5cm). Cut it into roughly 4 x 2-½ in (10 x 6cm) slabs, or a size to suit your needs.

METHOD Place small pebbles on the surface of a slab of clay and work over them with a roller, ensuring that the pebbles are embedded in the clay. Once the sculpture has been formed, leave it to dry out, and then fire in a kiln to 2102°F (1150°C).

Clear glass granules

Glass granules are a specialist product that you will be able to obtain from your local pottery suppliers.

MATERIAL
• **Clear glass granules**

PREPARATION Wedge the clay and roll it out to a thickness of ½ in (1.5cm). Cut it into 4 x 2-½ in (10 x 6cm) slabs, or a size to suit your requirements.

METHOD Sprinkle clear glass granules over the surface of a slab of clay, then go over them with a roller, ensuring that the granules are embedded into the clay. Once the sculpture has been formed, allow it to dry out, and then fire in a kiln to 2102°F (1150°C).

Clear glass shards

Glass shards made by smashing a clean bottle make an interesting clay addition.

MATERIAL
• **Clear glass bottle**

PREPARATION Wedge the clay and roll it out to a thickness of ½ in (1.5cm). Cut it into slabs of 4 x 2-½ in (10 x 6cm), or a size to suit your needs. Wearing gloves, place an empty clear glass bottle in a plastic sack. Close the sack and hit the bottle with a hammer until it is smashed into small pieces.

METHOD Place the clear glass shards on the surface of a slab of clay and go over it with a roller, ensuring that the glass shards are embedded into the surface of the clay. Once the sculpture has been formed, leave it to dry out, and then fire in a kiln to 2102°F (1150°C).

Oak shavings

Your local lumberyard or carpentry works are an excellent source of a variety of different types of wood shavings.

MATERIAL
• **Oak shavings**

PREPARATION After wedging the clay, roll it out to a thickness of ½ in (1.5cm). Cut it into slabs of 4 x 2-½ in (10 x 6cm), or a size to suit your needs.

METHOD Sprinkle oak shavings on top of a slab of clay and go over it with a roller, ensuring that the shavings are embedded into the surface of the clay. Once the sculpture is formed, leave it to dry, and then fire in a kiln to 2102°F (1150°C).

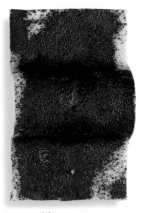

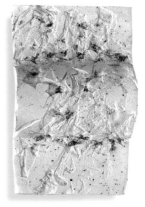

Paper pulp

This is a commercially available product especially produced for adding to clay. An alternative would be to produce your own by tearing up newsprint into small pieces and leaving it to soak in water. Once it has disintegrated, squeeze the water from the pulp and allow it to dry out thoroughly before using.

MATERIAL
• Paper pulp

PREPARATION Wedge the clay and roll it out to a thickness of $\frac{1}{2}$ in (1.5cm). Cut it into slabs of 4 x 2-$\frac{1}{2}$ in (10 x 6cm), or a size to suit your needs.

METHOD Place the paper pulp on top of a slab of clay and go over it with a roller, ensuring that the pulp is embedded into the surface of the clay. Once the sculpture is formed, allow it to dry, and then fire in a kiln to 2102°F (1150°C).

Brass filings

Also consider using bronze, copper, iron, or aluminum filings or fillers. These can be obtained from specialist sculpture material suppliers.

MATERIAL
• Brass filings

PREPARATION After wedging the clay, roll it out to a thickness of $\frac{1}{2}$ in (1.5cm). Cut it into slabs of 4 x 2-$\frac{1}{2}$ in (10 x 6cm), or a size to suit your needs.

METHOD Sprinkle brass filings over the surface of a slab of clay and go over them with a roller, ensuring that the brass filings are embedded into the clay. Once the sculpture has been formed, leave it to dry out, and then fire in a kiln to 2102°F (1150°C).

Pantyhose

You can also use other items of clothing made from fine fabrics.

MATERIAL
• Pantyhose

PREPARATION Wedge the clay and roll it out to a thickness of about $\frac{1}{2}$ in (1.5cm). Cut it into 4 x 2-$\frac{1}{2}$ in (10 x 6cm) slabs, or a size to suit your needs. Cut the pantyhose into 1 x 1-$\frac{1}{2}$ in (2.5 x 4cm) strips.

METHOD Place the pieces of pantyhose on top of a slab of clay and go over them with a roller, ensuring that the pieces are embedded into the surface of the clay. When the sculpture has been formed, leave it to dry out, and then fire in a kiln to 2102°F (1150°C).

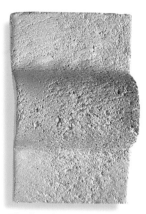

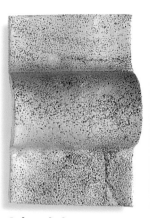

Firebrick

An old firebrick from the kiln is put to further use here.

MATERIAL
• Firebrick

PREPARATION Wedge the clay and roll it out to a thickness of about ½ in (1.5cm). Cut it into 4 x 2-½ in (10 x 6cm) slabs, or a size to suit your needs. Place a firebrick in a plastic sack or bag and use a hammer to crush it.

METHOD Place the crushed firebrick on top of a slab of clay and go over it with a roller, ensuring that the crushed firebrick is embedded into the surface of the clay. Once the sculpture has been formed, leave it to dry out, and then fire in a kiln to 2102°F (1150°C).

Colored glass granules

Glass granules in a range of colors are available from specialist craft suppliers for artists working in glass.

MATERIAL
• Colored glass granules

PREPARATION After wedging the clay, roll it out to a thickness of ½ in (1.5cm). Cut it into slabs of 4 x 2-½ in (10 x 6cm), or a size to suit your needs.

METHOD Sprinkle colored glass granules over the surface of a slab of clay, then work over them with a roller, ensuring that the glass granules are embedded into the clay. Once the sculpture has been formed, allow it to dry out, and then fire in a kiln to 2102°F (1150°C).

String

String, twine, and rope are available in many differing textures, and some are also colored, so you can create a wealth of effects.

MATERIAL
• String

PREPARATION Wedge the clay and roll it out to a thickness of ½ in (1.5cm). Cut it into slabs of 4 x 2-½ in (10 x 6cm), or a size to suit your needs. Cut the string into 1 in (2.5cm) lengths.

METHOD Place the lengths of string on top of a slab of clay and go over them with a roller, ensuring that the lengths are embedded into the surface of the clay. Once the sculpture has been formed, allow it to dry out, and then fire in a kiln to 2102°F (1150°C).

Polystyrene

This packaging material comes in all shapes and sizes, and it can be easily broken down to the size required.

MATERIAL
• **Small pieces of polystyrene**

PREPARATION After wedging the clay, roll it out to a thickness of ½ in (1.5cm). Cut it into slabs of 4 x 2-½ in (10 x 6cm), or a size to suit your needs.

METHOD Place small pieces of polystyrene on top of a slab of clay and go over them with a roller, making sure the pieces are embedded into the surface of the clay. When the sculpture has been formed, leave it to dry out, and then fire in a kiln to 2102°F (1150°C).

Tin mesh

You will find a variety of different types of meshes in hardware and gardening stores, giving you a wide palette of potential effects to work from.

MATERIAL
• **Tin mesh**

PREPARATION Wedge the clay and roll it out to a thickness of ½ in (1.5cm). Cut it into roughly 4 x 2-½ in (10 x 6cm) slabs, or a size to suit your requirements.

METHOD Place some tin mesh on the surface of a slab of clay and go over it with a roller, ensuring that the tin mesh is embedded into the clay. Once the sculpture has been formed, leave it to dry, and then fire in a kiln to 2102°F (1150°C).

Soil

Allow the soil to dry out as much as possible before using it, and ensure that it is cleared of large stones and other impurities.

MATERIAL
• **Soil**

PREPARATION Wedge the clay and roll it out to a thickness of ½ in (1.5cm). Cut it into slabs of 4 x 2-½ in (10 x 6cm), or a size to suit your needs.

METHOD Sprinkle some soil over the surface of a slab of clay and work over it with a roller, ensuring that the soil is embedded into the clay. Once the sculpture has been formed, leave it to dry out, and then fire in a kiln to 2102°F (1150°C).

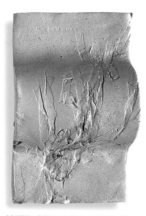

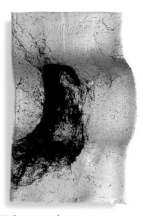

WEDGED ADDITIONS

These additions are wedged into the clay body before firing. See page 140 for safety note.

Shredded paper

You can find plenty of paper to shred at your local recycling facility or from a large office complex.

MATERIAL
• Shredded paper

PREPARATION Thoroughly wedge the clay.

METHOD Take a lump of clay and roll it out to a thickness of 1 in (2.5cm). Evenly distribute shredded paper over the surface of the clay. Lift up one end of the slab and fold it back on itself. Proceed to wedge the clay until the shredded paper is evenly distributed. Roll out the clay again to a $\frac{1}{2}$ in (1.5cm) thickness and cut it into slabs of 4 x 2-$\frac{1}{2}$ in (10 x 6cm), or a size to suit your needs. Once the sculpture has been formed, leave it to dry out, and then fire in a kiln to 2102°F (1150°C).

Wire wool

The varying grades of wire wool allow you to make variations to the effect obtained here.

MATERIAL
• Wire wool

PREPARATION Thoroughly wedge the clay.

METHOD Take a lump of clay and roll it out to a thickness of 1 in (2.5cm). Evenly distribute the wire wool over the surface of the clay. Lift up one end of the slab and fold it back on itself, then continue to wedge the clay until the wire wool is evenly distributed. Roll out the clay again, to a $\frac{1}{2}$ in (1.5cm) thickness, and cut it into slabs of 4 x 2$\frac{1}{2}$ in (10 x 6cm), or a size to suit your needs. Once the sculpture has been formed, leave it to dry out, and then fire in a kiln to 2102°F (1150°C).

Aluminum grindings

Always wear protective gloves when handling aluminum grindings, which can be sourced from a local engineering company.

MATERIAL
• **Aluminum grindings**

PREPARATION Thoroughly wedge the clay.

METHOD Take a lump of clay and roll it out to a thickness of 1 in (2.5cm). Evenly distribute aluminum grindings over the surface of the clay. Lift up one end of the slab and fold it back on itself, then wedge the clay until the aluminum grindings are evenly distributed. Roll out the clay again, to a $\frac{1}{2}$ in (1.5cm) thickness, and cut it into slabs of 4 x 2$\frac{1}{2}$ in (10 x 6cm), or a size to suit your needs. Once the sculpture has been formed, leave it to dry out, and then fire in a kiln to 2102°F (1150°C).

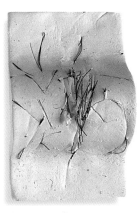

Copper wire

As well as copper wire, you could add galvanized binding wire, fuse wire, or even soldering wire to your clay.

MATERIAL
• Copper wire

PREPARATION Thoroughly wedge the clay and cut the copper wire into 1 in (2.5cm) lengths.

METHOD Take a lump of clay and roll it out to a thickness of 1 in (2.5cm). Evenly distribute the lengths of copper wire over the surface of the clay. Lift up one end of the slab and fold it back on itself, then wedge the clay until the lengths of wire are evenly distributed. Roll out the clay again, to a ½ in (1.5cm) thickness, and cut it into slabs of 4 x 2½ in (10 x 6cm), or a size to suit your needs. Once the sculpture has been formed, leave it to dry out, and then fire in a kiln to 2102°F (1150°C).

Sharp sand

Dry out the sand before you add it to the clay by spreading it out on a tray and leaving it in the sun until the moisture has evaporated.

MATERIAL
• Sharp sand

PREPARATION Thoroughly wedge the clay.

METHOD Take a lump of clay and roll it out to a thickness of 1 in (2.5cm). Evenly distribute the sharp sand over the surface of the clay. Lift up one end of the slab and fold it back on itself. Continue to wedge the clay until the sharp sand is evenly distributed. Roll out the clay again to a thickness of ½ in (1.5cm) and cut it into slabs of 4 x 2-½ in (10 x 6cm), or a size that suits your requirements. Once the sculpture has been formed, leave it to dry, and then fire in a kiln to 2102°F (1150°C).

Small pebbles

To get rid of any impurities, always wash the pebbles before use, and then spread them out on a tray and leave them to dry in the sun.

MATERIAL
• Small pebbles

PREPARATION Thoroughly wedge the clay.

METHOD Take a lump of clay and roll it out to a thickness of 1 in (2.5cm). Evenly distribute small pebbles over the surface of the clay. Lift up one end of the slab and fold it back on itself, then wedge the clay until the pebbles are evenly distributed. Roll out the clay again, to a ½ in (1.5cm) thickness, and cut it into slabs of 4 x 2½ in (10 x 6cm), or a size to suit your needs. Once the sculpture has been formed, leave it to dry out, and then fire in a kiln to 2102°F (1150°C).

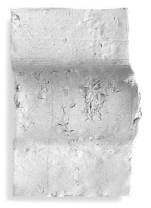

Clear glass granules

These clear glass granules are a specialist product that you may obtain from your local pottery supplier.

MATERIAL
• **Clear glass granules**

PREPARATION Thoroughly wedge the clay.

METHOD Take a lump of clay and roll it out to a thickness of 1 in (2.5cm). Evenly distribute the clear glass granules over the surface of the clay. Lift up one end of the slab and fold it back on itself. Proceed to wedge the clay until the glass granules are evenly distributed. Roll out the clay again, to a $\frac{1}{2}$ in (1.5cm) thickness, and cut it into slabs of 4 x 2½ in (10 x 6cm), or a size to suit your needs. Once the sculpture has been formed, leave it to dry out, and then fire in a kiln to 2102°F (1150°C).

Clear glass shards

Carefully smashing a clear, clean glass bottle provides you with shards that can be wedged into a clay slab.

MATERIAL
• **Clear glass bottle**

PREPARATION Thoroughly wedge the clay. Wearing gloves, place an empty clear glass bottle in a plastic bag. Close the bag and hit the bottle with a hammer until it is smashed into small pieces.

METHOD Take a lump of clay and roll it out to a thickness of 1 in (2.5cm). Evenly distribute the clear glass shards over the surface of the clay. Lift up one end of the slab and fold it back on itself, then wedge the clay until the glass shards are evenly distributed. Roll out the clay again, to a $\frac{1}{2}$ in (1.5cm) thickness, and cut it into slabs of 4 x 2½ in (10 x 6cm), or a size to suit your needs. Once the sculpture has been formed, leave it to dry out, and then fire in a kiln to 2102°F (1150°C).

Oak shavings

A local joinery or lumber mill will be able to supply you with a variety of different types of wood shavings.

MATERIAL
• **Oak shavings**

PREPARATION Thoroughly wedge the clay.

METHOD Take a lump of clay and roll it out to a thickness of 1 in (2.5cm). Evenly distribute oak shavings over the surface of the clay. Lift up one end of the slab and fold it back on itself. Proceed to wedge the clay until the oak shavings are evenly distributed. Roll out the clay again to a $\frac{1}{2}$ in (1.5cm) thickness, and cut it into slabs of 4 x 2½ in (10 x 6cm), or a size to suit your needs. Once the sculpture has been formed, leave it to dry out, and then fire in a kiln to 2102°F (1150°C).

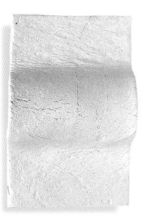
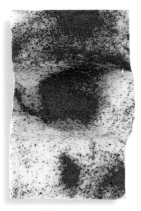
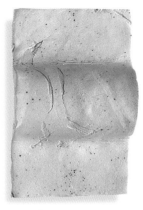

Paper pulp

There is a commercially available product especially produced to add to clay. Alternatively, you can make your own by tearing newspaper into small pieces and leaving them to soak in water. Once disintegrated, squeeze the water from the pulp, and leave to dry out thoroughly.

MATERIAL
• **Paper pulp**

PREPARATION Thoroughly wedge the clay.

METHOD Take a lump of clay and roll it out to a thickness of 1 in (2.5cm). Evenly distribute paper pulp over the surface of the clay. Lift up one end of the slab and fold it back on itself, then wedge the clay until the pulp is evenly distributed. Roll out the clay again to a ½ in (1.5cm) thickness, and cut it into slabs of 4 x 2½ in (10 x 6cm), or a size to suit your needs. Once the sculpture has been formed, leave it to dry out, and then fire in a kiln to 2102°F (1150°C).

Brass filings

Brass filings can be obtained from a specialist sculpture material supplier. You could also use bronze, copper, iron, or aluminum filings or fillers.

MATERIAL
• **Brass filings**

PREPARATION Thoroughly wedge the clay.

METHOD Take a lump of clay and roll it out to a thickness of 1 in (2.5cm). Evenly distribute brass filings over the surface of the clay. Lift up one end of the slab and fold it back on itself. Wedge the clay until the brass filings are evenly distributed. Roll out the clay again to a ½ in (1.5cm) thickness, and cut it into slabs of 4 x 2½ in (10 x 6cm), or a size to suit your needs. Once the sculpture has been formed, leave it to dry out, and then fire in a kiln to 2102°F (1150°C).

Pantyhose

Items of clothing made from fine fabrics, such as pantyhose or socks, make interesting clay additions.

MATERIAL
• **Pantyhose**

PREPARATION Thoroughly wedge the clay. Cut the pantyhose into 1 x 1½ in (2.5 x 4cm) strips.

METHOD Take a lump of clay and roll it out to a thickness of 1 in (2.5cm). Evenly distribute the strips of pantyhose over the surface of the clay. Lift up one end of the slab and fold it back on itself, then wedge the clay until the strips are evenly distributed. Roll out the clay again, to a ½ in (1.5cm) thickness, and cut it into 4 x 2½ in (10 x 6cm), or a size to suit your needs. Once the sculpture has been formed, leave it to dry out, and then fire in a kiln to 2102°F (1150°C).

Firebrick

Here is an interesting effect created using an old firebrick from the kiln.

MATERIAL
• Firebrick

PREPARATION Thoroughly wedge the clay. Place a firebrick in a plastic bag and use a hammer to crush it.

METHOD Take a lump of clay and roll it out to a thickness of 1 in (2.5cm). Evenly distribute the crushed firebrick over the surface of the clay. Lift up one end of the slab and fold it back on itself. Continue to wedge the clay until the crushed firebrick is evenly distributed. Roll out the clay again to a $\frac{1}{2}$ in (1.5cm) thickness, and cut it into slabs of 4 x 2$\frac{1}{2}$ in (10 x 6cm), or a size to suit your needs. Once the sculpture has been formed, leave it to dry out, and then fire in a kiln to 2102°F (1150°C).

Colored glass granules

These glass granules are available in a variety of colors and can be obtained from specialist craft suppliers for artists that work in glass.

MATERIAL
• Colored glass granules

PREPARATION Thoroughly wedge the clay.

METHOD Take a lump of clay and roll it out to a thickness of 1 in (2.5cm). Evenly distribute colored glass granules over the surface of the clay. Lift up one end of the slab and fold it back on itself. Now wedge the clay until the glass granules are evenly distributed. Roll out the clay again, to a $\frac{1}{2}$ in (1.5cm) thickness, and cut it into slabs of 4 x 2$\frac{1}{2}$ in (10 x 6cm), or a size to suit your needs. Once the sculpture has been formed, leave it to dry out, and then fire in a kiln to 2102°F (1150°C).

String

You can use any of the different types of string, twine, and rope that are available, whether with differing textures or colored.

MATERIAL
• String

PREPARATION Thoroughly wedge the clay. Cut the string into 1 in (2.5cm) lengths.

METHOD Take a lump of clay and roll it out to a thickness of 1 in (2.5cm). Evenly distribute the lengths of string over the surface of the clay. Lift up one end of the slab and fold it back on itself, then wedge the clay until the lengths of string are evenly distributed. Roll out the clay again to a $\frac{1}{2}$ in (1.5cm) thickness and cut it into slabs of 4 x 2$\frac{1}{2}$ in (10 x 6cm), or a size to suit your needs. Once the sculpture has been formed, leave it to dry out, and then fire in a kiln to 2102°F (1150°C).

Polystyrene

Collect pieces of this common packaging material whenever it comes to your door, and break it into the size you require.

MATERIAL
• **Small pieces of polystyrene**

PREPARATION Thoroughly wedge the clay.

METHOD Take a lump of clay and roll it out to a thickness of 1 in (2.5cm). Evenly distribute small pieces of polystyrene over the surface of the clay. Lift up one end of the slab and fold it back on itself, then wedge the clay until the pieces are evenly distributed. Roll out the clay again, to a ½ in (1.5cm) thickness, and cut it into slabs of 4 x 2½ in (10 x 6cm), or a size to suit your needs. Once the sculpture has been formed, leave it to dry out, and then fire in a kiln to 2102°F (1150°C).

Tin mesh

Hardware and gardening stores stock a variety of different types of mesh, giving you a wide palette of potential effects to choose from.

MATERIAL
• **Tin mesh**

PREPARATION Thoroughly wedge the clay.

METHOD Take a lump of clay and roll it out to a thickness of 1 in (2.5cm). Evenly distribute pieces of tin mesh over the surface of the clay. Lift up one end of the slab and fold it back on itself. Proceed to wedge the clay until the pieces of mesh are evenly distributed. Roll out the clay again, to a ½ in (1.5cm) thickness, and cut it into slabs of 4 x 2½ in (10 x 6cm), or a size to suit your needs. Once the sculpture has been formed, allow it to dry out, and then fire in a kiln to 2102°F (1150°C).

Soil

Before using soil, clear it of large stones and other impurities, and allow it to dry out as much as possible.

MATERIAL
• **Soil**

PREPARATION Thoroughly wedge the clay.

METHOD Take a lump of clay and roll it out to a thickness of 1 in (2.5cm). Evenly distribute the soil over the surface of the clay. Lift up one end of the slab and fold it back on itself, then wedge the clay until the soil is evenly distributed. Roll out the clay again, to a ½ in (1.5cm) thickness, and cut it into slabs of 4 x 2½ in (10 x 6cm), or a size to suit your needs. Once the sculpture has been formed, leave it to dry out, and then fire in a kiln to 2102°F (1150°C).

PAINT-ON EFFECTS

The following surface effects on textured clay samples are achieved after the clay has been fired in the kiln.

Chrome effect

Chrome enamel spray paint is very easy to apply and has a dramatic, shiny metallic effect.

MATERIAL
• **Chrome fast-dry enamel spray paint**

PREPARATION Make sure the surface is dry and free from dust or grease.

METHOD Work in a well-ventilated area and protect the surrounding work area. Spray the sculpture with a fluid motion to avoid runs; if necessary, apply two coats.

Gold

This is a bright, metallic paint effect.

MATERIAL
• **Water-based gold paint**

PREPARATION Ensure the surface is dry and free from dust or grease.

METHOD Apply two to three generous coats of paint using a brush, ensuring each layer is dry before applying the next. Overbrush lightly to eliminate brushmarks. Wash the brush in water.

Antique gold

This highly textured surface has an aged feel.

MATERIALS
• **Water-based gold paint**
• **Black ink**

PREPARATION Make sure the surface is dry and free from dust or grease.

METHOD Apply two to three generous coats of paint using a brush, ensuring each layer is dry before applying the next. Overbrush lightly to eliminate brushmarks. When the final coat of gold is dry, apply a layer of black ink with a brush. When dry, rub back the ink with a cloth to reveal the gold, while allowing the ink to remain in the texture. Buff with a cloth to bring out the gold. Wash the brushes in water.

Bronze

This layer of bronze can be brushed to a shine.

MATERIALS
• Bronze powder
• PVA

PREPARATION Ensure the surface is dry and free from dust or grease. Mix up a dilute solution of one part PVA to one part water. Spoon in 2 teaspoons of bronze powder and mix well. The mixture should be fairly thick.

METHOD Use a spatula or palette knife to apply the bronze. Leave for 24 hours to dry. If necessary, apply further layers until the desired effect is achieved. A rough or smooth surface can be produced; here we have chosen a rough finish. When the bronze is completely dry, polish it with a wire brush to make it shine. Polish and highlight raised areas of the sculpture to give a weathered effect.

Antique silver

A textured, aged effect.

MATERIALS
• **Chrome enamel spray paint**
• **Graphite/iron paste**

PREPARATION Ensure the surface is dry and free from dust or grease.

METHOD Work in a well-ventilated area and protect the surrounding work area. Apply one or two even layers of spray paint, letting the first coat dry before applying the next. When the final coat is dry, use a cloth to apply a layer of graphite/iron paste. Leave for 30 minutes to dry. Use the cloth to rub back the paste to reveal the chrome. Spray a very light layer of chrome again to bring back a slight shine.

Undercoat and enamel paint

This technique gives a textured, two-tone mottled metallic surface. We have used gray undercoat and insignia red enamel paint.

MATERIALS
• **Undercoat paint**
• **Fast-dry enamel paint**
• **Mineral spirits**

PREPARATION Make sure the surface is dry and free from dust or grease.

METHOD Use a brush to apply two coats of undercoat, letting the first coat dry before applying the next. Apply a good layer of enamel paint and allow to dry. Use a handful of wire wool to rub back the enamel paint and reveal the undercoat in places. Wash the brushes with mineral spirits.

Metal paint and charcoal

This metallic effect has a good shine.

MATERIALS
• Matte metal paint
• Cellulose thinners or recommended cleaner
• Charcoal
• PVA

PREPARATION Make sure the surface is dry and free from dust or grease.

METHOD Brush on one coat of metal paint and rub off with a cloth to highlight the surface texture. Allow to dry. Wash the brush with cellulose thinners of the cleaner recommended by the manufacturer. Rub in some crushed charcoal and remove the excess. Apply a layer of PVA to the surface. Leave to dry and then buff up with a soft cloth. Wash the brush with water.

Shellac with ink wash

Produces a strong, durable finish with interesting variations of texture and color.

MATERIALS
• Shellac
• Black ink
• Mineral spirits

PREPARATION Make sure the surface is dry and free from dust or grease.

METHOD Brush on one layer of shellac and allow to dry. Brush on a layer of ink, allowing it to run off and into the texture of the surface. Let dry. Wash the brush with water. Apply another layer of shellac to finish. Clean the brush in mineral spirits.

Oil paint and wax

Produces an opaque, mottled surface effect. We have used viridian oil paint.

MATERIALS
• Artists' oil paint
• Mineral spirits
• Candle

PREPARATION Ensure the surface is dry and free from dust or grease.

METHOD Brush on a layer of oil paint. Use a cloth to rub it back to reveal the surface texture. Allow to dry. Wash the brush with mineral spirits. Light a candle and drip wax onto the clay surface. Continue until the desired thickness and opacity has been achieved.

Wax and ink

This technique gives an opaque depth with many layers and tones.

MATERIALS
- White paint
- Candle
- Ink

PREPARATION Ensure the surface is dry and free from dust or grease.

METHOD Brush on a layer of white paint and allow to dry. Light a candle and drip layers of wax over the clay surface. Smoke from the candle can also add interesting surface qualities. Once the required layer of wax has been dripped on, scratch or carve patterns and textures into the wax with a scraper or similar tool. Paint on a layer of colored ink, allowing it to soak into the created surface. Wash the brushes with water.

Spatter effect

You may want to practice this effect on paper first.

MATERIALS
- Black ink
- White ink
- Red enamel paint
- Gold metallic paint

PREPARATION Make sure the surface is dry and free from dust or grease.

METHOD Wash on a layer of black ink and allow to dry. Next, drop on some white ink to create extra depth. Leave to dry. Wash brushes in water. Dip an old toothbrush into red enamel paint and lightly spray the paint onto the surface by pulling your thumbnail over the paint on the brush—you may want to practice on paper first. When the enamel paint is dry, repeat the spatter technique with gold paint.

Marbled effect

This technique gives the surface a multilayered effect.

MATERIALS
- Artists' acrylic paint
- Mineral spirits
- Two or more colored inks
- Beeswax

PREPARATION Ensure the surface is dry and free from dust or grease.

METHOD Brush on a layer of acrylic paint and allow to dry. Pour mineral spirits onto the painted surface and allow it to run and dribble. While the mineral spirits are still wet, drop small amounts of colored inks onto the wet surface. The spirits repel the ink and interesting marbling effects appear. When totally dry, polish and seal with beeswax.

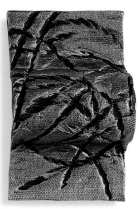

Flame-licked

This technique for producing variable swirls of black to gray marks is suitable for a surface that will not be handled too much.

MATERIALS
• Candle
• Hairspray

PREPARATION Ensure the surface is dry and free from dust or grease. Light a candle.

METHOD Pass the clay over the flame, just above it rather than in it. Vary the speed you use to pass the clay above the flame to achieve lighter and darker areas; use a fluid movement if swirls are required. Fix the marks with hairspray.

Boot polish

Boot polish gives the clay a leather-like appearance and is very useful for bringing out surface texture. Various colors can be used; here we have used maroon rouge.

MATERIAL
• Boot polish

PREPARATION Ensure the surface is dry and free from dust or grease.

METHOD Use a shoe brush to liberally rub on the polish, making sure it goes into all cracks and crevices. Leave to dry for 15 minutes, then buff with a soft cloth. Some of the polish will come off at this stage, but the more you rub and buff the richer the surface will become.

Black ink and metallic gold

With this technique you can create a deep textured surface.

MATERIALS
• Black ink
• Water-based gold paint

PREPARATION Make sure the surface is dry and free from dust or grease.

METHOD Use a paintbrush to apply a wash of black ink and allow to dry. When the ink is dry, rub off excess ink with a dry cloth. Use a brush to apply the gold paint very sparingly so that it does not smother the texture. Clean the brushes with water.

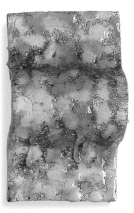

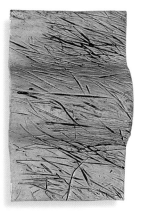

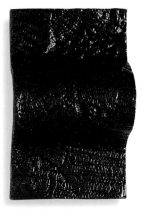

Shellac and wax

This method produces a mottled, shiny surface and is good for larger areas.

MATERIALS
- **Candle**
- **Shellac**
- **Mineral spirits**

PREPARATION Ensure the surface is dry and free from dust or grease. Light a candle.

METHOD Drip wax from the lit candle onto the surface of the clay. Different layers and depths can be created at this stage; here we have chosen a random effect. Allow the wax to dry. Paint on a layer of shellac and allow to dry. Scrape off the wax. Drip on another layer of wax and repeat the process with the shellac until the desired effect is achieved. Clean the brush with mineral spirits.

Shellac and boot polish

This effect produces a high polish and highlights the texture of the clay.

MATERIALS
- **Shellac**
- **Boot polish**
- **Mineral spirits**

PREPARATION Make sure the surface is dry and free from dust or grease.

METHOD Brush on a layer of shellac and leave to dry. Clean the brush with mineral spirits. Use a cloth to rub boot polish on and off of the surface to produce the desired effect.

Graphite paste and shellac

This technique gives a metallic high shine and produces a durable surface.

MATERIALS
- **Graphite/iron paste**
- **Shellac**
- **Mineral spirits**

PREPARATION Ensure the surface is dry and free from dust or grease.

METHOD Use a cloth to rub in graphite/iron paste and leave to dry. Use the cloth to polish the surface to a bright sheen, and then brush on a layer of shellac. Clean the brush with mineral spirits.

Charcoal and beeswax

This technique highlights the surface texture.

MATERIALS
- Charcoal
- Beeswax

PREPARATION Make sure the surface is dry and free from dust or grease.

METHOD Crush up some charcoal and rub it onto the clay, ensuring it goes into the textured surface. Rub off the excess charcoal. Use a cloth to apply a layer of beeswax. Leave for a few minutes, then polish with the cloth to achieve a shine.

Graphite/iron paste

Graphite/iron paste produces a soft, metallic iron finish and can be built up to a thick layer or used more sparingly to show some texture.

MATERIAL
- Graphite/iron paste

PREPARATION Ensure the surface is dry and free from dust or grease.

METHOD Use a cloth to rub on the graphite/iron paste. Leave to dry for 10 minutes, then buff up with the cloth to a metallic sheen. Repeat as often as necessary to achieve the desired effect.

Ink wash

This technique produces a colorful, matte surface, and is suitable for use on flat surfaces. Here we have used violet ink and white paint.

MATERIALS
- Ink
- Water (optional)
- Artists' acrylic paint

PREPARATION Ensure the surface is dry and free from dust or grease.

METHOD Use a brush to wash on the ink—this can be watered down to give a lighter color. Allow to dry. Use a cloth to rub on a layer of acrylic paint and rub back to the surface to reveal the texture. Clean the brush with water.

Oil paint

Oil paint gives a rich, colorful surface. It also highlights any texture and seals a porous surface. Here we have used viridian oil paint.

MATERIALS
• **Artists' oil paint**
• **Mineral spirits**

PREPARATION Make sure the surface is dry and free from dust or grease.

METHOD Thin the oil paint with mineral spirits and apply to the clay surface with a paintbrush or cloth. Allow to dry. Clean the brush with mineral spirits.

Wax crayon and candle smoke

This method creates a colorful surface with swirls of smoky black.

MATERIALS
• **Wax crayon**
• **Candle**

PREPARATION Make sure the surface is dry and free from dust or grease.

METHOD Vigorously rub the crayon onto the surface. For this sample a thick layer was built up. Light a candle and pass the crayoned surface over the flame. The crayon wax will melt and different effects will be achieved depending on how long the clay is held over the flame. Wisps of blackness will be left on the surface. Polish with a soft cloth to produce a shine.

Tea

Washes of tea give the clay a matte finish.

MATERIALS
• **Cup of cold tea**
• **Spray polish**

PREPARATION Ensure the surface is dry and free from dust or grease.

METHOD Use a brush to apply multiple washes of tea, allowing each layer to dry before applying the next. When the final wash is dry, spray the surface with polish to seal the finish.

Inspirational pieces

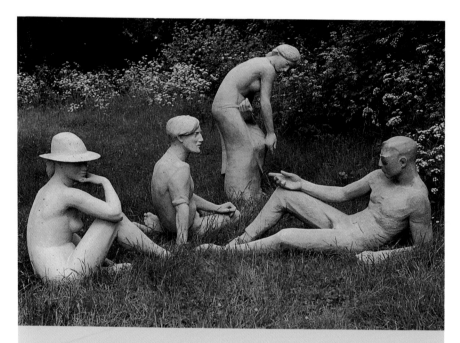

Déjeuner Sur L'Herbe
Althea Wynne

Built using a coiling technique and fired to a high temperature to be durable outdoors, these life-size ceramic sculptures are based on the famous Impressionist painting by Manet of the same title. Placing the figures directly onto the lawn creates a realistic, informal atmosphere while the uniformity of the surface color and texture give a calm mood that makes the pieces stand out against the greenery.

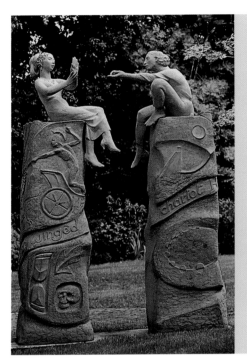

TIME'S WINGED CHARIOT
ALTHEA WYNNE

Combining relief images on the columns with three-dimensional figures seated on top, this large ceramic sculpture brings together many surface qualities to good effect. The textured surface creates a lively background out of which details emerge and become clearly defined, thus focusing our attention upon them. The words carved into the sculpture run from one column to the other, bridging them and, like the two figures above, reaching across the space to unite the two halves.

MONEY BOX VASES
TESSA WOLFE MURRAY

The burning technique used on the Diamond Vases (see page 163) was used on these pieces to accentuate the different qualities of the various parts of each vase. The rounded base of the vases is enhanced by a soft, diffused smoky effect, while the clear sharp edges at the top are made even bolder by a narrow and dark burn line.

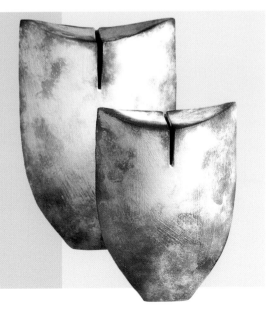

Blue Head With Back Tail
Patricia Volk

This head has been built using a coil technique, fired, and then colored with acrylic paint. The stillness and focus of the form is complemented by the blue color which works well on top of the dimpled surface texture, catching the light or darkening in the shadows.

DIAMOND VASES
TESSA WOLFE MURRAY

These vases were slab built with earthenware clay, fired, and marked by burning the surface with a mixture of sawdust and mineral spirits. The clean, geometrical lines of the vases are complemented by the randomly layered marks made by the burning. The burn marks create a dark coloring around the outside edges and leave a light space in the center and top; a beautiful reminder of the open gesture inside these receptacles.

TOTEM DEITIES
PATRICIA VOLK

These heads have been press-molded, then fired before coloring with acrylic paint. The strong features of these gods, with their closed eyes and painted matte black finish, make a striking contrast with the bright swirls of color and suggest they are experiencing vivid inner visions.

Plaster

Plaster, made from gypsum, has a very long history of being associated with sculpture and its accompanying techniques, and is suitable for making a mold or plaster cast, or working directly by adding the plaster onto an armature.

Plaster is supplied in a powdered form. When mixed with water, an exothermic chemical reaction occurs which gives off heat. If you put your hand to the surface of the plaster as it is going off (setting), you will be able to feel this heat. When the heat subsides, and the plaster becomes cold to the touch, you know that the plaster has gone off and can now be safely handled without risk of damage. However, although the plaster has gone off and set hard, it will still be wet and will take time to dry out completely.

Plaster needs to be stored in a dry atmosphere, such as in airtight plastic bins. If it is left in an opened bag exposed to the air, it will absorb moisture from the surrounding atmosphere, which will hinder the rate at which it goes off and its subsequent strength.

Mixing plaster

If followed correctly, this method of mixing plaster will consistently give you a good mix. Plaster is always added to the water, and not the other way round, and the amount of water you start with will be determined by the job at hand. You can expect the volume of mixed plaster to be about half as much again as the amount of water. Remember that plaster goes off very quickly, so only mix up an amount that can be used before this happens—it is better to mix up too little rather than too much.

YOU WILL NEED:

- Latex gloves
- Dust mask
- Water
- Plastic mixing bowl
- Casting plaster
- Bucket of water for cleaning up

SAFETY

- Work in a well-ventilated area.
- Always wear a dust mask when mixing plaster and latex gloves to protect your hands or use barrier cream.
- Never pour leftover plaster down the sink or a drain. Similarly, do not wash out tools under a running faucet. For this purpose, always keep a bucket of water on hand.

1 Pour the required amount of water into a plastic mixing bowl. Slowly sprinkle the plaster over the surface of the water. The plaster will sink to the bottom.

2 Keep adding the plaster, a handful at a time. It will start to rise and form peaks above the surface of the water. Let the plaster settle, and if the peaks remain, you have added enough. If not, add more.

3 Mix the plaster and water together to form a smooth, creamy consistency. Make sure that there are no lumps.

4 To test whether you have achieved a mix of the right consistency, dip your hand into the plaster. As you take it out, the plaster should be opaque and move slowly down off your hand.

5 If you have a poor, weak mix, the plaster will be translucent on your hand and drop off immediately into the mixing bowl. Do not use this mix. Put it to one side and let it go off, which will take some time, and make a fresh mix of plaster.

Making a two-piece waste mold

After modeling a sculpture in clay—or another modeling material such as wax—unless it is to be fired, the clay original will need to be cast in another material. In order to do this, you need to take a mold from the original clay sculpture. The mold is a negative impression of the original (the positive); a cast is then taken from this mold in another more durable material, such as plaster, resin, concrete, or cement fondue. The mold demonstrated in the following steps is an example of a waste mold. It is only possible to use it once since it is destroyed during the casting process.

YOU WILL NEED:

- Clay or wax sculpture on the modeling board
- Brass fencing
- Tape measure
- Scissors
- Pointed and flat plaster tools
- Plastic wrap
- Latex gloves
- Dust mask
- Water
- Plastic mixing bowl

SAFETY

- Remember to work in a well-ventilated area.
- Always wear a dust mask when mixing plaster and latex gloves, or use barrier cream to protect your hands when mixing and handling wet plaster.

- Casting plaster
- Bucket of water for cleaning up
- Pliers

1 First cut strips of brass fencing 1-inch (2.5cm) wide. Cut these strips into 1-½-, 2- and 3-inch (4, 5, and 7.5cm) lengths. The varying lengths of fencing will allow you to position strips over a rounded form.

2 Take two of the 3-inch (7.5cm) lengths and bend each into a "V"-shape midway. These will be used to create registration points on each piece of the mold.

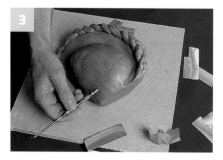

3 With a pointed tool, mark a dividing line from one side of the sculpture to the other.

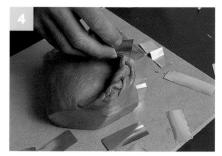

4 Using this line as a guide, position one of the "V"-shaped fencing strips, making sure that its end is against the surface of the modeling board. Gently push the fencing into the sculpture to a depth of about ¼ inch (0.5cm).

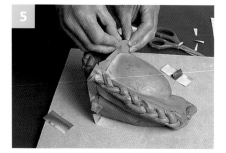

5 Continue positioning the brass fencing strips following the guideline around the sculpture to the other side. Finish off with the second "V"-shaped fencing strip.

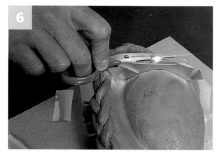

6 Use scissors to trim the fencing so that it maintains a consistent height around the sculpture.

7 Cover half of the sculpture with plastic wrap and mix up a small amount of plaster. Apply the first coat of plaster by flicking it hard against the surface of the sculpture. If necessary, tilt the modeling board to ensure that plaster is flicked into any inaccessible areas. Proceed in this way to cover the entire surface with plaster.

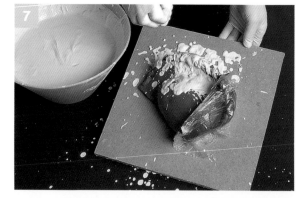

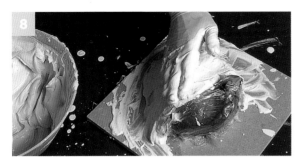

8 As the plaster thickens, using the height of the brass fencing as a guide, build up the plaster to an even thickness around the sculpture.

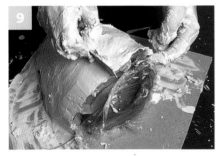

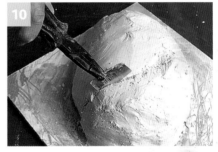

9 Once you have achieved an even thickness of plaster over one half of the mold, use a plaster tool to scrape it off level with the brass fencing. Remove the plastic wrap from the other side of the mold and add plaster to this side as before. It is important that you do not cover the tops of the brass fencing.

10 When the plaster has gone off, scrape it back to expose more of the edges of the brass fencing, then use pliers to pull the fencing free from the plaster.

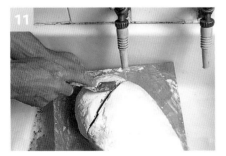

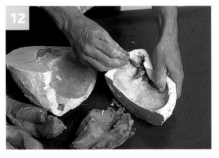

11 Place the mold under a running faucet and let the water run down into the gap left by the brass fencing. After a while, you will be able to pry the two pieces of the mold apart.

12 Finally, use the pointed plaster tool to remove all of the clay from the mold before completely rinsing it out with water.

PLAIN PLASTER

The amount of plaster used will determine the amount of time it takes to dry out completely. Wet plaster will be dark in tone; as it dries it will lighten, and the grade of plaster will determine the intensity of its white color.

PVA

PVA seals the surface of the plaster and forms a clear transparent layer, so retaining the original color of the plaster. Subsequent layers of PVA give a more opaque finish.

MATERIALS
- PVA
- Water

PREPARATION Allow the plaster to dry completely. Mix up a dilute solution of one part PVA to one part water.

METHOD Paint on one coat of dilute PVA. Allow this to dry and brush on another three coats, allowing each coat to dry before brushing on another. The more coats you add, the more opaque the surface will become. Clean the brush with water.

Light shellac

Shellac seals the surface, filling any small pores in the plaster. It dries quickly and reduces the opacity of the plaster by forming a protective, tinted film.

MATERIALS
- Shellac
- Denatured alcohol
- Mineral spirits

PREPARATION Allow the plaster to dry completely.

METHOD Paint on one coat of shellac and allow to dry. For a lighter color the shellac can be diluted with denatured alcohol. Afterwards, clean the brush with mineral spirits.

Dark shellac

Multiple layers of shellac form a shiny and lustrous skin, tinting the surface of the plaster a deep orange-brown. Take care with this finish, however, since fine details may be lost under too many coats of shellac.

MATERIALS
• Shellac
• Mineral spirits

PREPARATION Allow the plaster to dry completely.

METHOD Paint on one coat of shellac and allow to dry. Paint on a further three coats, allowing each coat to dry before applying the next. To make the shellac darker, apply more coats. Clean the brush with mineral spirits.

Shellac and PVA

Shellac seals the surface over which a layer of PVA is applied, creating a transparent film with a soft sheen.

MATERIALS
• Shellac
• PVA
• Water
• Mineral spirits

PREPARATION Allow the plaster to dry completely. Mix up a dilute solution of one part PVA to one part water.

METHOD Paint on one coat of shellac and allow to dry. Clean the brush with mineral spirits. Paint on one coat of dilute PVA and allow to dry. Clean the brush with water.

Acrylic varnish

Acrylic varnish dries to a clear finish, which retains the original color of the plaster.

MATERIALS
• PVA
• Water
• Acrylic varnish

PREPARATION Allow the plaster to dry completely. Mix up a dilute solution of one part PVA to one part water.

METHOD Brush on one coat of dilute PVA and allow to dry. Clean the brush with water. Paint on one coat of acrylic varnish. When the varnish is dry, paint on another coat. Clean the brush with water.

Polyurethane varnish

Polyurethane varnish provides a hard-wearing and protective coating. It dries clear, allowing a light tint of color from the shellac to show through.

MATERIALS
- Shellac
- Mineral spirits
- Polyurethane varnish

PREPARATION Allow the plaster to dry completely.

METHOD Paint on one coat of shellac and allow to dry. Clean the brush with mineral spirits. Paint on one coat of polyurethane varnish and allow to dry. Clean the brush in mineral spirits.

Acrylic paint

Acrylic paint dries quickly and smoothly, giving a good coverage of opaque color. Matte acrylic paint may flatten details since it absorbs light.

MATERIALS
- PVA
- Water
- Artists' acrylic paint

PREPARATION Allow the plaster to dry completely. Mix up a dilute solution of one part PVA to one part water. Add enough water to some acrylic paint to achieve the desired opacity and consistency for ease of painting.

METHOD Brush on one coat of dilute PVA and allow to dry. Clean the brush with water. Brush on the dilute acrylic paint as desired. Clean the brush with water.

Acrylic paint and polyurethane varnish

Polyurethane varnish leaves a glossy sheen on the opaque acrylic paint.

MATERIALS
- PVA
- Water
- Artists' acrylic paint
- Polyurethane varnish
- Mineral spirits

PREPARATION Allow the plaster to dry completely. Mix up a dilute solution of one part PVA to one part water. Add enough water to some acrylic paint to achieve the desired opacity and consistency for ease of painting.

METHOD Brush on one coat of dilute PVA and allow to dry. Clean the brush with water. Paint on one coat of dilute acrylic paint and allow to dry. Clean the brush with water again. Paint on one coat of polyurethane varnish. Clean the brush in mineral spirits.

Acrylic paint and sand

The acrylic paint forms a bond between the plaster and the sand, aiding the adhesion of the sand to the plaster. The sand and paint mixture dries to form an earth-colored matte surface.

MATERIALS
• PVA
• Water
• Artists' acrylic paint
• Sand

PREPARATION Allow the plaster to dry completely. Mix up a dilute solution of one part PVA to one part water. Mix acrylic paint with water to a creamy consistency, and then add sand to this mix, ensuring it is still brushable. You do not want to add so much sand that the mix becomes stodgy; if it does, add water to loosen the mixture.

METHOD Paint on one coat of dilute PVA and allow to dry. Clean the brush with water. Paint an even coat of dilute acrylic paint and sand onto the surface of the sculpture. Clean the brush with water.

Distressed surface

This dramatic finish is caused by the paint sitting in the grooves and rough areas of the plaster. The rubbing only removes paint from the high areas, leaving a mottled finish. Remember that acrylic paint dries quickly so do not wait too long before removing the excess paint.

MATERIALS
• Shellac
• Mineral spirits
• Artists' acrylic paint

PREPARATION Allow the plaster to dry completely.

METHOD Seal the surface with shellac and allow to dry. Clean the brush with mineral spirits. Use a cloth to rub acrylic paint over and into the surface of the sculpture. Before the paint has a chance to dry completely, use a damp cloth to remove the excess paint to create a distressed look.

Spray paint

Different tones of color can be built up using spray paints. Very thin layers can be applied, and overlapping these two colors gives a variety of orange tones. The different thicknesses of paint and the tonal range help to give the piece depth.

MATERIALS
• Shellac
• Mineral spirits
• Yellow enamel spray paint
• Red enamel spray paint

PREPARATION Allow the plaster to dry completely.

METHOD Seal the surface with one coat of shellac and allow to dry. Clean the brush with mineral spirits. Work in a well-ventilated area and protect the surrounding work area. Alternately spray on the yellow and red enamel spray paints to create the desired effect.

Gravel and spray paint

Here the gravel acts as a barrier to the spray paint. When removed, it reveals glimpses of the original color of the plaster through the yellow.

MATERIALS
- Medium gravel
- Yellow enamel spray paint

PREPARATION Allow the plaster to dry completely.

METHOD Work in a well-ventilated area and protect the surrounding work area. Place medium gravel over the bare plaster. Without disrupting the gravel, spray the sculpture with yellow enamel spray paint.

Two-color spray paint and gravel

A speckled, two-tone effect can be achieved by using gravel to mask the first coat of color.

MATERIALS
- Shellac
- Mineral spirits
- Yellow enamel spray paints
- Red enamel spray paints
- Medium gravel

PREPARATION Allow the plaster to dry completely.

METHOD Seal the surface with one coat of shellac and allow to dry. Clean the brush with mineral spirits. Work in a well-ventilated area and protect the surrounding work area. Spray the surface of the sculpture with an even coat of yellow enamel spray paint. Sprinkle medium gravel over the surface of the sculpture then, without moving the sculpture or disrupting the gravel, spray on an even coat of red enamel paint.

Neon orange enamel paint

The enamel paint dries to a flat, deep orange, with two coats giving an even coverage. This type of surface absorbs light and hides any imperfections.

MATERIALS
- PVA
- Water
- Neon orange enamel paint
- Mineral spirits

PREPARATION Allow the plaster to dry completely. Mix up a dilute solution of one part PVA to one part water.

METHOD Paint on one coat of dilute PVA and let dry. Clean the brush with water. Paint on one coat of neon orange enamel paint and allow to dry. Paint on another coat of neon orange enamel paint. Clean the brush with mineral spirits.

Acrylic paint and sand

The acrylic paint forms a bond between the plaster and the sand, aiding the adhesion of the sand to the plaster. The sand and paint mixture dries to form an earth-colored matte surface.

MATERIALS
- PVA
- Water
- Artists' acrylic paint
- Sand

PREPARATION Allow the plaster to dry completely. Mix up a dilute solution of one part PVA to one part water. Mix acrylic paint with water to a creamy consistency, and then add sand to this mix, ensuring it is still brushable. You do not want to add so much sand that the mix becomes stodgy; if it does, add water to loosen the mixture.

METHOD Paint on one coat of dilute PVA and allow to dry. Clean the brush with water. Paint an even coat of dilute acrylic paint and sand onto the surface of the sculpture. Clean the brush with water.

Distressed surface

This dramatic finish is caused by the paint sitting in the grooves and rough areas of the plaster. The rubbing only removes paint from the high areas, leaving a mottled finish. Remember that acrylic paint dries quickly so do not wait too long before removing the excess paint.

MATERIALS
- Shellac
- Mineral spirits
- Artists' acrylic paint

PREPARATION Allow the plaster to dry completely.

METHOD Seal the surface with shellac and allow to dry. Clean the brush with mineral spirits. Use a cloth to rub acrylic paint over and into the surface of the sculpture. Before the paint has a chance to dry completely, use a damp cloth to remove the excess paint to create a distressed look.

Spray paint

Different tones of color can be built up using spray paints. Very thin layers can be applied, and overlapping these two colors gives a variety of orange tones. The different thicknesses of paint and the tonal range help to give the piece depth.

MATERIALS
- Shellac
- Mineral spirits
- Yellow enamel spray paint
- Red enamel spray paint

PREPARATION Allow the plaster to dry completely.

METHOD Seal the surface with one coat of shellac and allow to dry. Clean the brush with mineral spirits. Work in a well-ventilated area and protect the surrounding work area. Alternately spray on the yellow and red enamel spray paints to create the desired effect.

Gravel and spray paint

Here the gravel acts as a barrier to the spray paint. When removed, it reveals glimpses of the original color of the plaster through the yellow.

MATERIALS
- Medium gravel
- Yellow enamel spray paint

PREPARATION Allow the plaster to dry completely.

METHOD Work in a well-ventilated area and protect the surrounding work area. Place medium gravel over the bare plaster. Without disrupting the gravel, spray the sculpture with yellow enamel spray paint.

Two-color spray paint and gravel

A speckled, two-tone effect can be achieved by using gravel to mask the first coat of color.

MATERIALS
- Shellac
- Mineral spirits
- Yellow enamel spray paints
- Red enamel spray paints
- Medium gravel

PREPARATION Allow the plaster to dry completely.

METHOD Seal the surface with one coat of shellac and allow to dry. Clean the brush with mineral spirits. Work in a well-ventilated area and protect the surrounding work area. Spray the surface of the sculpture with an even coat of yellow enamel spray paint. Sprinkle medium gravel over the surface of the sculpture then, without moving the sculpture or disrupting the gravel, spray on an even coat of red enamel paint.

Neon orange enamel paint

The enamel paint dries to a flat, deep orange, with two coats giving an even coverage. This type of surface absorbs light and hides any imperfections.

MATERIALS
- PVA
- Water
- Neon orange enamel paint
- Mineral spirits

PREPARATION Allow the plaster to dry completely. Mix up a dilute solution of one part PVA to one part water.

METHOD Paint on one coat of dilute PVA and let dry. Clean the brush with water. Paint on one coat of neon orange enamel paint and allow to dry. Paint on another coat of neon orange enamel paint. Clean the brush with mineral spirits.

Gold enamel paint

An aged appearance is created by rubbing the enamel onto the surface, catching on rough areas and lightly skimming the flatter areas. It gives the effect of a material that has undergone weathering.

MATERIALS
• Shellac
• Mineral spirits
• Antique gold enamel paint

PREPARATION Allow the plaster to dry completely.

METHOD Seal the surface with one coat of shellac and allow to dry. Clean the brush with mineral spirits. Use a cloth to rub antique gold enamel paint over the surface of the sculpture.

Copper enamel paint

A highly polished surface is achieved by painting on even layers of copper enamel paint and using sandpaper between coats to smooth down rough edges that would otherwise be magnified by the shiny surface.

MATERIALS
• Shellac
• Mineral spirits
• Copper enamel paint
• Sandpaper

PREPARATION Allow the plaster to dry completely.

METHOD Seal the surface with one coat of shellac and allow to dry. Clean the brush with mineral spirits. Paint on an even coat of copper enamel paint and allow to dry. Repeat twice more, allowing the paint to dry between coats. Give a light sand with sandpaper between coats. Clean the brush with mineral spirits.

Brass enamel paint

The textured area of the plaster is further emphasized by the shiny quality of the enamel paint. It reflects surface light, making surface marks and cracks more visible. The metallic color intensifies with each coat.

MATERIALS
• Shellac
• Mineral spirits
• Brass enamel paint
• Sandpaper

PREPARATION Allow the plaster to dry completely.

METHOD Seal the surface with one coat of shellac and allow to dry. Clean the brush with mineral spirits. Apply one coat of brass enamel paint and allow to dry. Lightly sand the surface, then paint on another coat. Clean the brush with mineral spirits.

Copper metallic powder

An effective imitation of copper can be achieved by painting a dense, smooth layer of copper powder suspended in shellac. Good coverage allows you to polish the surface without revealing the plaster beneath.

MATERIALS
• **Shellac**
• **Mineral spirits**
• **Copper metallic powder**

PREPARATION Allow the plaster to dry completely.

METHOD Seal the surface with one coat of shellac and allow to dry. Clean the brush with mineral spirits. Pour enough shellac into a container to cover the surface of the sculpture with one coat. Add copper metallic powder to the shellac and stir it in to achieve the desired opacity. Paint on an even coat over the surface of the sculpture and allow to dry. Clean the brush with mineral spirits.

Silver metallic powder

This powder can be bought from a paint manufacturer or metal paint manufacturer. You can usually buy it in a variety of shades of silver, bronze, and copper.

MATERIALS
• **Shellac**
• **Mineral spirits**
• **Silver metallic powder**

PREPARATION Allow the plaster to dry completely.

METHOD Seal the surface with one coat of shellac and allow to dry. Clean the brush with mineral spirits. Pour enough shellac into a container to cover the surface of the sculpture with one coat. Add the silver metallic powder to the shellac and stir it in to achieve the desired opacity. Paint on an even coat over the surface of the sculpture and allow to dry. Clean the brush with mineral spirits.

Metallic powder mix

This creates an effective finish, especially in the textured areas.

MATERIALS
• **Shellac**
• **Mineral spirits**
• **Copper metallic powder**
• **Silver metallic powder**

PREPARATION Allow the plaster to dry completely.

METHOD Seal the surface with one coat of shellac and allow to dry. Clean the brush with mineral spirits. Pour enough shellac into a container to cover the surface of the sculpture with one coat. Add copper metallic powder to the shellac and stir it in to achieve the desired opacity. Paint on an even coat over the surface of the sculpture. Before this has a chance to dry, load a brush with silver metallic powder and drag it over the surface of the sculpture. Clean the brushes with mineral spirits.

Copper hammered-metal effect paint

This finish creates the illusion of textured metal. The illusion of the hammer-like markings makes the surface appear thicker than it actually is.

MATERIALS
• Shellac
• Mineral spirits
• Copper hammered-metal effect paint
• Cellulose thinners or recommended cleaner

PREPARATION Allow the plaster to dry completely.

METHOD Seal the surface with one coat of shellac and allow to dry. Clean the brush with mineral spirits. Fully load the brush with copper hammered-metal effect paint and apply an even coat without overbrushing. Allow to dry. Clean the brush with cellulose thinners or as recommended by the paint manufacturer.

Mid-green hammered-metal effect paint

Fully loading the brush with paint allows you to make a good, even coverage of color. Avoid overbrushing, which leaves brush marks that spoil the illusion of metal.

MATERIALS
• Shellac
• Mineral spirits
• Mid-green hammered-metal effect paint
• Cellulose thinners or recommended cleaner

PREPARATION Allow the plaster to dry completely.

METHOD Seal the surface with one coat of shellac and allow to dry. Clean the brush with mineral spirits. Fully load the brush with mid-green hammered-metal effect paint and apply an even coat without overbrushing. Clean the brush with cellulose thinners or as recommended by the paint manufacturer.

Silver hammered-metal effect paint

Plaster must be completely dry before applying shellac or paint, since water trapped in plaster weakens the adhesion of paint and may cause peeling in areas.

MATERIALS
• Shellac
• Mineral spirits
• Silver hammered-metal effect paint
• Cellulose thinners or recommended cleaner

PREPARATION Allow the plaster to dry completely.

METHOD Seal the surface with one coat of shellac and allow to dry. Clean the brush with mineral spirits. Fully load the brush with silver hammered-metal effect paint and apply an even coat without overbrushing. Clean the brush with cellulose thinners or as recommended by the paint manufacturer.

Flicked-on paint

This paint effect imitates stone, like granite. The silver paint merges with the gray when wet to become one layer.

MATERIALS
- Shellac
- Mineral spirits
- Gray enamel paint
- Silver hammered-metal effect paint
- Cellulose thinners or recommended cleaner

PREPARATION Allow the plaster to dry completely.

METHOD Seal the surface with one coat of shellac and allow to dry. Clean the brush with mineral spirits. Paint on one coat of gray enamel paint. Clean the brush with mineral spirits. Before the gray enamel paint dries, load up a paintbrush with silver hammered-metal effect paint and flick it over the surface to obtain an even covering. Clean the brush with cellulose thinners or as recommended by the manufacturer.

Patinated bronze effect

A successful aged bronze effect is created using blackboard paint. A fine application of matte black paint creates a convincing dense bronze patina. The loaded cloth catches certain areas leaving the bronze to shine through.

MATERIALS
- Shellac
- Mineral spirits
- Gold enamel paint
- Matte blackboard paint

PREPARATION Allow the plaster to dry completely.

METHOD Seal the surface with one coat of shellac and allow to dry. Clean the brush with mineral spirits. Paint on one coat of gold enamel paint and allow to dry. Clean the brush with mineral spirits again. Wearing protective gloves, use a cloth to drag matte blackboard paint across the surface of the sculpture.

Patinated silver effect

Here the blackboard paint sits in the crevices with the silver catching on the high points, giving an aged appearance. A stiff polishing brush will make the surface shine. Wax polish can be used to remove a layer of paint, and polishing the wax will fix the surface.

MATERIALS
- Shellac
- Mineral spirits
- Matte blackboard paint
- Silver enamel paint

PREPARATION Allow the plaster to dry completely.

METHOD Seal the surface with one coat of shellac and allow to dry. Clean the brush with mineral spirits. Paint on one coat of matte blackboard paint and allow to dry. Clean the brush with mineral spirits. Wearing protective gloves, use a cloth to drag silver enamel paint across the surface of the sculpture.

Gloss paint

Gloss paint dries slowly, leaving a durable, shiny surface. It also adds depth by reflecting light and makes surface marks and cracks more visible.

MATERIALS
- Shellac
- Mineral spirits
- Gloss paint

PREPARATION Allow the plaster to dry completely.

METHOD Seal the surface with one coat of shellac and allow to dry. Clean the brush with mineral spirits. Paint on one coat of household gloss paint and allow to dry. Clean the brush with mineral spirits.

Poured gloss paint

A range of tones can be achieved when the red and yellow paint mix on the surface. When one color bleeds into the other, different shades of orange occur.

MATERIALS
- Shellac
- Mineral spirits
- Red gloss paint
- Yellow gloss paint

PREPARATION Allow the plaster to dry completely.

METHOD Paint on one coat of shellac to seal the surface and allow to dry. Clean the brush with mineral spirits. Pour red gloss paint over the sculpture, and then pour over some yellow gloss paint. Before the paint has a chance to dry and settle, move the sculpture around to distribute the paint over the surface.

Gloss paint and graphite paste

The sanding of the gloss paint allows the graphite paste to stick to the rough areas, particularly the crevices. While in strong contrast, the glossy nature of the yellow paint shows through.

MATERIALS
- Shellac
- Mineral spirits
- Yellow gloss paint
- Graphite/iron paste
- Sandpaper
- Toothbrush

PREPARATION Allow the plaster to dry completely.

METHOD Seal the surface with one coat of shellac and allow to dry. Clean the brush with mineral spirits. Apply one coat of yellow gloss paint and allow to dry. Clean the brush with mineral spirits. Sand back the surface lightly and use a toothbrush to apply graphite/iron paste, ensuring that you work it into the crevices of the sculpture.

Beeswax

Beeswax forms a finished protective layer that repels water. When polished with a soft cloth, it takes a high polish.

MATERIALS
• PVA
• Water
• Beeswax
• Toothbrush
• Soft cloth

PREPARATION Allow the plaster to dry completely. Mix up a dilute solution of one part PVA to one part water.

METHOD Paint on one coat of dilute PVA and allow to dry. Clean the brush with water. Use a cloth to apply beeswax, making sure that it is rubbed well into the surface of the plaster. Use a toothbrush to work the wax into crevices and areas that are difficult to reach. Use a soft cloth to buff up the wax.

Clear wax

This wax provides a fairly thick, cloudy layer, ivory-like in appearance.

MATERIALS
• Clear wax

PREPARATION Allow the plaster to dry completely. Melt enough clear wax to cover the sculpture in a saucepan over a low heat.

METHOD When the wax is completely molten, pour it over the surface of the sculpture, ensuring that you obtain a smooth and even coating across the entire surface of the sculpture.

Thin coat of blue wax

A subtle effect is achieved here by the lightness of the plaster showing through the variegated blue surface. The use of a cloth softens the finish, rather than scratching through to reveal color for a harsher effect.

MATERIALS
• Clear wax
• Blue wax dye
• Soft cloth
• Water

PREPARATION Allow the plaster to dry completely. Melt enough clear wax to cover the sculpture in a saucepan over a low heat.

METHOD When the wax is molten, add blue wax dye to give a faint hint of color. Pour a thin coat of tinted wax over the surface of the sculpture. Use a cloth dampened with hot water to rub back some of the wax to the surface of the plaster.

Wax mixture

The red wax pigment droplets appear to be suspended between the wax layers, with some color bleeding out across the surface.

MATERIALS
• Clear wax
• Red wax pigment

PREPARATION Allow the plaster to dry completely. Heat up enough wax to cover the sculpture in a saucepan over a low heat.

METHOD When the wax is molten, pour it over the surface of the sculpture. Before the wax hardens, drop on some red wax pigment. Heat up the same amount of wax again, and when molten, pour it over the sculpture and allow to harden.

Wax and sand

The plaster surface can just about be made out through this thick layer. Each layer appears separate with the sand trapped between plaster and wax.

MATERIALS
• Clear wax
• Red wax pigment
• Sand

PREPARATION Allow the plaster to dry completely. Heat up enough wax to cover the sculpture in a saucepan over a low heat.

METHOD When the wax is molten, add some red wax pigment to achieve the desired opacity. Pour the red wax over the surface of the sculpture. When this has hardened, pour sand over the surface of the sculpture. Heat up the same amount of wax again and color as before. Pour this red wax over the sand-covered sculpture and allow to harden.

Mix of colored wax

Here the different colored waxes become part of the same layer.

MATERIALS
• Clear wax
• Red wax pigment
• Yellow wax pigment

PREPARATION Allow the plaster to dry completely. Heat up enough wax to cover the sculpture in a saucepan over a low heat.

METHOD When the wax is molten, add some red wax pigment to achieve the desired opacity. Pour this over the surface of the sculpture and allow to harden. Scratch through the red wax to the plaster using a sharp point, such as a knife or a nail. Heat up enough wax to cover the sculpture again, and when molten, add some yellow wax pigment to achieve the desired opacity. Pour over the scratched red wax and allow to harden.

Speckled wax on wax

The smooth orange wax surface contrasts with the splattered yellow droplets of wax, which gives a bumpy effect.

MATERIALS
- Clear wax
- Orange wax pigment
- Yellow wax pigment
- Spoon

PREPARATION Allow the plaster to dry completely. Heat up enough wax to cover the sculpture in a saucepan over a low heat.

METHOD When the wax is molten, add some orange wax pigment to achieve the desired opacity. Pour this over the surface of the sculpture and allow to harden. Heat up more wax, and when molten, add yellow wax pigment to achieve the desired opacity. Use a spoon to flick the yellow wax onto the surface of the sculpture. Remember: the wax is hot so take extra care.

Speckled wax on plaster

A tactile, bumpy surface is created by building up layers of colored wax. The variety in size of the droplets gives the illusion of minerals that make up stone.

MATERIALS
- Clear wax
- Yellow wax pigment
- Spoon

PREPARATION Allow the plaster to dry completely. Heat up enough wax to cover the sculpture in a saucepan over a low heat.

METHOD When the wax is molten, add some yellow wax pigment to achieve the desired opacity. Use a spoon to flick this onto the surface of the sculpture. Remember: the wax is hot so take extra care.

Wax and spray paint

A striking contrast is made between the warm, textural quality of the yellow wax and the flat, dense opaque spray paint that pools in the crevices of the wax.

MATERIALS
- Clear wax
- Yellow wax pigment
- Gray enamel spray paint
- Soft cloth

PREPARATION Allow the plaster to dry completely. Heat up enough wax to cover the sculpture in a saucepan over a low heat.

METHOD When the wax is molten, add some yellow wax pigment to achieve the desired opacity. Pour this over the surface of the sculpture and allow to harden. Spray over with gray enamel spray paint. Before it has a chance to dry, rub the paint back with a soft cloth.

Wax and polyester resin

The blue wax varies in tone, depending on the texture of the surface.

MATERIALS
- **Clear wax**
- **Polyester resin and hardener**
- **Blue wax pigment**
- **Acetone or recommended cleaner**

PREPARATION Allow the plaster to dry completely. Heat up enough wax to cover the sculpture in a saucepan over a low heat. Weigh out enough polyester resin to cover the sculpture and add the catalyst in a ratio as recommended by the manufacturer.

METHOD When the wax is molten, add blue wax pigment to the desired opacity. Pour over the surface and allow to harden. Scratch into the wax surface with a sharp point. Brush an even coat of polyester resin and hardener mix over the wax. Clean the brush immediately with acetone or the manufacturer's recommended cleaner.

Polyester resin

Polyester resin can be transparent, opaque, colored, or filled with metal powder. It forms a protective layer that is impervious to water. See page 199 for safety precautions.

MATERIALS
- **Polyester resin and hardener**
- **Acetone or recommended cleaner**

PREPARATION Allow the plaster to dry completely. Weigh out enough polyester resin to cover the sculpture and add the catalyst in a ratio as recommended by the manufacturer.

METHOD Brush an even coat of polyester resin and hardener mix over the sculpture and leave to cure. Clean the brush immediately with acetone or the manufacturer's recommended cleaner. Repeat this process to paint on another coat of resin.

Milk

Building up layers of milk can dramatically alter the appearance of plaster, creating a marble-like effect.

MATERIALS
- **Milk**
- **Soft cloth**

PREPARATION Allow the plaster to dry completely.

METHOD Brush on one coat of fresh milk. Allow the plaster to absorb this and continue painting on further coats of milk, allowing each coat to dry before adding the next. A minimum of four coats is advisable. When the last coat has dried, use a soft cloth to buff up the plaster to a soft sheen.

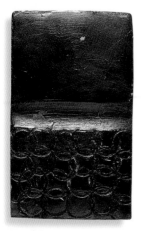
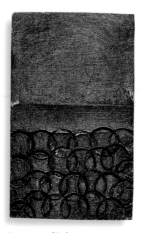
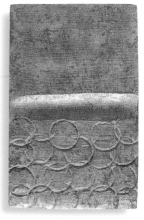

Graphite paste

Graphite paste can be used to create a convincing metal effect that looks like iron. It can be buffed up to a fine polish.

MATERIALS
- Shellac
- Mineral spirits
- Graphite/iron paste
- Soft cloth

PREPARATION Allow the plaster to dry completely.

METHOD Seal the surface with one coat of shellac and allow to dry. Clean the brush with mineral spirits. Use a cloth, toothbrush, or shoe brush to apply graphite/iron paste to the surface of the sculpture, working it in well. When dry, use a soft cloth to buff it up to a nice shine.

Boot polish

A leathery effect is achieved by building up layers of polish. Thicker, darker areas occur in the crevices and even fine lines are picked up and highlighted.

MATERIALS
- Shellac
- Mineral spirits
- Boot polish
- Shoe brush
- Toothbrush
- Soft cloth

PREPARATION Allow the plaster to dry completely.

METHOD Seal the surface with shellac and allow to dry. Clean the brush with mineral spirits. With a shoe brush, work boot polish into the surface of the sculpture; use a toothbrush for crevices and areas that are difficult to reach. Use a soft cloth or another shoe brush to buff up the surface of the sculpture.

Fake verdigris

This simple effect creates a beautiful green-gold finish which will enhance a variety of surfaces.

MATERIALS
- Shellac
- Mineral spirits
- Light green emulsion
- Dark green emulsion
- Mid-brown emulsion
- Gold paint
- Stencil brush
- Soft cloth

PREPARATION Allow the plaster to dry completely.

METHOD Seal the surface with shellac and allow to dry. Clean the brush with mineral spirits. Paint on a coat of brown emulsion and let dry. Stiple on dark green emulsion with the stencil brush and let dry. Repeat with the light green emulsion. When dry, take a little gold paint and smear lightly on the surface. Buff gently with the soft cloth.

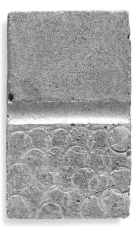

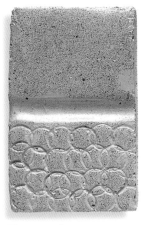

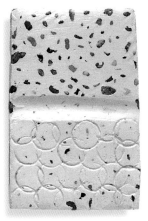

ADDITIONS
Coarse sand

The sand becomes an integral part of the plaster and not just a layer giving the illusion of sand running through the whole piece.

MATERIALS
• Coarse sand
• Plaster
• Water

PREPARATION Wash the coarse sand to get rid of any impurities and dirt, then make up a mix of plaster.

METHOD Add approximately 10 percent (by volume) of sand to the plaster and mix it in well. Pour into the mold immediately, tapping the side of the mold to ensure an even distribution of plaster in the mold.

Fine sand

Sand can be purchased from a builder's merchant or collected from a sandy beach.

MATERIALS
• Fine sand
• Plaster
• Water

PREPARATION Wash the fine sand to get rid of any impurities and dirt. Make up a mix of plaster.

METHOD Add approximately 10 percent (by volume) of sand to the plaster and mix it in well. Pour into the mold immediately, tapping the side of the mold to ensure there is an even distribution of plaster in the mold.

Medium gravel

The gravel is embedded at different depths within the plaster, an effect that could be seen to imitate stone.

MATERIALS
• Medium gravel
• Plaster
• Water

PREPARATION Wash the gravel to get rid of any impurities and dirt. Make up a mix of plaster.

METHOD Add approximately 10 percent (by volume) of gravel to the plaster and mix it in well. Pour into the mold immediately, tapping the side of the mold to ensure there is an even distribution of plaster in the mold.

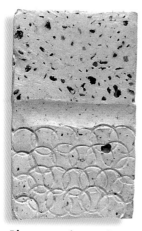
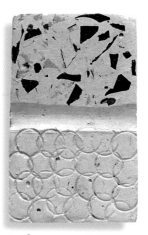

Blue aquarium grit

Colorful fragments emerge from the plaster, almost imitating minerals found in stone.

MATERIALS
- **Blue aquarium grit**
- **Plaster**
- **Water**

PREPARATION Wash the grit to get rid of any impurities. Make up a mix of plaster.

METHOD Add approximately 10 percent (by volume) to the plaster and mix it in well. Pour into the mold immediately, tapping the side of the mold to ensure an even distribution of plaster.

Broken ceramic tile pieces

The broken ceramic pieces form an interesting pattern. The larger pieces that sink into the plaster while in the mold appear on the surface. This effect could be seen as an imitation of granite.

MATERIALS
- **Ceramic wall tiles**
- **Plaster**
- **Water**

PREPARATION Place some ceramic wall tiles in a plastic sack or bag and use a hammer to smash the tiles into small pieces. Use gloves when handling the tiles since they will be sharp. Make up a mix of plaster.

METHOD Add approximately 5 percent (by volume) of broken tile pieces to the plaster and mix it in well. Pour into the mold immediately, tapping the side of the mold to ensure you have an even distribution of plaster.

Chopped brown paper strips

The weight of the paper is less than grit. Therefore, the strips are suspended in the plaster, rather than sinking and appearing on the surface.

MATERIALS
- **Brown paper**
- **Plaster**
- **Water**
- **Scissors**

PREPARATION Use scissors to cut up strips of brown paper. The size of strip will depend on the size of the mold. In this case they are $1/8$ x 1-$1/2$ inches (3 x 40mm). Make up a mix of plaster.

METHOD Add the paper strips to the plaster, stirring them well into the mix. Pour this mix into the mold immediately, tapping the side of the mold to ensure you have an even distribution of plaster.

Straw

A subtle effect is created using straw. Pale, delicate shapes form, reminiscent of objects trapped in limestone.

MATERIALS
- Straw
- Plaster
- Water
- Scissors

PREPARATION Use scissors to cut the straw into short lengths, about 1-¹/₂ inches (4cm) long. Make up a mix of plaster.

METHOD Add the straw lengths to the plaster, stirring them well into the mix. Pour this mix into the mold immediately, tapping the side of the mold to evenly distribute the mix.

Coarse scrim

The scrim leaves a textural effect, with the weave of the scrim just about visible.

MATERIALS
- Coarse scrim
- Plaster
- Water
- Scissors

PREPARATION From a 4-inch (10cm) wide roll, cut strips of scrim about 2 inches (5cm) long. Make up a plaster mix.

METHOD Add approximately 10 percent (by volume) of scrim to the plaster and mix it in well. Pour into the mold immediately, tapping the side of the mold to ensure an even distribution of plaster mix.

Human hair

A hairdressing salon or barbers' shop is a good place to source hair.

MATERIALS
- Human hair
- Plaster
- Water
- Scissors

PREPARATION Use scissors to cut the hair into short lengths, about 1-¹/₂ inches (4cm) long. Make up a plaster mix.

METHOD Add the hair to the plaster and stir the lengths into the mix well. Pour this mix into the mold immediately, tapping the side of the mold to ensure an even distribution of plaster mix.

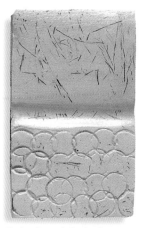

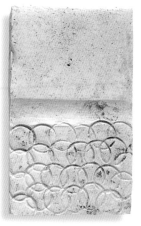

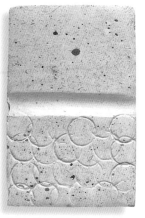

Paintbrush bristles

These paintbrush bristles form a series of very linear marks.

MATERIALS
- Old paintbrushes
- Plaster
- Water
- Scissors

PREPARATION Use scissors to cut the bristles from old paintbrushes into short lengths. Make up a mix of plaster.

METHOD Add approximately 10 percent (by volume) of bristles to the plaster and mix it in well. Pour into the mold immediately, tapping the side of the mold to ensure an even distribution of plaster mix in the mold.

Crushed charcoal

The charcoal and plaster mix to form a chalky, speckled gray finish. The gray of the charcoal picks up the texture of the plaster.

MATERIALS
- Barbeque charcoal
- Plaster
- Water

PREPARATION Place some barbeque charcoal in a plastic sack or bag and use a hammer to crush it into small pieces. Then make up a plaster mix.

METHOD Add approximately 10 percent (by volume) of crushed charcoal to the plaster and mix it in well. Pour into the mold immediately, tapping the side of the mold to ensure an even distribution of plaster mix in the mold.

Sawdust

A lumberyard or pet store is a good place to source sawdust.

MATERIALS
- Sawdust
- Plaster
- Water

PREPARATION Make up a mix of plaster.

METHOD Add approximately 10 percent (by volume) of sawdust to the plaster and mix it in well. Pour the mix into the mold immediately, tapping the side of the mold to ensure an even distribution of plaster mix in the mold.

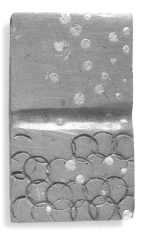

Polystyrene balls

The polystyrene balls that sink to the bottom of the plaster appear on the surface like bubbles.

MATERIALS
• Water
• Brown artists' acrylic paint
• Plaster
• Polystyrene balls

PREPARATION Pour water into a plastic mixing bowl and add brown acrylic paint. Mix it well into the water to obtain a strong hue. Now add the plaster and make a mix in the usual way.

METHOD Add approximately 10 percent (by volume) of polystyrene balls to the plaster and mix it in well. Pour into the mold immediately, tapping the side of the mold to ensure an even distribution.

Wire wool

Wire wool makes very fine markings in the plaster, creating a subtle and natural looking effect.

MATERIALS
• Wire wool
• Plaster
• Water
• Scissors

PREPARATION Use a sharp pair of scissors to cut wire wool into short lengths, about 1-½ inches (4cm) long. Make up a mix of plaster.

METHOD Add the wire wool pieces to the plaster, stirring them well into the mix. Pour this mix into the mold immediately, tapping the side of the mold to ensure an even distribution.

Staples

The variety and positioning of the staples creates an interesting patterned surface.

MATERIALS
• Stationery staples
• Plaster
• Water

PREPARATION Separate a quantity of stationery staples from the strips in which they are sold. Make up a mix of plaster.

METHOD Add approximately 10 percent (by volume) of staples to the plaster and mix in well. Pour into the mold immediately, tapping the side of the mold to evenly distribute the plaster mix.

Iron powder

Iron powder works as quite a strong colorant, with the color successfully distributed throughout the plaster.

MATERIALS
- Plaster
- Water
- Iron powder

PREPARATION Make up a mix of plaster.

METHOD Add approximately 10 percent (by volume) of iron powder to the plaster and mix it in well. Pour the mix into the mold immediately, tapping the side of the mold to ensure an even distribution of plaster in the mold.

Brewed tea

A quite surprisingly highly speckled gray pattern is created by the tea.

MATERIALS
- Tea
- Plaster
- Water

PREPARATION Brew up a very strong pot of tea. Leave it to brew overnight to ensure that a very strong brown color is achieved. Pour water into your plaster-mixing bowl and add the strong tea. Now add the plaster and make a mix in the usual way.

METHOD Pour the plaster mix into the mold immediately, tapping the side of the mold to ensure an even distribution of plaster mix in the mold.

Instant coffee

Coffee is dissolved in water and so works as a colored stain. It creates an effective, mottled finish.

MATERIALS
- Water
- Instant coffee granules
- Plaster

PREPARATION Pour water into a plastic mixing bowl and add some instant coffee granules. Stir to make sure it is mixed up well. Now add the plaster and make a mix in the usual way.

METHOD Pour the plaster into the mold immediately, tapping the side of the mold to ensure an even distribution.

Red and white plaster

The red is bleached out in places. You can see where the white plaster mix has run into the red, producing a variety of shades of pink and red.

MATERIALS
• Water
• **Red artists' acrylic paint**
• Plaster

PREPARATION Pour water into your plaster-mixing bowl and add red acrylic paint. Mix it into the water well to obtain a strong hue. Now add the plaster and make a mix in the usual way.

METHOD Make another mix of plaster in the usual way and add this to the red plaster. Pour the mix into the mold immediately, tapping the side of the mold to ensure an even distribution.

Red plaster

When paint is mixed into the plaster the color becomes an integral part, rather than a superficial layer. A uniform color is made; however, the intensity of the color is lost when mixed with water. To achieve a greater intensity of color, raw pigment is preferable to paint.

MATERIALS
• Water
• **Red artists' acrylic paint**
• Plaster

PREPARATION Pour water into your plaster-mixing bowl and add red acrylic paint. Mix it into the water well to obtain a strong hue. Now add the plaster and make a mix in the usual way.

METHOD Pour the red plaster mix into the mold immediately, tapping the side of the mold to ensure an even distribution of plaster in the mold.

Marbled effect

A watery-like surface is created where the green plaster bleeds into the white. The green plaster was not stirred thoroughly to produce a uniform color, resulting in a range of green hues.

MATERIALS
• Water
• **Green artists' acrylic paint**
• Plaster

PREPARATION Pour water into your plaster-mixing bowl and add green acrylic paint. Mix the color into the water well to obtain a strong hue. Add the plaster and make a mix in the usual way.

METHOD Make up a normal mix of plaster and stir this into the green mix to create a marbled effect. Pour the mix into the mold immediately, tapping the side of the mold to ensure an even distribution.

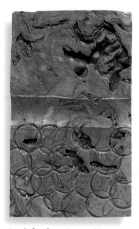

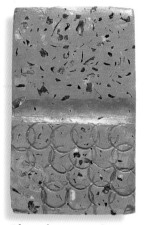

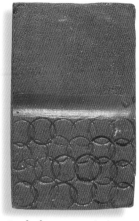

Swirled paint effect

Patterns can be created using strong colors while mixing the plaster.

MATERIALS
• Water
• Blue and orange artists' acrylic paint
• Plaster

PREPARATION Pour water into a plastic mixing bowl and add blue acrylic paint. Mix it into the water well to obtain a strong hue. Now add the plaster and make a mix in the usual way.

METHOD Add some orange acrylic paint to the plaster mix. Use a stick to swirl it around to create a stripy effect and quickly pour the mix into the mold to retain the effect. Tap the side of the mold to ensure the plaster is evenly distributed.

Blue plaster and broken glass

The glassy fragments look good as a contrast to the paler matte finish of the plaster.

MATERIALS
• Glass bottle
• Water
• Blue artists' acrylic paint
• Plaster

PREPARATION Place a glass bottle in a plastic sack or bag and smash it into small pieces with a hammer, while wearing gloves for protection. Pour water into your plaster-mixing bowl and add blue acrylic paint. Mix the paint into the water well to obtain a strong hue. Now add the plaster and make a mix in the usual way.

METHOD Add approximately 10 percent (by volume) of broken glass to the blue plaster. Mix it in well with a stick; don't use your hands. Pour the mix into the mold immediately, tapping the side of the mold to ensure an even distribution.

Red plaster and glass powder

Glass powder can be obtained from ceramic glaze suppliers.

MATERIALS
• Water
• Red artists' acrylic paint
• Plaster
• Glass powder

PREPARATION Pour water into your plaster-mixing bowl and add red acrylic paint. Mix the paint into the water well to obtain a strong hue. Now add the plaster and make a mix in the usual way.

METHOD Add approximately 10 percent (by volume) of glass powder to the red plaster. Mix it in well with a stick; don't use your hands. Pour the mix into the mold immediately, tapping the side of the mold to ensure an even distribution of plaster in the mold.

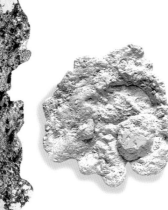

CASTING OFF

Casting off surfaces is a very quick, immediate way of making a variety of textures, markings, and shapes in plaster. It is also cheap and relatively easy to do. Even the most mundane of objects can leave surprising and interesting details in the plaster.

Coarse sand

The surface of the plaster appears dimpled, cratered, and rough to the touch. It has the appearance of weathered rock.

MATERIALS
• Plaster
• Water
• Coarse sand

PREPARATION Make up a mix of plaster.

METHOD Form a pile of coarse sand on a flat surface. Pour the plaster mix onto the sand and let the plaster go off. Once set, pull the plaster from the sand.

Crushed kiln brick

Kiln brick can be substituted for breeze block or household brick.

MATERIALS
• Plaster
• Water
• Kiln brick pieces

PREPARATION Place some kiln brick pieces in a plastic sack or bag and then smash them into small pieces with a hammer. Make up a mix of plaster.

METHOD Place the crushed kiln brick pieces on a flat surface and pour plaster over them. Let the plaster go off. Once the plaster has set, pull it away from the crushed kiln brick pieces.

Polystyrene balls

A regular and fairly even pattern forms with the negative shape of the ball as a dip in the plaster.

MATERIALS
• Plaster
• Water
• Polystyrene balls

PREPARATION Make up a mix of plaster.

METHOD Place a pile of polystyrene balls on a smooth surface and pour the plaster mix over them. Let the plaster go off. Once set, pull the plaster from the polystyrene balls.

Human hair

An interesting effect is created by leaving some of the hair on the plaster.

MATERIALS
• Plaster
• Water
• Human hair

PREPARATION Make up a mix of plaster.

METHOD Place a clump of hair on a flat surface and pour the plaster over it. Let the plaster go off. Once the plaster has almost set, pull the plaster from the hair as required.

Crumpled plastic bag

The bag creates quite an organic series of lines, reminiscent of the layers making up sedimentary stone.

MATERIALS
• Plaster
• Water
• Plastic bag

PREPARATION Make up a mix of plaster.

METHOD Crumple up a plastic bag and position it on a flat surface. Pour the plaster onto the bag and let it go off. Once the plaster has set, pull it away from the plastic bag.

Drinking straws

The uniformity in the size of the straws and the use of repetition creates a regular series of lines.

MATERIALS
• Plaster
• Water
• Drinking straws

PREPARATION Make up a mix of plaster.

METHOD Lay down a row of drinking straws, side-by-side, on a flat surface. Pour the plaster onto the straws and let it go off. Once the plaster has set, pull it away from the drinking straws.

Folded plastic bag

The lack of texture on a plastic bag leaves the plaster very smooth and featureless, apart from the folds that look more dramatic in the plaster because of this.

MATERIALS
• Plaster
• Water
• Plastic bag

PREPARATION Make up a mix of plaster.

METHOD Fold a plastic bag and position it on a flat surface. Pour the plaster onto the bag and allow it to go off. When it has set, pull the plaster away from the bag.

Folded fabric

The fabric leaves subtle impressions in the plaster, which picks up the weave of the material.

MATERIALS
• Plaster
• Water
• Fabric

PREPARATION Make up a mix of plaster.

METHOD Fold some fabric and place it on a flat surface. Pour plaster over the fabric and let the plaster go off. Once the plaster has set, pull it away from the fabric.

Soft sand

The sand leaves a very fine, lightly textured surface full of very small pores.

MATERIALS
• Plaster
• Water
• Soft sand

PREPARATION Make up a mix of plaster.

METHOD Pour some soft sand onto a flat surface and pat it down level with your hand. Pour plaster over the sand and leave it to go off. Once the plaster has set, pull it away from the sand.

Inspirational pieces

Floating Form
Ken Smith

The white and soft nature of plaster is used in this piece to create the impression of a gentle and dreamy floatiness. There are no clear boundaries, so the light falls over the matte, convex surface to create subtle shades of light and shadow. This sculpture was first modeled in clay, then cast, and finally sanded with increasingly fine grades of sandpaper. The surface is untreated, so it needs to be protected from any substance that could stain or discolor the plaster.

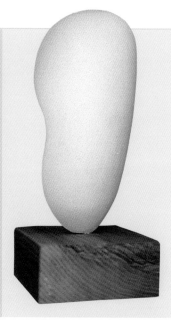

Orgy
Sarah Wesley

This sculptural relief illustrates the versatile nature of plaster. Extruded while in a flexible state, it adheres to itself while maintaining the tube-like shape of the extrusion. Plaster sets quickly and this has also been used to its advantage by working fast to create a spontaneous, energetic piece with many layers that appear chaotic but invite the eye of the viewer to find rhythms, depths, and order. Once thoroughly dry, the plaster has been spray-painted to create a gloss metallic finish.

HO-1 1988
ALAN SANDMAN

Two female figures have been molded from life using plaster bandage, then reassembled to create a sculpture that looks both forward and backward. By using parts of the human figure, white material, and cloth-like folds where the two figures are joined, associations with ancient Greek and Roman sculpture are invoked.

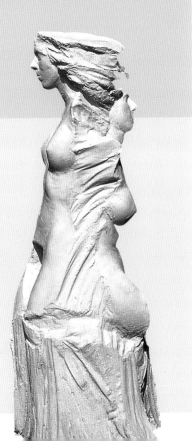

TWISTED
SARAH WESLEY

The energetic twist of this sculpture is shown to its best advantage by the clean lines and surfaces, which allow the eye to readily follow the dynamic movement. The plaster has been carved and sanded with a great deal of care, to ensure exact, continuously curving edges.

Resin

Polyester resin is strong and lightweight. It is also highly inflammable and its fumes are harmful in excess; but don't let this put you off because, if used sensibly and safely, it is an ideal casting material for sculpture. A range of colored pigments can be added to the resin, negating the need to color the sculpture after it has been cast. More significantly, polyester resin has the capability of mimicking other materials by the addition to the resin of fillers prior to application. Many fillers are available, such as bronze, brass, copper, aluminum, iron, marble, and slate. Used correctly, a sculpture cast with polyester resin and bronze filler will be indistinguishable from a sculpture cast in bronze using the lost wax process. The difference becomes apparent only when lifted, since the resin cast is a lot lighter.

If adding pigments or material fillers to the resin, you will need to measure out and mix together the quantity of resin and pigment or filler needed for the entire job to ensure that there are no discrepancies in the coloring of the cast.

Casting with resin

In the following steps the ratio used is 0.17fl oz (5ml) hardener to 1lb (450g) polyester resin. In this example, 3-½oz (100g) of resin is used and 0.04fl oz (1.25ml) of hardener.

YOU WILL NEED:
- Latex gloves, respirator mask, and goggles
- Glass jars
- Weighing scales
- Multipurpose polyester resin
- Red opaque polyester pigment
- Spoon and wooden stirrer
- Auto dispenser calibrated measuring container
- Liquid hardener
- ½-inch (1.5cm) paintbrush
- Rubber mold
- Acetone or recommended cleaner
- Fiberglass matting

SAFETY
Polyester resin is highly flammable and excessive exposure to its fumes is harmful, so take the following precautions. This advice should be used in association with the specific advice given by the manufacturer:
- Always work in a well-ventilated area.
- Wear a respirator mask, clear goggles, and latex gloves.
- Always discard containers that have been used to mix polyester resin.
- Brushes should be cleaned with the cleaner recommended by the manufacturer.
- Store polyester resin in a cool, dark place.
- Wear latex gloves when handling fiberglass matting.

1 Place a glass jar on weighing scales and turn the dial to 0. Pour in 3-½oz (100g) of polyester resin, or the amount estimated for the job.

2 To ensure an even distribution of pigment in the resin, first pour a small amount of this resin into another jar. Now add enough red opaque polyester pigment to achieve the desired opacity.

3 Pour this colored, concentrated resin back into the first jar and mix in with the rest of the resin.

4 Pour half of the resin and pigment mix into another jar and add the measured amount of hardener, following the manufacturer's instructions. Remember that you are currently working with half of the original weighed amount of resin.

5 Paint an even layer of the gel coat onto the inside of a rubber mold and leave to cure.

6 While the gel coat is curing, cut ½-inch (1.5cm) wide strips of fiberglass matting.

7 Add the necessary amount of hardener to the rest of the resin and pigment mix before painting on another layer on top of the gel coat. Clean the brush with acetone or the manufacturer's recommended cleaner.

8 Lay down a piece of fiberglass matting and use a brush loaded with resin and pigment mix to push it into the corners of the mold. Continue tamping down to ensure that the fiberglass matting is fully impregnated with the resin and pigment mix.

9 Continue laminating, overlapping the fiberglass matting and tamping down and fully impregnating it with the resin mix. When complete, leave to cure.

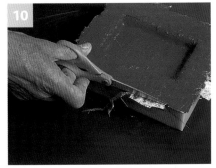

10 While the resin is curing, use scissors to trim off any excess fiberglass matting and resin.

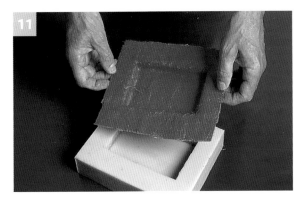

11 When the resin has cured, the cast can be easily lifted out of the rubber mold.

POLYESTER RESIN

The first coat of resin applied to the inside surface of the mold is called the gel coat. Once the mold is removed this becomes the surface of the sculpture. It is important that you know what you want this surface to look like. The following examples illustrate some of the pigments and fillers that can be added to the gel coat. You will need to do some basic calculation to work out the amount of filler you need to add to the resin, but as a general rule you will need to add equal parts (by volume) of filler to resin.

Laminated polyester resin

Always mix together enough resin and pigment or filler to complete the whole job, to ensure there are no discrepancies in the coloring of the cast.

MATERIALS
• **Multipurpose polyester resin**
• **Liquid hardener**
• **Acetone or recommended cleaner**

METHOD Taking the necessary safety precautions, (see page 199) mix together enough polyester resin and hardener to suit your mold, following the manufacturer's instructions. Stir thoroughly and use immediately. Paint an even layer of the gel coat onto the inside of the mold and leave to cure. Clean tools with acetone or the recommended cleaner. Once the gel coat has cured continue to laminate the cast.

Poured polyester resin

If you are pouring resin into a small mold you will need to have an idea of the volume of the mold. A good way to judge this is to fill the mold with water and then pour it into a calibrated measuring jug. It is absolutely essential that you thoroughly dry out the mold before making the resin cast.

MATERIALS
• **Multipurpose polyester resin**
• **Liquid hardener**
• **Acetone or recommended cleaner**

METHOD Taking the necessary safety precautions, mix together enough polyester resin and hardener to suit your mold. Stir thoroughly and use immediately. Slowly pour the resin mix into the mold. Allow it to settle before gently tapping the side of the mold to expel any air bubbles. If necessary, add more resin mix to fill the mold. Once the resin has cured remove it from the mold. Clean tools with acetone or the recommended cleaner. Safely dispose of any leftover resin.

PIGMENTS

Colored pigments can be added to the resin.

Blue translucent pigment: poured

MATERIALS
• Multipurpose polyester resin
• Blue translucent polyester pigment
• Liquid hardener
• Acetone or recommended cleaner

PREPARATION Take the necessary safety precautions (see page 199) and weigh out the required amount of polyester resin for the mold.

METHOD Pour a small quantity of the weighed resin into a container and add blue pigment (between 2 and 5 percent of the weighed amount of resin), stirring continuously into a smooth paste. Return the paste to the remainder of the weighed resin, stirring to ensure even color distribution. Mix in the hardener as recommended by the manufacturer. Follow the instructions for pouring resin on page 202.

Green translucent pigment: laminated

MATERIALS
• Multipurpose polyester resin
• Green translucent polyester pigment
• Liquid hardener
• Acetone or recommended cleaner

PREPARATION Take the necessary safety precautions (see page 199) and weigh out the required amount of polyester resin for the mold.

METHOD Pour a small quantity of resin into another container and add green translucent polyester pigment (between 2 and 5 percent of the weighed amount of resin), stirring continuously into a smooth paste. Return the paste to the remainder of the resin, stirring again to ensure even distribution of color. Mix in the hardener as recommended by the manufacturer. Follow the instructions for laminating resin on page 202.

Yellow translucent pigment: laminated

MATERIALS
• Multipurpose polyester resin
• Yellow translucent polyester pigment
• Liquid hardener
• Acetone or recommended cleaner

PREPARATION Take the necessary safety precautions (see page 199) and weigh out the required amount of polyester resin for the mold.

METHOD Pour a small quantity of resin into another container and add yellow translucent polyester pigment, (between 2 and 5 percent of the weighed amount of resin) stirring continuously into a smooth paste. Return the paste to the remainder of the weighed resin, stirring continuously to ensure even distribution of color. Mix in the hardener as recommended by the manufacturer. Follow the instructions for laminating resin on page 202.

Green and red translucent pigments: poured

MATERIALS
- Multipurpose polyester resin
- Green translucent polyester pigment
- Red translucent polyester pigment
- Liquid hardener
- Acetone or recommended cleaner

PREPARATION See page 203.

METHOD Pour a small quantity of resin into a container and add green pigment, (between 2 and 5 percent of the weighed amount of resin) stirring to achieve a paste. Pour a little of the weighed resin into another container and add red pigment, stirring continuously. Pour half of the remainder of the weighed resin into another container. Return the red paste to one jar of resin and the green to the other. Stir well to ensure an even distribution of color. Mix in the hardener as recommended by the manufacturer. Follow the instructions for pouring resin on page 202.

Red translucent pigment: laminated

MATERIALS
- Multipurpose polyester resin
- Red translucent polyester pigment
- Liquid hardener
- Acetone or recommended cleaner

PREPARATION See page 203.

METHOD Pour a small quantity of resin into a container and add red pigment, (between 2 and 5 percent of the weighed amount of resin) stirring continuously into a smooth paste. Return the paste to the remainder of the resin, stirring again to ensure even distribution of color. Mix in the hardener as recommended by the manufacturer. Follow the instructions for laminating resin on page 202.

Yellow translucent pigment and onyx filler: laminated

MATERIALS
- Multipurpose polyester resin
- Yellow translucent polyester pigment
- Liquid hardener
- Acetone or recommended cleaner
- Onyx filler

PREPARATION See page 203.

METHOD Pour a small quantity of resin into a container and add yellow pigment, stirring continuously to achieve a smooth paste (between 2 and 5 percent of the weighed amount of resin). Return the colored paste to the remainder of the weighed resin and stir to ensure an even distribution of color. Measure an equal volume of onyx filler and add it to the resin. Stir well to combine the two. Mix in the hardener as recommended by the manufacturer. Follow the instructions for laminating resin on page 202.

Brown opaque pigment

MATERIALS
- Multipurpose polyester resin
- Brown opaque polyester pigment
- Liquid hardener
- Acetone or recommended cleaner

PREPARATION See page 203.

METHOD Pour a small quantity of resin into a container and add brown opaque polyester pigment, (between 2 and 5 percent of the weighed amount of resin) stirring continuously into a smooth paste. Return the paste to the remainder of the resin, stirring again to ensure an even distribution of color. Mix in the hardener as recommended by the manufacturer. Laminate or pour as required following the instructions on page 202.

Ivory opaque pigment

MATERIALS
- Multipurpose polyester resin
- Ivory opaque polyester pigment
- Liquid hardener
- Acetone or recommended cleaner

PREPARATION See page 203.

METHOD Pour a small quantity of resin into a container and add ivory opaque polyester pigment, (between 2 and 5 percent of the weighed amount of resin) stirring continuously to achieve a smooth paste. Return the colored paste to the remainder of the weighed resin and stir to ensure an even distribution of color. Measure an equal volume of onyx filler and add it to the resin. Stir well to combine the two. Mix in the hardener as recommended by the manufacturer. Laminate or pour as required following the instructions on page 202.

Yellow opaque pigment

MATERIALS
- Multipurpose polyester resin
- Yellow opaque polyester pigment
- Liquid hardener
- Acetone or recommended cleaner

PREPARATION See page 203.

METHOD Pour a small quantity of resin into a container and add yellow opaque polyester pigment, (between 2 and 5 percent of the weighed amount of resin) stirring continuously into a smooth paste. Return the colored paste to the remainder of the weighed resin and stir to ensure an even distribution of color. Mix in the hardener as recommended by the manufacturer. Laminate or pour as required following the instructions on page 202.

Green opaque pigment

MATERIALS
- Multipurpose polyester resin
- Green opaque polyester pigment
- Liquid hardener
- Acetone or recommended cleaner

PREPARATION See page 203.

METHOD Pour a small quantity of resin into a container and add green opaque pigment, (between 2 and 5 percent of the weighed amount of resin) stirring continuously to achieve a smooth paste. Return the colored paste to the remainder of the weighed resin and stir to ensure an even distribution of color. Mix in the hardener as recommended by the manufacturer. Laminate or pour as required following the instructions on page 202.

Red opaque pigment

MATERIALS
- Multipurpose polyester resin
- Red opaque polyester pigment
- Liquid hardener
- Acetone or recommended cleaner

PREPARATION See page 203.

METHOD Pour a small quantity of resin into a container and add red opaque pigment, (between 2 and 5 percent of the weighed amount of resin) stirring continuously into a smooth paste. Return the paste to the remainder of the resin, stirring again to ensure an even distribution of color. Mix in the hardener as recommended by the manufacturer. Laminate or pour as required following the instructions on page 202.

White opaque pigment

MATERIALS
- Multipurpose polyester resin
- White opaque polyester pigment
- Liquid hardener
- Acetone or recommended cleaner

PREPARATION See page 203.

METHOD Pour a small quantity of resin into another container and add white opaque pigment, (between 2 and 5 percent of the weighed amount of resin) stirring continuously into a smooth paste. Return the paste to the weighed resin, stirring continuously to ensure an even distribution of color. Mix in the hardener as recommended by the manufacturer. Laminate or pour as required following the instructions on page 202.

Aquarium stones, white opaque pigment, and plain resin: poured

MATERIALS
• Multipurpose polyester resin
• White opaque polyester pigment
• Aquarium stones
• Liquid hardener
• Acetone or recommended cleaner

PREPARATION See page 203.

METHOD Pour equal amounts of weighed resin into three separate containers. Pour a small quantity from the first container into a another container and add white pigment, (between 2 and 5 percent of the weighed amount of resin) stirring into a paste. Return this to the first container. Measure an equal volume of the aquarium stones and add it to the resin in the second container. Stir well. Add hardener to each of the three containers following the manufacturer's instructions and stir thoroughly. Slowly pour each of the resin mixes into different areas of the mold.

Scrim

MATERIALS
• Multipurpose polyester resin
• Liquid hardener
• Acetone or recommended cleaner
• Scrim

PREPARATION See page 203.

METHOD Pour half of the resin into another container and add the hardener, following the manufacturer's instructions and remembering that you are working with half the original weight. Stir thoroughly. Slowly pour the resin mix into the mold. Allow it to settle then gently tap the side of the mold to expel any air bubbles. Once the resin has fully cured, lay the scrim on top of it. Add hardener to the remaining resin and stir thoroughly. Pour into the mold as before.

Resin layers

MATERIALS
• Multipurpose polyester resin
• White opaque polyester pigment
• Red and black opaque polyester resins
• Liquid hardener
• Acetone or recommended cleaner

PREPARATION See page 203.

METHOD Pour equal amounts of resin into four separate containers: A for plain resin, B for the red mix, C for the black mix, and D for the white mix. Pour a small quantity from B into another container and add the red pigment, (between 2 and 5 percent of the weighed amount of resin) stirring into a paste. Return this to B. Stir well. Repeat this procedure with containers C and D. Add hardener to A and stir thoroughly. Slowly pour the resin mix in container A into the mold. When cured, add hardener to container B and repeat the pouring process. When this has cured repeat the process with containers C and D ensuring that the resin is fully cured each time.

Red, black, and white opaque pigments: poured

MATERIALS
• Multipurpose polyester resin
• Red, white, and black opaque polyester pigments
• Liquid hardener
• Acetone or recommended cleaner

PREPARATION See page 203.

METHOD Pour a small quantity of resin into a container and add red pigment, (between 2 and 5 percent of the weighed amount of resin) stirring continuously into a smooth paste. Return the paste to the remainder of the weighed resin, stirring continuously. Mix in the hardener as recommended by the manufacturer. Slowly pour the resin mix into the mold. Before the resin starts to cure, pour black and white pigments onto the surface. Leave to cure.

Red translucent and blue opaque pigments: poured and stirred

MATERIALS
• Multipurpose polyester resin
• Red translucent polyester pigment
• Blue opaque polyester pigment
• Liquid hardener
• Acetone or recommended cleaner

PREPARATION See page 203.

METHOD Pour equal amounts of resin into two separate containers, A and B. Pour a small quantity from container A into another container and add the red pigment, (between 2 and 5 percent of the weighed amount of resin) stirring continuously into a paste. Return this to container A and stir well. Repeat this procedure with container B, adding blue pigment. Add hardener to both containers and stir thoroughly. Pour the red resin mix into the mold, followed by the blue mix. Before they start to cure, gently stir with a stick.

Plain, red, black, and white resin layers

MATERIALS
• Multipurpose polyester resin
• Plain and white opaque polyester pigments
• Red and black opaque polyester resins
• Liquid hardener
• Acetone or recommended cleaner

PREPARATION See page 203.

METHOD Pour equal amounts of resin into four containers. Pour a small quantity from one into another container and add the red pigment stirring continuously. Return this paste to the first container and stir well. Repeat this procedure with the next container, adding black pigment. Add hardener and stir well. Slowly pour this mix into the mold. When cured, add hardener to the first container and repeat the pouring process. When this has cured repeat the procedure with the last two containers ensuring that the resin is fully cured before the next pour.

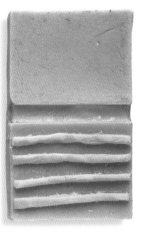

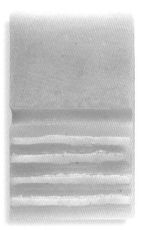

FILLERS

In the following examples equal parts by volume of filler to resin is used.

Kiln brick dust

This is the accumulation of residue found on the shelves of a ceramic kiln after firing clay. It makes a suitable material to add to resin since you can be sure that it is completely dry.

MATERIALS
• **Multipurpose polyester resin**
• **Kiln brick dust**
• **Liquid hardener**
• **Acetone or recommended cleaner**

PREPARATION See page 203.

METHOD Measure an equal volume of kiln brick dust and add it to the resin. Stir well to combine. Mix in the hardener as recommended by the manufacturer. Laminate or pour as required following the instructions on page 202.

Fine marble

This filler is very fine and will give you a very opaque white, sculptural surface.

MATERIALS
• **Multipurpose polyester resin**
• **Fine marble filler**
• **Liquid hardener**
• **Acetone or recommended cleaner**

PREPARATION See page 203.

METHOD Measure an equal volume of fine marble filler and add it to the resin, stirring well. Add the hardener as recommended by the manufacturer and stir thoroughly. Laminate or pour as required following the instructions on page 202.

Onyx

This filler can be used on its own to create an interesting opaque surface. Alternatively, it can be added to resin and pigment mixes to increase the opacity of the color.

MATERIALS
• **Multipurpose polyester resin**
• **Onyx filler**
• **Liquid hardener**
• **Acetone or recommended cleaner**

PREPARATION See page 203.

METHOD Measure out an equal volume of onyx filler and add it to the resin, stirring well. Add the hardener as recommended by the manufacturer. Stir thoroughly. Laminate or pour as required following the instructions on page 202.

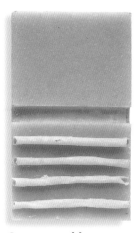

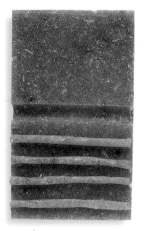

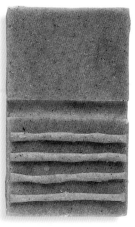

Coarse marble

This filler will give an interesting coarse marble finish.

MATERIALS
• **Multipurpose polyester resin**
• **Coarse marble filler**
• **Liquid hardener**
• **Acetone or recommended cleaner**

PREPARATION See page 203.

METHOD Measure an equal volume of coarse marble filler and add it to the resin. Stir well to combine the two. Mix in the hardener as recommended by the manufacturer. Laminate or pour as required following the instructions on page 202.

Sawdust

As an alternative you could try using coarser wood versions such as wood chips or pencil shavings.

MATERIALS
• **Multipurpose polyester resin**
• **Sawdust**
• **Liquid hardener**
• **Acetone or recommended cleaner**

PREPARATION See page 203.

METHOD Measure an equal volume of sawdust and add it to the resin, stirring well. Remember that the sawdust must be dry before you use it. Add the hardener as recommended by the manufacturer. Stir thoroughly. Laminate or pour as required following the instructions on page 202.

Fine sand

MATERIALS
• **Multipurpose polyester resin**
• **Fine sand**
• **Liquid hardener**
• **Acetone or recommended cleaner**

PREPARATION See page 203.

METHOD Measure out an equal volume of fine sand and add this to the resin, stirring well. Ensure the sand is completely dry before mixing it with the resin. Mix in the hardener as recommended by the manufacturer. Laminate or pour as required following the instructions on page 202.

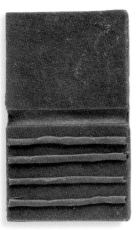

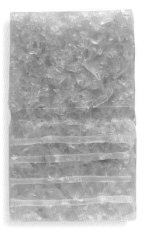

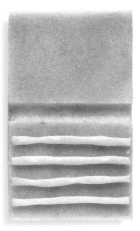

Coarse sand

There are many different grades of coarse sand, any of which would be suitable for this example.

MATERIALS
• Multipurpose polyester resin
• Coarse sand
• Liquid hardener
• Acetone or recommended cleaner

PREPARATION See page 203.

METHOD Measure an equal volume of coarse sand, ensuring it is completely dry, and add it to the resin. Stir well to combine the two. Add the hardener as recommended by the manufacturer and stir thoroughly. Laminate or pour as required following the instructions on page 202.

Broken glass

A good source of glass for this example would be the shattered glass from a car windshield. Be sure to wear leather gloves when handling the glass.

MATERIALS
• Multipurpose polyester resin
• Broken glass
• Liquid hardener
• Acetone or recommended cleaner

PREPARATION See page 203.

METHOD Measure an equal volume of broken glass and add it to the resin, stirring well. Add the hardener as recommended by the manufacturer. Stir thoroughly. Laminate or pour as required following the instructions on page 202.

Glass powder

This fine glass powder is available from specialist ceramic suppliers and you may find that it is available in different colors as well.

MATERIALS
• Multipurpose polyester resin
• Glass powder
• Liquid hardener
• Acetone or recommended cleaner

PREPARATION See page 203.

METHOD Measure out an equal volume of glass powder and add this to the resin, stirring well. Mix in the hardener as recommended by the manufacturer. Laminate or pour as required following the instructions on page 202.

Bark

There is a variety of different colored and textured barks that can be used with polyester resin.

MATERIALS
• **Multipurpose polyester resin**
• **Bark**
• **Liquid hardener**
• **Acetone or recommended cleaner**

PREPARATION See page 203.

METHOD Measure an equal volume of bark, ensuring it is thoroughly dry, and add it to the resin. Stir well to combine the two. Mix in the hardener as recommended by the manufacturer. Laminate or pour as required following the instructions on page 202.

Hair

Obviously there are lots of different hair colors available; a good source is a hairdressing salon.

MATERIALS
• **Multipurpose polyester resin**
• **Hair**
• **Liquid hardener**
• **Acetone or recommended cleaner**

PREPARATION See page 203.

METHOD Measure out an equal volume of hair and add this to the resin, stirring well. Add the hardener as recommended by the manufacturer. Stir thoroughly. Laminate or pour as required following the instructions on page 202.

Copper

When using metal fillers it may be necessary to increase the amount of hardener you add to the resin, since the filler will inhibit the cure time. Always read the manufacturer's instructions carefully.

MATERIALS
• **Multipurpose polyester resin**
• **Copper filler**
• **Liquid hardener**
• **Acetone or recommended cleaner**

PREPARATION See page 203.

METHOD Measure an equal volume of copper filler, or the volume recommended by the manufacturer, and add it to the resin. Stir well to combine the two. Add the hardener as recommended by the manufacturer (you may need to use double the hardener). Stir thoroughly. Laminate or pour as required following the instructions on page 202.

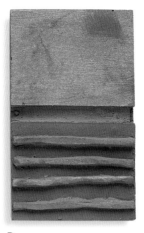
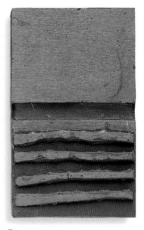

Aluminum

When using metal fillers it may be necessary to increase the amount of hardener added to the resin, since the filler will inhibit the cure time. Read the manufacturer's instructions carefully.

MATERIALS
• **Multipurpose polyester resin**
• **Aluminum filler**
• **Liquid hardener**
• **Acetone or recommended cleaner**

PREPARATION See page 203.

METHOD Measure an equal volume of aluminum filler, or the volume recommended by the manufacturer, and add it to the resin. Stir well to combine the two. Add the hardener as recommended by the manufacturer (you may need to use double the hardener). Stir well. Laminate or pour as required following the instructions on page 202.

Brass

When using metal fillers it may be necessary to incrase the amount of hardener added to the resin, since the filler will inhibit the cure time. Read the manufacturer's instructions carefully.

MATERIALS
• **Multipurpose polyester resin**
• **Brass filler**
• **Liquid hardener**
• **Acetone or recommended cleaner**

PREPARATION See page 203.

METHOD Measure an equal volume of aluminum filler, or the volume recommended by the manufacturer, and add it to the resin. Stir well to combine the two. Add the hardener as recommended by the manufacturer (you may need to use double the hardener). Stir thoroughly. Laminate or pour as required following the instructions on page 202.

Bronze

When using metal fillers it may be necessary to increase the amount of hardener added to the resin, since the filler will inhibit the cure time. Read the manufacturer's instructions carefully.

MATERIALS
• **Multipurpose polyester resin**
• **Bronze filler**
• **Liquid hardener**
• **Acetone or recommended cleaner**

PREPARATION See page 203.

METHOD Measure an equal volume of bronze filler, or the volume recommended by the manufacturer, and add it to the resin. Stir well to combine the two. Add the hardener as recommended by the manufacturer (you may need to use double the hardener). Stir well. Laminate or pour as required following the instructions on page 202.

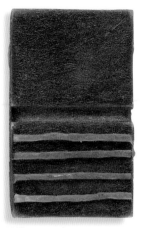

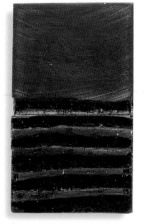

Wire wool

There are various grades of wire wool available, any of which would be suitable for use in this example.

MATERIALS
• **Multipurpose polyester resin**
• **Wire wool**
• **Liquid hardener**
• **Acetone or recommended cleaner**

PREPARATION See page 203.

METHOD Measure an equal volume of wire wool and add it to the resin. Stir well to combine the two. Add the hardener as recommended by the manufacturer and stir thoroughly. Laminate or pour as required following the instructions on page 202.

Slate

This particular filler is useful when the color of the sculpture's surface is not of primary importance.

MATERIALS
• **Multipurpose polyester resin**
• **Slate filler**
• **Liquid hardener**
• **Acetone or recommended cleaner**

PREPARATION See page 203.

METHOD Measure out an equal volume of slate filler and add this to the resin, stirring well. Mix in the hardener as recommended by the manufacturer. Laminate or pour as required following the instructions on page 202.

Long grain rice

A viable alternative here would be one of the variety of pulses available, you could even try pasta shapes.

MATERIALS
• **Multipurpose polyester resin**
• **Long grain rice**
• **Liquid hardener**
• **Acetone or recommended cleaner**

PREPARATION See page 203.

METHOD Measure an equal volume of rice and add it to the resin, stirring well. Add the hardener as recommended by the manufacturer. Stir thoroughly. Laminate or pour as required following the instructions on page 202.

Short grain rice

A viable alternative here would be one of the variety of pulses available, you could even try pasta shapes.

MATERIALS
• **Multipurpose polyester resin**
• **Short grain rice**
• **Liquid hardener**
• **Acetone or recommended cleaner**

PREPARATION See page 203.

METHOD Measure an equal volume of rice and add it to the resin, stirring well. Add the hardener as recommended by the manufacturer. Stir thoroughly. Laminate or pour as required following the instructions on page 202.

Cotton wool

It is advisable to cut this material into small lengths before mixing it with the resin.

MATERIALS
• **Multipurpose polyester resin**
• **Cotton wool**
• **Liquid hardener**
• **Acetone or recommended cleaner**

PREPARATION See page 203.

METHOD Measure out an equal volume of cotton wool and add this to the resin, stirring well. Mix in the hardener as recommended by the manufacturer. Laminate or pour as required following the instructions on page 202.

White opaque pigment and medium gravel

With the exception of the metal fillers, a pigment can be added to most of the fillers on pages 209–215.

MATERIALS
• **Multipurpose polyester resin**
• **White opaque polyester pigment**
• **Medium gravel**
• **Liquid hardener**
• **Acetone or recommended cleaner**

PREPARATION See page 203.

METHOD Pour a small amount of resin into a container and add white pigment, (between 2 and 5 percent of the weighed amount of resin) stirring continuously to achieve a paste. Return the colored paste to the remainder of the weighed resin and stir. Measure an equal volume of dry gravel. Add the gravel to the resin and stir well. Mix in the hardener as recommended by the manufacturer. Laminate or pour as required following the instructions on page 202.

Fine gravel

MATERIALS
- Multipurpose polyester resin
- Fine gravel
- Liquid hardener
- Acetone or recommended cleaner

PREPARATION See page 203.

METHOD Measure an equal volume of fine gravel, ensuring it is completely dry, and add it to the resin. Stir well to combine the two. Add the hardener as recommended by the manufacturer. Stir thoroughly. Laminate or pour as required following the instructions on page 202.

Medium gravel

MATERIALS
- Multipurpose polyester resin
- Medium gravel
- Liquid hardener
- Acetone or recommended cleaner

PREPARATION See page 203.

METHOD Measure an equal volume of gravel; making sure it is completely dry. Add the gravel to the resin. Stir well to combine the two. Mix in the hardener as recommended by the manufacturer. Laminate or pour as required following the instructions on page 202.

Broken tile

The tiles that you use can be ceramic wall tiles, roofing tiles, or floor tiles. If you break them yourself with a heavy hammer, ensure you wear goggles and gloves.

MATERIALS
- Multipurpose polyester resin
- Broken tiles
- Liquid hardener
- Acetone or recommended cleaner

PREPARATION See page 203.

METHOD Measure out an equal volume of broken tile and add this to the resin, stirring well. Mix in the hardener as recommended by the manufacturer. Laminate or pour as required following the instructions on page 202.

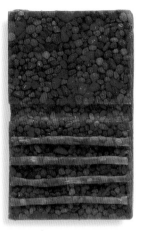

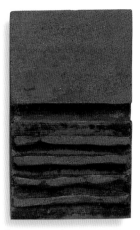

Swarf

Swarf is the fine metal residue removed by grinding on a metal lathe, so an engineering workshop would be a good source for this material. Ensure you wear gloves when handling swarf.

MATERIALS
• **Multipurpose polyester resin**
• **Swarf**
• **Liquid hardener**
• **Acetone or recommended cleaner**

PREPARATION See page 203.

METHOD Measure an equal volume of swarf and add it to the resin, stirring well. Add the hardener as recommended by the manufacturer. Stir thoroughly. Laminate or pour as required following the instructions on page 202.

Aquarium stones

At your local aquarium suppliers you will find a vast array of different colored stones to use for this effect.

MATERIALS
• **Multipurpose polyester resin**
• **Aquarium stones**
• **Liquid hardener**
• **Acetone or recommended cleaner**

PREPARATION See page 203.

METHOD Measure out an equal volume of aquarium stones and add this to the resin, stirring well. Mix in the hardener as recommended by the manufacturer. Laminate or pour as required following the instructions on page 202.

Iron powder

This filler is suitable for use on its own, or can add weight to a small solid cast in which the gel coat is of another resin and filler mix, such as bronze. When using metal fillers it may be necessary to increase the amount of hardener added to the resin, since the filler will inhibit the cure time. Read the manufacturer's instructions carefully.

MATERIALS
• **Multipurpose polyester resin**
• **Iron powder filler**
• **Liquid hardener**
• **Acetone or recommended cleaner**

PREPARATION See page 203.

METHOD Measure out an equal volume of iron powder filler and add it to the resin, stirring well. Add the hardener as recommended by the manufacturer (you may need to use double the hardener). Stir thoroughly. Laminate or pour as required following the instructions on page 202.

SHINY DOME PIGMENTS

The mold used in the following examples is one of a range of small molds that are available in art and craft shops. The shiny opaque or translucent surface of the various treatments gives a clear indication of the ability of polyester resin to mimic the surface from which it is cast.

Black opaque pigment

MATERIALS
- Multipurpose polyester resin
- Black opaque polyester pigment
- Liquid hardener
- Acetone or recommended cleaner

PREPARATION See page 203.

METHOD Follow this method for whichever pigment you chose. Pour a small quantity of resin into a container and add the opaque pigment, (between 2 and 5 percent of the weighed amount of resin) stirring continuously into a smooth paste. Return the paste to the remainder of the resin, stirring again to ensure an even distribution of color. Add the hardener as recommended by the manufacturer and stir thoroughly. Slowly pour the resin mix into the mold. Allow it to settle before gently tapping the side of the mold to expel any air bubbles. If necessary, add more resin mix to fill the mold. Once the resin has fully cured remove it from the mold. Clean tools with acetone or the recommended cleaner.

White opaque pigment

MATERIALS
- Multipurpose polyester resin
- White opaque polyester pigment
- Liquid hardener
- Acetone or recommended cleaner

Red opaque pigment

MATERIALS
- Multipurpose polyester resin
- Red opaque polyester pigment
- Liquid hardener
- Acetone or recommended cleaner

Yellow opaque pigment

MATERIALS
- Multipurpose polyester resin
- Yellow opaque polyester pigment
- Liquid hardener
- Acetone or recommended cleaner

Green opaque pigment

MATERIALS
- Multipurpose polyester resin
- Green opaque polyester pigment
- Liquid hardener
- Acetone or recommended cleaner

Blue translucent pigment

MATERIALS
• Multipurpose polyester resin
• Blue translucent polyester pigment
• Liquid hardener
• Acetone or recommended cleaner

Red translucent pigment

MATERIALS
•Multipurpose polyester resin
•Red translucent polyester pigment
•Liquid hardener
•Acetone or recommended cleaner

Green translucent pigment

MATERIALS
• Multipurpose polyester resin
• Green translucent polyester pigment
• Liquid hardener
• Acetone or recommended cleaner

Amber translucent pigment

MATERIALS
• Multipurpose polyester resin
• Amber translucent polyester pigment
• Liquid hardener
• Acetone or recommended cleaner

Yellow translucent pigment

MATERIALS
• Multipurpose polyester resin
• Yellow translucent polyester pigment
• Liquid hardener
• Acetone or recommended cleaner

Red and blue translucent pigments

MATERIALS
• Multipurpose polyester resin
• Blue translucent polyester pigment
• Red translucent polyester pigment
• Liquid hardener
• Acetone or recommended cleaner

Inspirational pieces

Man In Search Of God
Mike Roles

A transparent resin cast of the body, where the edges end randomly to leave the form open and unfinished, creates a very modern image of the human being. The real surface of the face and body captured in this modern material take on a more temporal quality being formed and dissolving away.

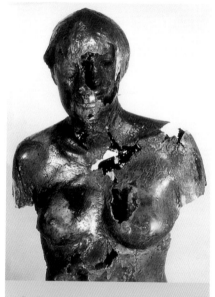

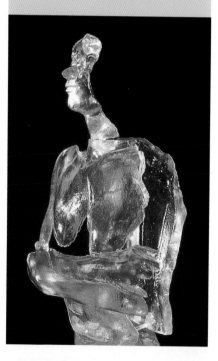

Of Dreadful Nights
Mike Roles

Brass powder and photographic emulsion are suspended in the resin of this sculpture to create a figure that seems at the same time both metallic and real. Cast from life, the form is hollow, and where the surface is broken through, we can see into the inside and, in the case of the head, to another inner face. The surface of this sculpture, with its varying degrees of solidity, transparency, and openness, shows the full range of possibilities to explore the inner life concealed behind the outer form.

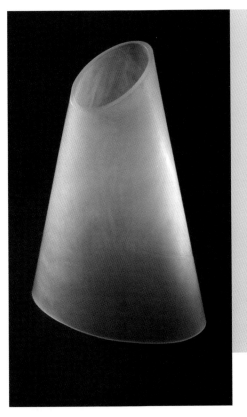

UNTITLED 1
MICHAEL SHAW

This piece is unashamedly plastic and reveals how this material, which is often made to look like other, more traditional materials, has a modern beauty of its own. This very precise geometrical form has been carefully sanded with fine wet and dry paper to produce a milky, translucent surface which adds an ethereal, timeless mood. The flattened cone shape is cut through at the top at an angle to produce a perfectly circular opening, reversing the mathematical experiment well known to many school children.

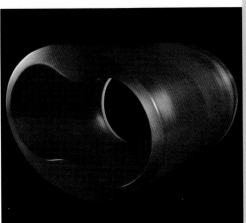

UNTITLED 2
MICHAEL SHAW

Amber translucent pigment has been added to the clear casting resin to bring an element of warmth and energy to this piece. The balance of opaqueness and translucency of the resin allows the play of light on the surface, the shadows and reflections, which shine into and through the form, to reveal the shapes and movements in a way that is difficult to achieve with other materials.

Cement and cement fondue

Three types of cement have been used in this section. Standard Portland cement is the everyday cement used in the building trade, mixed with sand to make mortar, and mixed with sand and shingle to produce concrete. Cement fondue has high alumina content and is available in gray or white. Both of these latter cements are very strong and durable, so suitable for casting or working directly.

A Portland cement and sand mix is the best cement to use when pouring into a small mold to produce a solid cast. Soft sand has been used in the examples because a small mold was used; however, you can substitute the soft sand for sharp sand for larger molds. This mix would increase the strength of the resultant cast, but it may not pick up very fine detail from the surface of the mold. Cement fondue is able to replicate the very finest detail from a mold and is highly recommended for use when making a cast of a finely detailed or textured sculptural surface.

Casting with cement fondue

Although cement fondue mixed with a suitable aggregate can be cast solid, it is better as a hollow cast, using a laminating technique with fiberglass matting, as shown in the following steps. This has the advantage of producing a very lightweight yet extremely strong cast. A parting agent is not really needed when making a cement fondue cast from a plaster mold because plaster and cement fondue do not get along due to the chemical reaction between the two. However, there will be a residue of the plaster color on the surface of the cement fondue sculpture, known as a bloom. Although this is not harmful, some sculptors do find it unsightly.

YOU WILL NEED:
- Two-piece plaster waste mold (see pages 166–169)
- Paintbrush
- Soft soap
- Latex gloves and dust mask
- Plastic mixing bowls
- Cement fondue
- Soft sand
- Wooden spoon
- Chisel
- Sponge
- Cloth
- Fiberglass matting

SAFETY
- Remember to work in a well-ventilated area.
- Always wear latex gloves when working with cement fondue and fiberglass matting.
- Wear a dust mask when mixing the cement fondue.

- Scissors
- Small rasp
- String
- Mallet
- Bucket of water for cleaning up

1 Soak a two-piece plaster waste mold in water, and then use a paintbrush to work soft soap into the surface of the mold. Cover the entire surface, working it up into a lather, and then let the soap dry and repeat.

SEE ALSO

Making A Two-Piece Plaster Waste Mold (pages 166-169)

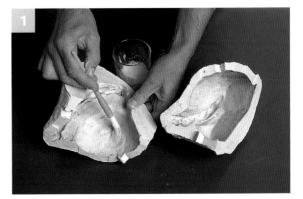

2 Depending on the size of your mold, use a cup to act as a measure and make a mix of one part cement fondue to three parts soft sand. Mix these up well with a wooden spoon.

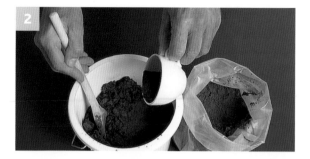

3 Add water to the mix, being careful that you do not add too much. The cement fondue mix needs to be moist enough that when you squeeze it water starts to leak out but the body of the mix stays firm and does not disintegrate.

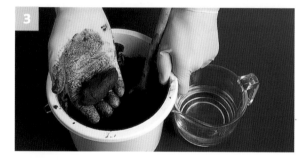

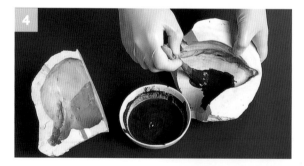

4 Now make a mix of cement fondue and water to produce a slurry that has a thick, creamy consistency. Paint this slurry in even strokes onto the interior surface of the mold, keeping the seams of the mold clean.

5 Take up a thumb-size lump of the first cement fondue mix. Starting from the edge of the mold, place it on top of the slurry and push it firmly down, so that a small mound of slurry is pushed out in front of the mix.

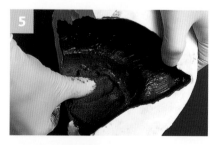

6 Continue in the same way to fill the entire surface of the inside of the mold to a depth of ⅛ inch (3mm). Trim off the cement fondue mix along the seam of the mold with a chisel.

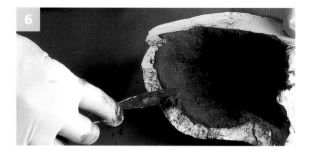

7 It is important to keep the seam clean, so use a damp sponge to wipe it. Repeat Steps 4 to 7 with the other half of the mold.

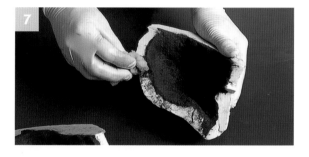

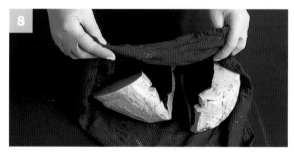

8 When both sides of the mold are filled and the seams are clean, cover both molds with a damp cloth and leave for 24 hours to fully cure.

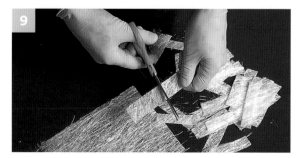

9 Once cured, you can prepare for the laminating stage by cutting ½ x 2-inch (1.5 x 5cm) strips of fiberglass matting. Cut enough to cover the interior surface of the mold twice.

10 Make a fresh mix of cement fondue slurry and paint this onto the first layer of cement fondue, again taking care not to get any slurry on the seams of the mold.

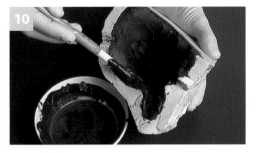

11 Fully immerse a piece of fiberglass matting in the slurry and bring it out, squeezing off any excess slurry.

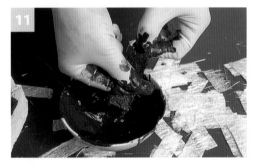

12 Lay the fiberglass matting down on the slurry in the mold. Continue to coat fiberglass strips in slurry and lay them in the mold, overlapping the previous strip and going right up to the edge of the mold.

13 Holding a paintbrush vertically, tamp the fiberglass matting down firmly to ensure that it is fully impregnated with slurry and to push out any trapped air. Repeat with the other half of the mold. Wipe the seams clean, cover both halves with a damp cloth, and leave for 24 hours to cure.

14 Once the two halves have cured, fit them together using the registration locking points. If, for any reason, they do not fit snugly together use a small rasp to bring the cement fondue level with the edge of the mold.

15 When you are sure that the two halves fit, tie them firmly together.

16 Cut strips of fiberglass matting 2 x 1 inches (5 x 2.5cm) and make a fresh slurry mix. Paint the slurry 1 inch (2.5cm) on either side of the join. Soak a strip of fiberglass matting in the slurry and place across the join at one end. Continue overlapping along the length of the join. Cover with a damp cloth and leave to cure for 24 hours.

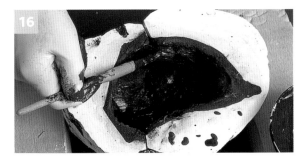

17 Using a mallet and chisel, gently start to break off the plaster mold from the cast. You will find it comes away very easily.

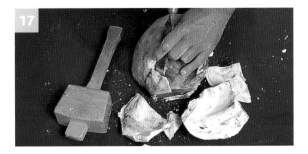

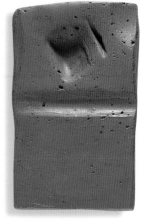

PORTLAND CEMENT

This basic mix is able to pick up detailing from small molds. The following instructions make a mix suitable for pouring into a mold.

MATERIALS
• Portland cement
• Soft sand
• Water

METHOD Combine one part Portland cement to three parts sand and mix well. Add water and combine until pourable. Slowly pour the mix into the mold to its halfway point. Gently tap the sides to even the distribution and to expel any air bubbles. Fill the remaining half of the mold. Leave to cure for 24 hours. The following surface treatments have been applied to cured Portland cement.

PVA

PVA is a multipurpose bonding agent used right across the industrial sector. As such, it is an essential item for the materials store of the sculptor's studio. Here it is used ostensibly to seal the surface of the cement cast, thereby affording it some degree of protection, but it also has the ability to affect a slight change in the surface color of a cement sculpture.

MATERIALS
• PVA
• Water

PREPARATION Allow the cement cast to dry completely. Mix up a dilute solution of one part PVA to one part water.

METHOD Paint on one coat of dilute PVA and allow to dry. Thoroughly clean the brush with water.

Acrylic paint

If your sculpture is going to be sited outdoors, it is recommended that you apply two coats of acrylic varnish after the application of acrylic paint.

MATERIALS
• PVA
• Water
• Artists' acrylic paint

PREPARATION Allow the cement cast to dry completely. Mix up a dilute solution of one part PVA to one part water.

METHOD Brush on two coats of dilute PVA, allowing the first to dry before applying the second. Add enough water to the artists' acrylic paint to make a very thin mix. Paint an even coat over the surface of the sculpture. Clean the brushes with water.

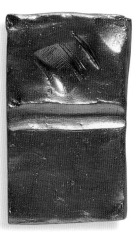
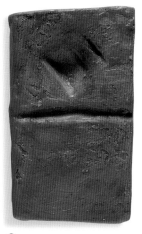
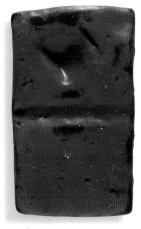

Metal-effect enamel paint

A wide range of metal-effect enamel paints are available, any of which would be suitable for application to the surface of your sculpture.

MATERIALS
• PVA
• Water
• Metal-effect enamel paint
• Mineral spirits

PREPARATION Allow the cement cast to dry completely. Mix up a dilute solution of one part PVA to one part water. Mix the enamel paint well.

METHOD Brush on two coats of dilute PVA, allowing the first to dry before applying the second. Clean the brush with water. Paint an even coat of metal-effect enamel paint over the surface of the sculpture and allow to dry. Clean the brush with mineral spirits. For extra opacity and shine, you can apply additional coats of enamel paint, letting each coat dry before applying the next.

Orange wax

Molten wax is hot, so it is a good idea to melt just enough wax to comfortably work with before it starts to cool and harden. This technique is not suitable for outdoor sculptures.

MATERIALS
• PVA, Water
• Polyurethane varnish
• Clear crystalline wax
• Orange wax dye

PREPARATION As preparation for PVA.

METHOD Brush on two coats of dilute PVA. With a clean brush, paint one coat of polyurethane varnish on the surface of the sculpture and allow to dry. Gently heat the solid wax in a melting pot. Once molten, add the wax dye and stir well. Slowly pour the wax from the pot over the surface of the sculpture, taking care not to cause splashes. When the wax has cooled and is starting to harden, scrunch a cloth into a ball and rub the wax into the surface of the sculpture.

Red wax

Molten wax is hot, so it is a good idea to melt just enough wax to comfortably work with before it starts to cool and harden. This technique is not suitable for outdoor sculptures.

MATERIALS
• PVA, Water
• Polyurethane varnish
• Clear crystalline wax
• Red wax dye

PREPARATION As preparation for PVA.

METHOD Brush on two coats of dilute PVA. With a clean brush, paint one coat of polyurethane varnish on the surface of the sculpture and allow to dry. Clean the brush with mineral spirits. Put enough solid wax in a melting pot to comfortably work with, then gently heat it up until it has melted. Once molten, add the wax dye and stir well. Slowly pour the wax from the pot over the surface of the sculpture, taking care not to cause splashes, until you have achieved an even coating over the entire surface.

Varnish

Polyurethane varnish is used here. It is a very resilient varnish that is suitable for use on sculptures that will be sited out of doors. This varnish is also available with a range of color tints added, thus giving you an opportunity to add another nuance to your sculpture.

MATERIALS
• **Polyurethane varnish**
• **Mineral spirits**

PREPARATION Allow the cement cast to dry completely.

METHOD Brush an even coat of polyurethane varnish over the surface of the sculpture, taking care to avoid puddles in crevices, and drips. Leave to dry for 24 hours and clean the brush with mineral spirits. Apply a second coat as before and clean the brush with mineral spirits.

Hammered-metal effect paint

A wide range of hammered-metal effect paints are available, any of which would be suitable for this technique. Here green is used. These paints are designed for a one-coat application.

MATERIALS
• **Shellac**
• **Mineral spirits**
• **Hammered-metal effect paint**
• **Cellulose thinners or recommended cleaner**

PREPARATION Allow the cement cast to dry completely.

METHOD Brush on one coat of shellac to seal the surface. With a clean brush apply one even coat of hammered-metal effect paint over the surface of the sculpture. You will need to lay the paint on quickly and evenly. Immediately clean the brush with cellulose thinners or the medium recommended by the paint manufacturer. Allow the paint to dry before handling the sculpture.

Green residue

Although a green hammered-metal effect paint is used in this example, you can use this technique with other types of oil- or cellulose-based paints.

MATERIALS
• **Hammered-metal effect paint**
• **Cellulose thinners or recommended cleaner**

PREPARATION Allow the cement cast to dry completely.

METHOD Brush one even coat of hammered-metal effect paint over the surface of the sculpture. You will need to lay the paint on quickly and evenly, without brushing it out too thinly. Immediately clean the brush with cellulose thinners or the medium recommended by the paint manufacturer. Before the paint has a chance to dry, use a cloth to wipe over the surface of the sculpture to reveal the cement and leave a green residue on its surface.

Gloss spray paint

Although gloss spray paint was used here, other types of spray paint can be used, such as those used for cars. This technique allows you to experiment with a number of colors and color combinations.

MATERIALS
- Shellac
- Mineral spirits
- Gloss spray paint

PREPARATION Allow the cement cast to dry completely.

METHOD Seal the surface with a coat of shellac. Work in a well-ventilated area and protect the surrounding work area. Hold the spray can about 12 in (30cm) away from the surface of the sculpture and spray on an even and light coat of paint. Move the can back and forth across the surface of the sculpture to avoid accumulating paint in any one area. Repeat the spraying technique in short bursts until you have achieved an even and opaque coating of paint.

Distressed spray paint

Matte car spray paint was used here, but you can use any of the varieties of spray paint that are available. You can also experiment with the number of colors you use and dream up a wealth of color combinations.

MATERIALS
- Shellac
- Mineral spirits
- Matte car spray paint

PREPARATION Allow the cement cast to dry completely.

METHOD Seal the surface with a coat of shellac. Work in a well-ventilated area and protect the surrounding work area. Hold the spray can about 12 in (30cm) away from the surface of the sculpture and spray on an even and light coat of paint. Move the can back and forth across the surface of the sculpture to avoid accumulating paint in any one area. Repeat the spraying technique in short bursts until you have achieved an even and opaque coating of paint.

Polyester resin

See page 199 for safety instructions.

MATERIALS
- Shellac
- Mineral spirits
- Multipurpose polyester resin
- Opaque polyester pigment
- Liquid hardener
- Acetone or recommended cleaner

PREPARATION Allow the cement cast to dry completely.

METHOD Seal the surface with shellac. Weigh out the required amount of polyester resin and pour a small amount into a container. Add opaque polyester pigment—between 2 and 5 percent of the weighed amount of resin—stirring continuously into a paste. Return the paste to the remainder of the resin, stirring continuously. Add the catalyst in a ratio of 1g hardener to 100g resin (or as recommended by the manufacturer) and stir well. Drip it over the surface of the sculpture. Allow the resin to cure and clean the brush immediately with acetone.

ADDITIONS
Medium shingle

This method produces a concrete mix comprised of an aggregate, a mix of sand and shingle mixed with the cement. A medium-grade shingle was used in this example, but you can vary the size according to the size of your mold.

MATERIALS
- Portland cement
- Soft sand
- Water
- Medium shingle

METHOD Combine one part Portland cement to two parts soft sand and one part medium shingle. Mix well to achieve an even consistency. Add water to the mix and combine until a pourable mix is achieved. Slowly pour the concrete mix into the mold up to its halfway point. Gently tap the sides of the mold to ensure an even distribution of mix and to expel any air bubbles. Fill the remaining half of the mold, again tapping the sides to ensure an even mix. Leave to cure for 24 hours.

Dye and shingle

Concrete dyed with proprietary cement dyes can be used for sculptures that are to be sited outdoors. As an alternative, you could try using artists' acrylic colors for a sculpture that is intended for an indoor location.

MATERIALS
- Cement dye
- Water
- Portland cement
- Soft sand
- Medium shingle

PREPARATION Following the manufacturer's instructions, add cement dye to water.

METHOD Combine one part Portland cement to two parts soft sand and one part medium shingle. Mix well to achieve an even consistency. Add the dyed water to the mix and combine until pourable. Slowly pour the concrete mix into the mold to halfway. Gently tap the sides of the mold to ensure an even distribution of mix and to expel any air bubbles. Fill the remaining half of the mold. Leave to cure for 24 hours.

Red dye

This dye is produced for the construction industry. Although you will not find many colors to choose from, the resultant cast will be colorfast and able to withstand extremes of temperature. You may also be able to find suitable dyes at sculpture material suppliers.

MATERIALS
- Red cement dye
- Water
- Portland cement
- Soft sand

PREPARATION Following the manufacturer's instructions, add cement dye to water.

METHOD Combine one part Portland cement to three parts soft sand and mix well to achieve an even consistency. Add the dyed water to the mix and combine until pourable. Slowly pour the cement mix into the mold to halfway. Tap the sides of the mold to ensure an even distribution of mix and to expel any air bubbles. Fill the remaining half of the mold. Leave for 24 hours to cure.

CEMENT FONDUE

Cement fondue will set in about four hours, and fully cure after 24 hours in a damp atmosphere. The instructions will make a mix suitable for pouring into a mold.

MATERIALS
• Cement fondue
• Soft sand
• Water

METHOD Combine one part cement fondue to three parts sand and mix well. Add water to the mix, taking care not to add too much; the mix needs to be moist enough so that when you squeeze it, water starts to leak out but the body of mix stays firm and does not disintegrate. Cast the cement fondue following the instructions on page 223. The following surface treatments have been applied to cured cement fondue.

Graphite paste

This product is used ostensibly to revitalize old cast-iron fireplaces and cooking ranges, and is available under a variety of brand names. It is an extremely useful coloring material for sculpture and produces an interesting matte sheen.

MATERIALS
• Shellac
• Mineral spirits
• Graphite/iron paste

PREPARATION Allow the cement fondue cast to dry completely.

METHOD Seal the surface with a coat of shellac. Apply the graphite paste to the surface of the sculpture with a shoe brush, working it well into the surface of the sculpture. A toothbrush is useful for gaining access to awkward areas. Allow the graphite paste to dry and then vigorously buff the surface with a soft cloth to create an even sheen over the entire surface.

Enamel spray paint

It is essential that you carry out this procedure in a well-ventilated area. Also ensure that you protect surrounding areas with polyethylene or newspapers as the spray tends to travel when you apply it.

MATERIALS
• Shellac
• Mineral spirits
• Enamel spray paint

PREPARATION Allow the cement fondue cast to dry completely.

METHOD Seal the surface with a coat of shellac. Follow the safety instructions above. Hold the spray can about 12 in (30cm) away from the surface of the sculpture and spray an even and light coat of paint. Move the can back and forth across the surface of the sculpture to avoid accumulating paint in any one area. Repeat the spraying technique in short bursts until you have achieved an even and opaque coating of paint.

Matte black paint

The paint that has been used in this example is an oil-based paint used for chalkboards. Alternatives include matte black paint suitable for iron gates and railings, or even water-based black latex paint, although the latter would be unsuitable for a sculpture placed outdoors.

MATERIALS
• Shellac
• Mineral spirits
• Matte black paint

PREPARATION Allow the cement fondue cast to dry completely.

METHOD Brush on one coat of shellac and leave to dry. Clean the brush with mineral spirits. Brush an even coat of matte black paint over the surface of the sculpture. Allow to dry and apply a second and final coat. Clean the brush with mineral spirits.

PVA

In this example, three coats of PVA have been applied to the surface of the cement fondue. However, the more coats you apply the more opaque the surface coloring will be.

MATERIALS
• PVA
• Water

PREPARATION Allow the cement fondue cast to dry completely. Mix up a dilute solution of one part PVA to one part water.

METHOD Paint on one coat of dilute PVA. Allow this to dry before applying further coats, allowing each coat to dry before brushing on another. Clean the brush with water.

Antique hammered-metal effect

Antique copper is used here.

MATERIALS
• Shellac
• Hammered-metal effect paint
• Cellulose thinners or recommended cleaner
• Matte black paint

PREPARATION Allow the cement fondue cast to dry completely.

METHOD Seal the surface with a coat of shellac. With a clean brush, apply one even coat of hammered-metal effect paint over the surface of the sculpture. You will need to lay the paint on quickly and evenly. Immediately clean the brush with cellulose thinners or the recommended cleaner. Allow the paint to dry, then dip a cloth in matte black paint and gently rub the paint over the surface of the sculpture. Before it has a chance to dry, rub back the black paint to reveal the hammered metallic surface underneath.

Metal-effect enamel paint

There is a good range of metal-effect enamel paints available, any of which is suitable for application to the surface of your sculpture, as described here. Gold leaf enamel paint is used here.

MATERIALS
- Shellac
- Mineral spirits
- Metal-effect enamel paint

PREPARATION Allow the cement fondue cast to dry completely.

METHOD Brush on one coat of shellac and leave to dry. Clean the brush with mineral spirits. Paint on an even coat of metal-effect enamel paint. Leave to dry before brushing on another coat. Clean the brush with mineral spirits.

Gloss paint

The paint used here is ordinary household blue gloss paint. You could also try using masonry paint, which is particularly suitable for use on a sculpture that is exposed to harsh weather conditions.

MATERIALS
- Shellac
- Mineral spirits
- Gloss paint

PREPARATION Allow the cement fondue cast to dry completely.

METHOD Brush on one coat of shellac and leave to dry. Clean the brush with mineral spirits. Apply an even coat of gloss paint over the surface of the sculpture, making sure you brush out the paint well. Do not expect to obtain a completely opaque surface with one coat; you will need at least two or three more coats. Allow each coat to dry before applying another. Clean the brush with mineral spirits after each use.

Red spray on white

Although enamel spray paint was used here, feel free to try other types of spray paint, such as car spray paint.

MATERIALS
- Shellac
- Mineral spirits
- White enamel spray paint
- Red enamel spray paint

PREPARATION Allow the cement fondue cast to dry completely.

METHOD Seal the surface with a coat of shellac. Work in a well-ventilated area and protect the surrounding work area. Take the white spray paint and hold the can about 12 in (30cm) away from the surface of the sculpture and spray an even and light coat of paint. Repeat the spraying technique in short bursts until you have achieved an even and opaque coating of white paint. Using the same technique, spray the red paint intermittently across the surface to produce a red speckled effect that allows the white to show through.

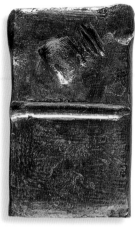

Yellow polyester resin and orange pigment

Refer to the safety instructions on page 199.

MATERIALS
- Shellac
- Multipurpose polyester resin
- Yellow translucent polyester pigment
- Liquid hardener
- Orange opaque polyester pigment
- Acetone or recommended cleaner

PREPARATION Allow the cement fondue cast to dry completely.

METHOD Seal the surface with a coat of shellac. Follow the instructions for the polyester resin sample on page 231, this time adding yellow polyester pigment to the resin. Brush an even coat of yellow resin over the sculpture. Before the resin has a chance to cure, load a brush with orange opaque pigment and drip this over the surface. Allow the resin to cure. Clean brushes as recommended.

Acrylic paint

These paints are water-soluble and available in a variety of colors that are easy to mix, allowing you to obtain the largest possible spectrum. If your sculpture is going to be sited outdoors, paint on two coats of acrylic varnish after the application of the acrylic paint.

MATERIALS
- PVA
- Water
- Artists' acrylic paint

PREPARATION Allow the cement fondue cast to dry completely. Mix up a dilute solution of one part PVA to one part water.

METHOD Brush on two coats of dilute PVA, allowing the first to dry before applying the second. Add water to acrylic paint until it has the consistency of cream. Paint an even coat over the surface of the sculpture. Allow this to dry and brush on another coat. Clean the brushes with water.

Varnish and hammered-metal effect paint

There is a wide range of hammered-metal effect paints available, any of which is suitable for this technique. Here silver has been used. These paints are designed for a one-coat application.

MATERIALS
- PVA
- Acrylic varnish
- Hammered-metal effect paint

PREPARATION Allow the cement fondue cast to dry completely. Mix up a dilute solution of one part PVA to one part water.

METHOD Brush on two coats of dilute PVA, allowing the first to dry before applying the second. Paint on two coats of acrylic varnish, allowing the first coat to dry before applying the second. When the second coat of varnish has dried, dip a cloth in hammered-metal effect paint and rub it over the varnish.

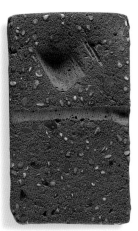
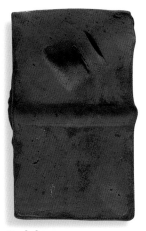
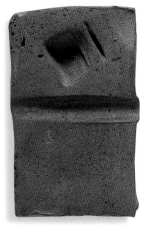

ADDITIONS
Colored gravel

A good source of decorative and colored gravels would be your local garden store or aquarium supplier.

MATERIALS
• Cement fondue
• Soft sand
• Colored gravel
• Water

METHOD Combine one part cement fondue to two parts soft sand and one part colored gravel. Mix well to achieve an even consistency. Add water to the mix and combine until a pourable mix is achieved. Slowly pour the cement fondue into the mold up to its halfway point. Gently tap the sides of the mold to ensure an even distribution of mix and to expel any air bubbles. Fill the remaining half of the mold, again tapping the sides to ensure an even mix. Cover with a damp cloth and leave to cure for 24 hours.

Red dye

This dye is produced for the construction industry. Although you will not find many colors to choose from, the resultant cast will be colorfast and able to withstand extremes of temperature.

MATERIALS
• Red cement dye
• Water
• Cement fondue
• Soft sand

PREPARATION Following the manufacturer's instructions, add cement dye to water.

METHOD Combine one part cement fondue to three parts soft sand. Mix well to achieve an even consistency. Add the dyed water to the mix and combine until a pourable mix is achieved. Slowly pour the dyed cement fondue into the mold to halfway. Gently tap the sides of the mold to ensure an even distribution of mix and to expel any air bubbles. Fill the remaining half of the mold. Cover with a damp cloth and leave to cure for 24 hours.

Yellow dye

This dye is produced for the construction industry. Although you will not find many colors to choose from, the resultant cast will be colorfast and able to withstand extremes of temperature.

MATERIALS
• Yellow cement dye
• Water
• Cement fondue
• Soft sand

PREPARATION Following the manufacturer's instructions, add cement dye to water.

METHOD Combine one part cement fondue to three parts soft sand. Mix well to achieve an even consistency. Add the dyed water to the mix and combine until a pourable mix is achieved. Slowly pour the dyed cement fondue into the mold to halfway. Gently tap the sides of the mold to ensure an even distribution of mix and to expel any air bubbles. Fill the remaining half of the mold. Cover with a damp cloth and leave to cure for 24 hours.

WHITE CEMENT FONDUE

Like gray cement fondue, white cement fondue likes to cure in a damp atmosphere.

MATERIALS
• **White cement fondue**
• **Soft sand**
• **Water**

METHOD Combine one part white cement fondue to three parts soft sand and mix well. Add water to the mix, taking care not to add too much; the mix needs to be moist enough so that when you squeeze it, water starts to leak out but the body of mix stays firm and does not disintegrate. Cast the cement fondue following the instructions on page 223. The following surface treatments have been applied to cured white cement fondue.

Shellac

Shellac is an all-purpose sealing agent suitable for a variety of porous materials, such as wood, plaster, and, in this case, cement. It will also color the surface of the material; the general rule being that the more coats you apply, the more opaque the resultant color will be.

MATERIALS
• **Shellac**
• **Mineral spirits**

PREPARATION Allow the white cement fondue cast to dry completely.

METHOD Paint on one coat of shellac to seal the surface. Thoroughly clean the brush with mineral spirits.

Polyurethane varnish

Polyurethane varnish is a very resilient varnish and is suitable for use on sculptures that will be sited out of doors. This varnish is also available with a range of color tints added, giving you an opportunity to add another nuance to your sculpture.

MATERIALS
• **Shellac**
• **Mineral spirits**
• **Polyurethane varnish**

PREPARATION Allow the white cement fondue cast to dry completely.

METHOD Brush on one coat of shellac and leave to dry. Clean the brush with mineral spirits. Apply an even coat of polyurethane varnish, taking care to avoid puddles in crevices, and drips. Clean the brush with mineral spirits. Leave to dry for 24 hours.

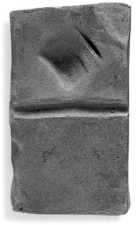

Aged silver effect

This is a basic faux aging or patination technique that can be used with any of the different metal color paints that are available, be they oil-, water-, or, in this case, cellulose-based.

MATERIALS
- **Shellac**
- **Mineral spirits**
- **Silver paint**
- **Cellulose thinners**
- **Matte black paint**

PREPARATION Allow the white cement fondue cast to dry completely.

METHOD Seal the surface with a coat of shellac. Use a clean brush to apply one even coat of silver paint over the surface of the sculpture. Immediately clean the brush with cellulose thinners. Allow the paint to dry, then dip a cloth in matte black paint and gently rub the black paint over the surface of the sculpture. Before it has a chance to dry, rub back the black paint to reveal the silver metallic surface beneath.

PVA

PVA is a multipurpose bonding agent used right across the industrial sector and an essential item for the materials store of the sculptor's studio. Here it is used ostensibly as a means to seal the surface of the white cement fondue cast, thereby affording it some degree of protection. However, it also has the ability to affect a slight change in the surface color of white cement fondue.

MATERIALS
- **PVA**
- **Water**

PREPARATION Allow the white cement fondue cast to dry completely. Mix up a dilute solution of one part PVA to one part water.

METHOD Brush on three coats of dilute PVA, allowing each coat to dry before applying the next. Clean the brush with water.

Acrylic paint

Acrylic paints are water-soluble and available in a variety of colors that are easy to mix. Here we have used crimson. If your sculpture is going to be sited out of doors, it is recommended that you apply two coats of acrylic varnish after the application of the acrylic paint.

MATERIALS
- **PVA**
- **Water**
- **Artists' acrylic paint**

PREPARATION Allow the white cement fondue cast to dry completely. Mix up a dilute solution of one part PVA to one part water.

METHOD Brush on two coats of dilute PVA, allowing the first to dry before applying the second. Add water to acrylic paint until it has the consistency of cream. Paint an even coat over the surface of the sculpture. Allow this to dry and brush on another coat. Clean the brushes with water.

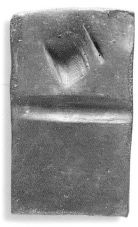
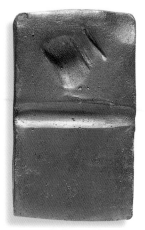
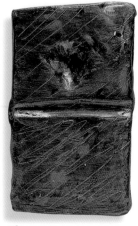

Liming wax

Liming wax is usually applied to wood that has a raised grain or interesting carved texture—the white wax gets trapped in the crevices. The same interesting effect can be obtained on cement fondue sculptures, particularly if they have a textured or raised surface. This technique is only suitable for a sculpture that will be sited indoors.

MATERIALS
• PVA
• Water
• Liming wax

PREPARATION Allow the white cement fondue cast to dry completely. Mix up a dilute solution of one part PVA to one part water.

METHOD Brush on two coats of dilute PVA, allowing the first to dry before applying the second. Use a shoe brush to work liming wax well into the surface of the sculpture. Begin to buff the wax with the brush and finish off with a soft cloth.

Wax polish and brass enamel paint

A proprietary brand of furniture polish is used here, but as an alternative, you could use beeswax. This technique is not suitable for sculpture that will be sited outdoors.

MATERIALS
• PVA
• Water
• Wax polish
• Brass enamel paint

PREPARATION Allow the white cement fondue cast to dry completely. Mix up a dilute solution of one part PVA to one part water.

METHOD Brush on two coats of dilute PVA, allowing the first to dry before applying the second. Clean the brush with water. Use a shoe brush to work the wax polish well into the surface of the sculpture. Leave to dry. Dip a cloth in brass enamel paint and rub it over the waxed surface of the sculpture.

Clear wax

Remember to melt just enough wax to comfortably work with before it starts to cool and harden. This technique is not suitable for sculptures that will be sited outdoors.

MATERIALS
• PVA
• Clear crystalline wax
• Enamel paint

PREPARATION Let the cement fondue cast dry completely. Mix up a dilute solution of one part PVA to one part water.

METHOD Brush on two coats of dilute PVA, allowing the first to dry before applying the second. Gently heat the wax in a melting pot until it has melted. Slowly pour the wax from the pot over the surface of the sculpture, taking care not to cause splashes. Once the wax has hardened, scratch into its surface with a sharp point. Finally, dip a cloth into the enamel paint and rub it into the scratches in the wax, then wipe off the paint residue.

Polyurethane varnish

Polyurethane varnish is particularly resilient and suitable for use on sculptures that will be sited outdoors. This varnish is also available with a range of color tints added.

MATERIALS
•Polyurethane varnish
•Mineral spirits

PREPARATION Allow the white cement fondue cast to dry completely.

METHOD Apply an even coat of polyurethane varnish to the surface of the sculpture, taking care to avoid puddles in crevices, and drips. Clean the brush with mineral spirits. Leave to dry for 24 hours. Apply a second coat as before, remembering to clean the brush with mineral spirits.

Yellow polyester resin

Refer to the safety instructions on page 199.

MATERIALS
• Shellac
• **Multipurpose polyester resin**
• **Yellow translucent polyester pigment**
• **Liquid hardener**
• **Acetone or recommended cleaner**

PREPARATION Allow the cast to dry completely.

METHOD Seal the surface with a coat of shellac. Follow the instructions for the polyester resin swatch on page 231, this time adding yellow translucent polyester pigment to the resin. Brush an even coat of yellow resin over the sculpture. Allow the resin to cure. Clean the brushes as recommended.

Orange polyester resin and sand

Refer to the safety instructions on page 199.

MATERIALS
• Shellac
• **Multipurpose polyester resin**
• **Soft sand**
• **Orange opaque polyester pigment**
• **Liquid hardener**
• **Acetone or recommended cleaner**

PREPARATION Allow the cast to dry completely.

METHOD Seal the surface with a coat of shellac. Follow the instructions for the polyester resin swatch on page 231 but also weigh out an equal amount of the dry sand. Make the paste as on page 231, but this time with orange opaque polyester pigment. Add the sand to the final mix before you add the catalyst. Brush a thin coat of orange resin and sand mix over the sculpture, then leave to cure. Clean the brush immediately with acetone.

Brown wax

Molten wax is hot, so it is a good idea to melt just enough wax to comfortably work with before it starts to cool and harden. This technique is not suitable for sculptures that will be sited outdoors.

MATERIALS
• PVA
• Water
• Clear crystalline wax
• Brown wax dye

PREPARATION Allow the white cement fondue cast to dry completely. Mix up a dilute solution of one part PVA to one part water.

METHOD Brush on two coats of dilute PVA, allowing the first to dry before applying the second. Gently heat the wax in a melting pot until it has melted. Once molten, add the wax dye until you obtain a strong opacity and stir well. Slowly pour the wax from the pot over the surface of the sculpture, taking care not to cause splashes, until you have achieved an even coating over the entire surface.

Green wax

It is a good idea to melt just enough wax to comfortably work with before it starts to cool and harden. This technique is not suitable for sculptures that will be sited out of doors.

MATERIALS
• PVA
• Water
• Green wax

PREPARATION Allow the white cement fondue cast to dry completely. Mix up a dilute solution of one part PVA to one part water.

METHOD Brush on two coats of dilute PVA, allowing the first to dry before applying the second. Gently heat the wax in a melting pot until it has melted. Slowly pour the wax from the pot over the surface of the sculpture, taking care not to cause splashes, until you have achieved an even coating over the entire surface. If necessary, melt more wax to ensure the entire surface of the sculpture is covered.

ADDITIONS
Brown and yellow dye

An interesting marble effect is created by adding two colors of dye separately.

MATERIALS
• Water
• Brown cement dye
• Yellow cement dye
• White cement fondue
• Soft sand

PREPARATION Fill two containers with water. Following the manufacturer's instructions, add brown dye to one and yellow to the other. Stir thoroughly.

METHOD Combine one part cement fondue to three parts soft sand. Mix well to achieve an even consistency. Divide this mix in two, add the yellow dye water to one, and the brown dye water to the other. Combine both mixes until pourable. Slowly pour the brown dye mix into the mold to halfway. Then fill with the yellow mix. Leave to cure for 24 hours. Create swirls of color with a stick. Cover with a damp cloth and leave to cure for 24 hours.

Brown dye

Produced for the construction industry, this dye doesn't have a huge range of colors, but the resultant cast will be colorfast and able to withstand extremes of temperature.

MATERIALS
• Brown cement dye
• Water
• White cement fondue
• Soft sand

PREPARATION Following the manufacturer's instructions, add cement dye to water.

METHOD Combine one part white cement fondue to three parts soft sand. Mix well to achieve an even consistency. Add the dyed water to the mix and combine until pourable. Slowly pour the dyed cement fondue into the mold to halfway. Gently tap the sides of the mold to ensure an even distribution of mix and to expel any air bubbles. Fill the remaining half of the mold. Cover with a damp cloth and leave to cure for 24 hours.

Red dye

Produced for the construction industry, this dye doesn't have a huge range of colors, but the resultant cast will be colorfast and able to withstand extremes of temperature.

MATERIALS
• Red cement dye
• Water
• White cement fondue
• Soft sand

PREPARATION Following the manufacturer's instructions, add cement dye to water.

METHOD Combine one part white cement fondue to three parts soft sand. Mix well to achieve an even consistency. Add the dyed water to the mix and combine until pourable. Slowly pour the dyed cement fondue into the mold to halfway. Gently tap the sides of the mold to ensure an even distribution of mix and to expel any air bubbles. Fill the remaining half of the mold. Cover with a damp cloth and leave to cure for 24 hours.

Yellow dye

Produced for the construction industry, this dye doesn't have a huge range of colors, but the resultant cast will be colorfast and able to withstand extremes of temperature.

MATERIALS
• Yellow cement dye
• Water
• White cement fondue
• Soft sand

PREPARATION Following the manufacturer's instructions, add cement dye to water.

METHOD Combine one part white cement fondue to three parts soft sand. Mix well to achieve an even consistency. Add the dyed water to the mix and combine until pourable. Slowly pour the dyed cement fondue into the mold to halfway. Gently tap the sides of the mold to ensure an even distribution of mix and to expel any air bubbles. Fill the remaining half of the mold. Cover with a damp cloth and leave to cure for 24 hours.

Inspirational pieces

VENUS
HEATHER DADAK

This work is cast in white Winterbourne cement and polished with brown wax. The surface texture, which is similar to Travertine stone with its random holes and crevices, is achieved by casting the cement as dry as possible. Waxing with brown wax creates an ancient feel which complements the strong, simple figure.

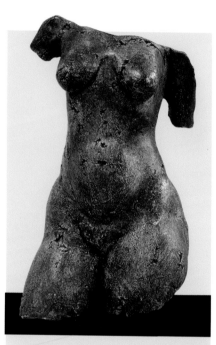

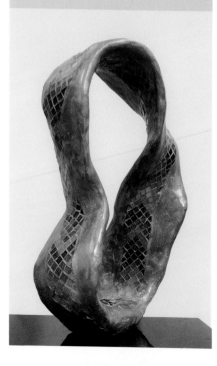

MOBIUS OUROBURUS
HEATHER DADAK

In this piece, cement is used in a fresh way, combining stainless steel powder to create a metallic impression. Combing tiles with cement is an old and well-known practice in the building industry and in the creation of mosaic images. Here, it is used in three dimensions to emphasize the twisting of the form.

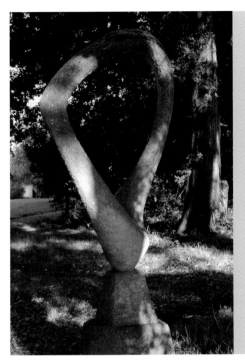

HEART FORM
CLAUDIA PLUER

The cement on this sculpture has been placed in small patches with great care to create a regular, consistent surface and clean lines that encourage the eye to follow the twisting movement. The dynamics of the shape create a rhythmic movement expanding at the top and contracting at the bottom, both in the solid form and in the space that is held within.

WATER FIGURE
ANNE KRISTIN V MOEN

Built in cement fondue over a steel and wire mesh armature, and placed in a garden near a pond, this female figure reflects the inner stillness of the setting. The surface has a rough, random texture which fits well in the natural environment and allows moss to grow, so that in a short time, the piece will look a part of its environment.

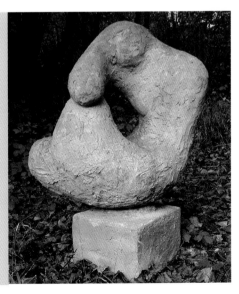

Glossary

Asymmetry
Where the two sides of a sculpture are different from each other and not a mirror image (symmetrical).

Bloom
White colorings on the surface of a material as a result of a chemical reaction with another material or through exposure to moisture while curing.

Bush hammer, bushing tool
A hammer used in stone carving to create a uniform textured surface. It has many small points on its head.

Centerline
A line running through the center of a sculpture, which may be drawn onto the piece or only imagined. It allows the sculptor to balance the two sides of the sculpture, especially if it is symmetrical.

Close-grained
A wood with a compact, tightly knit cell structure, which allows the wood to be precisely carved and finely finished.

Coarse-grained
A wood with large or long cells, which will show its grain strongly even when finished. It also describes a stone with large, loosely bonded particles or with the strong lines running through it from its formation.

Concave
A surface that moves in toward the center of the sculpture to form a hollow.

Convex
A surface that bulges outward, giving an impression of expansion.

Cure, cure time
The process of a material setting or hardening. This term is most often used when a chemical reaction is involved rather than when a material dries through exposure to the air.

Degrease
To clean with a strong detergent to remove all traces of oil, including those left by hands and fingerprints. Degreasing products are specially manufactured for this purpose.

Distress, distressed
Where a sculpture is deliberately made to look older than it is by artificially subjecting it to some of the processes that may have happened to it naturally over a longer period of time.

End grain
The grain exposed by cutting or carving across a piece of wood at 90 degrees to the direction of the tree growth. It shows the annual growth rings of a tree.

Figure, figuring
Markings in wood made by the cellular structures and growth patterns other than the grain. Certain woods are recognizable by these figures and may be cut in special ways to reveal them.

Filler
A material, natural or manufactured, used to fill holes and cracks in a sculpture. In relation to resin, it is a material that is added to the resin to create a specific appearance.

Fine-grained
A wood with cells that are small and tightly packed together.

Flux
A substance that keeps a metal clean during welding, brazing, or soldering. There are specific fluxes for each of these tasks.

Gloss

A natural, painted, or varnished surface that is hard, shiny, and reflective.

Grit

A product used to sand and polish. The level of abrasiveness is given a number, and the finer the grade, the higher the number—60 grit sandpaper is very coarse for rough sanding, and 400 grit is for fine finishing.

Grog

Ground-up ceramic products added to clay to give it more body and structure. Grogged clay is used for hand-building large ceramic pieces.

Igneous stone

Stone formed deep below the earth's surface and formed by the intense heat generated by volcanic action cooling over the years. As a general rule this type of stone is very hard.

Laminate

A material built up by gluing thin layers together. Plywood and fiberglass are made in this way.

Lightfast, colorfast

Materials, dyes, and paints whose colors are permanent and do not fade when exposed to sunlight.

Matte

A surface that is not shiny or reflective.

Metamorphic stone

Generally a soft stone; created by the exposure of sediments to enormous pressure and heat, resulting in a chemical reaction which crystalizes the sediment.

Open grained

A wood with large cells and/or a loose cell structure.

Opaque

A material or finish through which you cannot see clearly.

Oxidize

The process where substances react to oxygen in the air, causing them to change. Rusting is the common term for the oxidization of iron.

Patinate

The process of coloring a metal surface using chemicals and heat to cause a chemical reaction.

Pestle and mortar

Simple tools for grinding up substances by hand.

Plasterbat

A cast slab of plaster used as a surface for wedging clay on. It is absorbent and can be used to dry out clay that is too wet.

Pneumatic

Powered by compressed air.

Polyester

Plastic synthetic material for sculpting. It comes in liquid form—resin—and is hardened by adding a chemical hardener.

Porous

Materials that have an open structure and can soak up liquids. This can be an advantage if you want to stain or treat them with oils However it can be a problem if they are exposed to the weather.

Preserver

Chemical treatments that can be applied to woods to protect them from various forms of rot and decay. They are useful for outdoor pieces but are often poisonous.

Pumice powder

A soft volcanic rock that has been ground into powder to make a very fine abrasive.

Quarter-sawn

Wood that is sawn at 90 degrees to the radius of the log. It is the most stable cut of wood and is the least liable to warping or cupping.

Relief

A sculpture that is not completely three-dimensional but protrudes from a background and is flat at the back. It is usually intended to be placed against a wall.

Rough out

The first part of the sculpting process where the basic shapes are made or carved without any finer detail.

Sedimentary stone

Stone formed by a buildup of organic matter—plants, insects, and sea creatures—in low-lying areas. Over time, the pressure created by the buildup of layers has caused them to harden.

Silicosis

A disease of the lungs caused by inhaling dust.

Site-specific

A sculpture that is made especially to fit or complement a particular setting.

Stable

Materials and colors that will not react and change in a normal environment.

Stippling

Dabbing a surface using the end of a paintbrush to apply color or texture without brushing sideways.

Symmetrical

Where the two sides of a sculpture are mirror images of each other.

Tamping down

Tapping the surface so that the material becomes consolidated and integrated, without any air pockets.

Tangential

A plank of wood that has been cut across the radius of the log.

Template

A two-dimensional cut-out that is used as a guide when sculpting and allows shapes to be duplicated.

Tungsten-tipped tools

These have tungsten—a very hard material—bonded into the tip or blade so that they can be used on hard materials such as granite.

Undercut

Where the shape of a sculpture cuts around, behind, or into itself. It is of importance when using a mold because the mold can be difficult to remove.

Veneer

A thin layer of material, usually wood, which is glued onto the surface of another less precious material.

Waste material

The part of a block of wood or stone that will be carved away.

Wedging

The process of preparing clay, similar to kneading, to remove air pockets, blend in additives, and prepare it for use.

Wet and dry

A type of sandpaper made of waterproof paper and glue. It can be used dry, or with water.

Suppliers

UNITED STATES

The Clay Alley 75 Kinsey Drive, Gettysburg, PA 17325
Tel: +1 717-334-7473 www.clayalley.com/sculpting.htm

Polyform Products Co 1901 Estes Avenue, Elk Grove Village, IL 6000
Tel: +1 847-427-0020 www.sculpey.com/index.htm

Polymer Clay Express at TheArtWay Store 9890 Main Street, Damascus, MD20872
Tel: +1 301-482-0399 www.polymerclayexpress.com

2Sculpt Tel: +1 785-838-3885 Email: sculpt@bigplanet.com
http://2sculpt.com/index.html

The Alberene® Soapstone Company 42 Alberene Loop, Schuyler, VA 22969
Phone: +1 866-831-5100 (toll free) Email: information@alberenesoapstone.com
www.getf.org/customers/alberene/

Seattle Pottery Supply 35 South Hanford Street, Seattle WA 98134
Tel: +1 800-522-1975 Email: info@seattlepotterysupply.com
www.seattlepotterysupply.com

Trow & Holden Inc. 45 South Main Street, Barre, VT 05641
Tel: +1 802-476-7221 Email: info@trowandholden.com
http://trowandholden.com/home.html

Stoneman Inc. 2925 Rufina Court, Santa Fe, NM 87507
Tel: +1 505-471-0018

The Compleat Sculptor, Inc. 90 Vandam Street, New York City, NY 10013
Email: tcs@sculpt.com www.sculpt.com

Colorado Alabaster Supply 1507 N. College Avenue, Fort Collins, CO 80524
Tel: + 1 970-221-0723 www.coloradoalabaster.com

Rockler Woodworking and Hardware 4365 Willow Drive, Medina, MN 55340
Tel: +1 800-279-444 www.rockler.com

Christy Metals, Inc. 2810 Old Willow Road, Northbrook, IL 60062
Tel: +1 847-729-5744 Email: info@christymetals.com
www.christymetals.com

Brad Oren Sculpture Supply 800 Lone Oak Road, Eagan, MN 55121
Tel: +1 800-366-9000 Email: art@bradsculpture.com
www.bradsculpture.com

Alumilite Corp. 315 E. North St, Kalamazoo, MI 49007
Tel: +1 800 447-9344 www.alumilite.com

Ceramics & Crafts Supply Co., Inc. 490 Fifth Street, San Francisco, California 94107
Tel: + 1 415-982-9231 Email: ceramics@ceramicsSF.com
www.ceramicssf.com

UNITED KINGDOM

Alec Tiranti Ltd 70 High Street, Theale, Reading, Berkshire, RG7 5AR
Tel: +44 (0)118 930 2775 Email: enquiries@tiranti.co.uk
London shop: 27 Warren Street, London, W1T 5NB Tel: +44 (0)20 7636 8565
www.tiranti.co.uk

Potclays Ltd Brickkiln Lane, Stoke-on-Trent, ST4 4BP
Tel: +44 (0)1782 219816 Email: sales@potclays.co.uk

Alltek UK The Old Railway Buildings, Silk Road, Macclesfield, Cheshire SK10 1JD
Tel: +44 (0)1625 434 043 Email: info@icp-alltek.co.uk
www.icp-alltek.co.uk

Canonbury Arts 266 Upper Street, Islington, London, N1 2UQ
Tel: +44 (0)20 7226 4652 Email: sc@canonburyarts.co.uk
www.canonburyarts.co.uk

4D Modelshop Ltd The Arches, 120 Leman Street, London, E1 8EU
Tel: +44 (0)20 7264 1288 www.modelshop.co.uk

The Polymer Clay Pit 3 Harts Lane, Wortham, Diss, Norfolk IP22 1PQ
Tel: +44 (0)1379 890176 Email: info@polymerclaypit.co.uk
www.polymerclaypit.co.uk

Will to Carve 8 Newport Drive, Sutton Farm, Shrewsbury, SY2 6HZ
Tel: +44 (0)7753 363378 Email: doc.parry@btopenworld.com

D. M. Foundries Ltd Stafford Mill, London Road, Thrupp, Stroud,
Gloucestershire, GL5 2AZ Tel: +44 (0)1453 763325
www.users.globalnet.co.uk/~dmfound/

Index

Credits

Quarto would like to thank the following contributors who provided additional material for this book:

Additional text: Ken Smith, Eve Conybeare
Additional samples and text: Russell Parry (wood)
Lucy Smith (fired clay— paint-on effects)
Technical advisor (US): Marc Fields

Quarto would also like to thank all the sculptors who kindly submitted work for inclusion in this book.

We are also indebted to the following: Art Outside www.art-outside.com; William Fairbank www.williamfairbank.com; The Royal Society of British Sculptors www.rbs.org.uk.

The following photographers have work reproduced in this book: Antony Barrington Brown 160, 161t; HDP 63b, 64t; Anthony Middleton 103b; Graham Murrell 162; Stuart Whittall 221.